ARTISTS
—
LIVING
—
WITH ART

BY STACEY GOERGEN
AND AMANDA BENCHLEY

Photography by Oberto Gili
Foreword by Robert Storr

ARTISTS
LIVING
WITH ART

Abrams, New York

CONTENTS

FOREWORD

When Neighbors Drop In

Living with art is not a neutral experience. At least it shouldn't be—and won't be if the art is any good. It's not like having visual Muzak blandly hover in the background but rather like turning the volume up on a song or a symphony that makes its presence known, a sound that is keenly felt as it permeates the room. Which is why people who choose to live with art are very selective about the things they have around them.

They are especially choosy if they happen to be artists themselves, because in that case the presence of another artist's work is like dealing with an assertive guest in the house: one with whom it is impossible to avoid conversation, even argument; one who whispers, mutters, interrupts other conversations, even harangues—although it takes a special personality for anyone to extend an invitation to someone who makes themselves a constant irritant. Nevertheless, such people exist and much art does just that: It needles, stings, or discomforts the viewer in ways that simply cannot be ignored.

Which is why many artists choose not to have art in their environment, not even things they've made. Because rather than stimulating their minds it may crowd out nascent ideas that have yet to find form. There is a Zen parable told by Philip Guston, who learned it from the composer John Cage: When an artist enters his or her studio all those who are important to their lives await them there—family, lovers, friends, enemies, and of course all the artists who haunt their memory—all those from whom they have learned something whether positive or negative, through fellow feeling or animosity. And, so the parable goes, as the artist becomes increasingly engaged in his or her own work, one by one these phantoms leave until the artist is alone. Then, on really productive days, the artist—or rather their ego or active self-awareness—leaves too and only the work remains.

Of course the existence of an actual work by another artist in an artist's environment changes everything, which is why many—although by no means all—elect to pursue their vocations in spaces utterly devoid of images or objects other than their own works in progress. Even so, Guston himself kept an impression of Durer's engraving *Melancholia* in the kitchen over the small table where he ate meals or had coffee when he left the studio, and no work by any Old Master speaks more eloquently or more cryptically of the moody solitude in

which creation churns in the mind of the maker, nor sets a higher mark for what a work of art can, indeed must be. To that extent it functioned as a talisman of the burdens of an aesthetic calling—and a goad to action.

That said, artists who collect (and historically some, like Rembrandt van Rijn, Edgar Degas, and Jasper Johns, have done or do so avidly) generally fall into two categories. First come those who can't resist owning things that catch their eye and in some way remind them of roads not taken or possibilities that they have not exploited (not yet anyway). Omnivorous but discerning men and women who accumulate images and objects the way others buy books or CDs and DVDs, artists who make sure that the widest affordable visual frame of reference is always open to them. Often these artists have traveled extensively and brought back tokens of the places they have been and examples of art by artists they met or cultures they "discovered" far from home. I am this kind of artist; so, it would appear from vicariously crawling the walls and navigating the floors in this book are many of the talents represented in these pages.

Of a similar turn of mind are those who immerse themselves sequentially in specific types of work or periods in art history. Andy Warhol and his Carnegie Mellon classmate and friend Philip Pearlstein were of this stripe; Warhol shopped till he dropped and ended up with one of the largest hoards of decorative arts—most notoriously of cookie jars—ever assembled. For his part Pearlstein buys folk art of every description and, like Rembrandt, whose mid-career pictures sometimes contained Scottish tartans and Indonesian krises, he has used them as props in his pictures, prompting his fellow realist Chuck Close to quip that Pearlstein did so in order to write the acquisitions off in his tax returns as a studio expense.

Whether that's true or not—I doubt it is, though such a deduction would be entirely legitimate—Close's motivation for collecting the Old Master canvases and drawings that fill his apartment is of another order. These pictures are a testament to craft and to what assiduous attention to the possibilities still residing in supposedly obsolete methodologies can achieve. Close has no interest in aping historical styles but every day he looks at examples of how high standards of illusionistic representation once were, and how marvelous the creations of those who met them in the past still are. Close has overhauled or reinvented those techniques but admiration for and

competition with artists who came before him is a constant feature of his visual environment, even as earlier phases of Close's collecting included works by Old Masters of his own era such as Roy Lichtenstein and Willem de Kooning for much the same reason. If an artist's work can hold the wall with that of his heroes, he knows he's on the right track—and "she" does too.

For his part John Currin pastiches and parodies traditional painting and surrounds himself with his own ironic work alongside a sampling of the *un*ironic "real thing." However, the tell tale icon in this mix in the well-appointed loft Currin shares with his wife, sculptor Rachel Feinstein, is a drawing of a 1930s or 1940s beauty by the sardonic comrade-in-arms of Marcel Duchamp and unrepentant "kitschmeister" Francis Picabia. "Be warned!" this small sketch announces, "You have left the realm of aesthetic consensus and conventional 'good taste'! Now you're on your own." Still, in comparison to Close it would seem as if Currin and Feinstein stick fairly close to their distinctive brand of "taste"—as does Andres Serrano, who also favors an antique aura with dark subjects, dark surfaces, and heavy furnishings—rather than branching out widely.

In contrast, sculptor Joel Shapiro and painter Ellen Phelan take the prize for museum-quality choices of canonical artists; their collection includes extraordinary paintings and drawings by Arshile Gorky plus exceptional examples of Edgar Degas, Chaim Soutine, Henri Matisse, Jasper Johns, and Alex Katz alongside archaic sculptures from Asia and the Americas. But nobody is more far-reaching and invigoratingly eclectic than Cindy Sherman, who has delighted at playing the chameleon in her photos, and in her loft has amassed the most engagingly disparate amalgam of works by largely little-known artists, a substantial portion of whom rate as "outsiders." I've been there and had the thrill of feeling as if there was no end to the surprises to be found. And for as long as I was free to let my glance wander there wasn't.

Second come the artists who concentrate on very specific, but not necessarily narrow, seams of visual culture, art emanating from movements or affinity groups, or bodies of work by a select few belonging to a single category and sometimes by other members of their generational cohort. This is true of photo-surrealist painter Marilyn Minter, who, among many other things, has a chair designed by Mary Heilmann as well as a canvas by her, plus a goofy drawing of a demonic mouse—like

Disney on hallucinogens—by Joyce Pensato. For her part, Mary Heilmann, who in addition to a rich array of her own creations—painterly caprices, prints, and furniture as sprightly as Serrano's is ponderous—lives with a skateboard decorated with the image of costume jewelry painted by her friend Minter. Likewise, Rashid Johnson has largely focused on fellow African Americans—notably William Pope.L, Ellen Gallagher, and Glenn Ligon—while also making room for the Swiss mischief maker Dieter Roth, even as Mickalene Thomas clusters small works by Kiki Smith, Derrick Adams, and her Yale posse, including alumna Wangechi Mutu and professor Sam Messer, while Glenn Ligon bunches his approximate contemporaries Christopher Wool with David Wojnarowicz with their collective elder Ellsworth Kelly and elsewhere gives pride of place to On Kawara and an aboriginal painting from Australia. Which effectively dissolves the categories I provisionally set up.

So let's put it more simply: Unlike collectors who approach art like postage stamps or stock portfolios, artists acquire and put up things that mean something very specific to them, things that energize them and help them to make their work better and more distinctive. Accordingly this book not only offers a privileged peek at where some of the most accomplished artists of today live, but also into the corners of their imaginations.

Robert Storr
Dean of the School of Art, Yale University
2015

INTRODUCTION

The seeds of this book were planted almost eight years ago, while I was visiting the art-filled SoHo loft of artists John Currin and Rachel Feinstein. John was showing me around when I encountered, in a red lacquered hallway, a small, delicate Old Master study by Ludovico Carracci and a drawing from a group of late works by Frances Picabia. The pair immediately struck me, as they seemed to provide a window into Currin's own painting: his lauded Old Masterly technique in combination with the almost kitschy, sexualized content of Picabia's later oeuvre. At the time I was working at the Whitney Museum, and I was familiar with Currin's painting, but learning that he lived with these pieces provided new, personal insight into his thought process.

I remembered having seen the catalogue from The Drawing Center's 1999 exhibition *Drawn from Artists' Collections*, which showcased pieces owned by prominent contemporary artists. I had wondered about the stories behind these acquisitions. No doubt many were trades with other artists, reflecting their relationships, yet the artists lived with these drawings and so to an extent the works must represent their interests, perhaps even their influences.

I sat with the idea, talking to friends, artists, and others in the art world, but the format did not emerge until editor and writer Sue Hostetler mentioned that she thought it would make a great book. The actual process of creating *Artists Living with Art* was set in motion when another journalist friend, Amanda Benchley, agreed to collaborate with me.

It is an intimate gesture to be invited into someone's home, to see the backdrop of their personal life and hear stories related to how they live, and Amanda and I are inexpressibly grateful to the artists who agreed to work with us. Though the residences we visited were quite different in taste and appearance, each combined a gracious balance and consideration between the display of art, furniture, and objects. And while it is impossible to pigeonhole each artist's approach to what they have chosen to live with, general categories emerged. Some artists revealed themselves to be actively seeking out specific pieces, genres, or historical periods, while others have almost accidentally built world-class collections simply due to a lifetime spent in the art world. Many are foraging and exploring sources like flea markets, eBay, or nature, pursuing an interest in objects as varied as textiles, clocks, minerals, and fossils. We discovered ceramics in almost every home, as well as a surprising number of scholars' rocks.

Frequently, we realized that an artist possessed one or two items that told a specific story, providing true insight into what is meaningful to them. For Glenn Ligon, an original "I AM A MAN" poster used by striking African American sanitation workers in 1968 is one piece that never rotates from his bedroom wall. Ligon used the placard's phrase for an early text painting in 1988, and now *Untitled (I Am a Man)* is in the collection of the National Gallery of Art in Washington, DC.

Pat Steir's elegant Greenwich Village townhouse is filled with pieces by some of the most influential artists of her generation. In her second-floor parlor, Sol LeWitt conceived a yellow wall-size drawing with a circle of white squiggles, while across the room Richard Tuttle installed a delicate, leaf-shaped tin sculpture on a light-gray wall. Yet two of the only works she has purposefully acquired are *Fire* prints by John Cage—an artist whose philosophy of chance greatly influenced Steir.

Will Cotton is interested in the process of drawing, and his collection includes sketches by Reginald Marsh as well as images of rocket ships from NASA. His favorite piece is particularly illuminating: It's a drawing by the mid-nineteenth-century illustrator Gil Elvgren, whose luscious depictions of pinup girls inspired Cotton to put scantily clad women in his own candy landscape paintings.

In her Mercer Street loft, Michele Oka Doner has amassed pre-Columbian artifacts, Mesopotamian seals, Egyptian amulets, and Roman buttons among hundreds of other natural and manmade treasures. A seventh-century Khmer Buddha, which she received in exchange for a Cy Twombly "scribble" early in her career, remains one of her favorite objects. These relics from everyday life inform Oka Doner's exploration of ritual objects, and inspire her use of organic imagery and material.

Cindy Sherman's broad collection includes many contemporary figurative works, frequently with marred or masked visages and a twisted sense of humor. She also owns a nineteenth-century photograph of the Comtesse de Castiglione, an aristocrat who commissioned more than four hundred portraits by Pierre-Louis Pierson of herself posing in elaborate costumes, reenacting roles taken from theater, literature, or her own imagination.

The shared collections of artist-couples, built together over years, reflect their active dialogue about the art they own and create. Laurie Simmons feels more comfortable acquiring photographs, while Carroll Dunham is often drawn toward colorful, expressionist works that reflect his interest in drawing and printmaking. Though Joel Shapiro emphasizes his interest in both two- and three-dimensional work, he has collected many of the museum-quality sculptures in their home, while Ellen Phelan has instigated a number of their important drawing and painting purchases.

In fact, through this project, as we've more directly explored the relationship of domestic space to an artist's practice, I've come to realize that in spite of the two drawings at John Currin and Rachel Feinstein's, their home—with its brass-plated columns, midcentury Italian sideboards and light fixtures, and boldly colored sofas and chairs—is perhaps more related to the theatrical, baroque nature of Feinstein's artwork than to Currin's.

An emphasis on form and shape, and a highly deliberate positioning of objects, was a constant throughout every home we visited. This book is a testament to a refined aesthetic that comes from being totally immersed in creating and living with art. These collections are largely contemplated outside the commercial art market—across the board artists did not intend to part with the pieces they own—because they are driven principally by inspiration, interest, or influence.

Thanks to the beautiful photography of Oberto Gili and the team at Abrams, we hope that the pages ahead will provide a greater understanding of artists' creative processes—to perhaps allow the reader to see things through their eyes—by illustrating what they choose to live with so passionately.

Stacey Goergen

TAUBA
—
AUERBACH

A painting by Josh Smith that Tauba Auerbach admires for its acrostic wordplay hangs in the corner of her living room above a 2012 sculpture by Mary Manning, *Radicchio*, which rests on a colorful lamp.

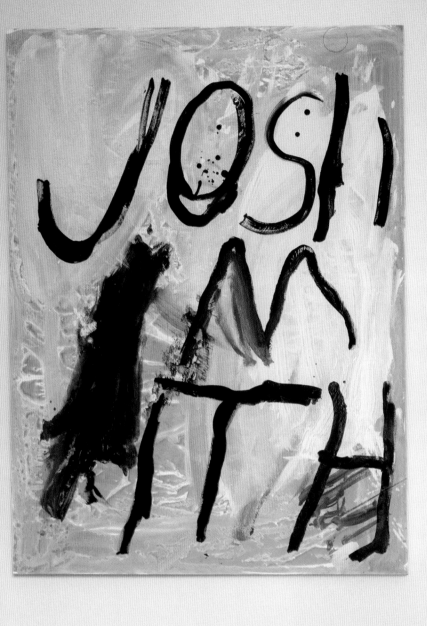

Tauba Auerbach's intimate, jewel-box apartment in SoHo brims with brightly colored artwork, lamps, books, puzzles, and what she describes as "touchstone objects," all set against painted white walls and floors. Like the artist herself, the fifth-floor walk-up is quietly thoughtful and meticulous. Auerbach relocated to New York from her hometown of San Francisco six years ago, a move that's been nothing but positive. "I'm very happy here. There's an energy I feel a kinship with here," she says. "I may be one of those people who never leaves."

Considered one of today's most innovative contemporary painters, Auerbach investigates how we perceive visual information across a variety of media, breaking down systems and structure. She came to prominence in the mid-2000s with her text-based works that alter letters until they are almost unrecognizable, exposing the possibilities and limitations of language. Auerbach's background as a formally trained sign artist laid the foundation for her distorted word paintings and sculptures, and, pushing this further, she has created her own fonts, designed limited-edition artist books, and recently launched her own open-edition imprint.

In addition to exploring language and patterns, Auerbach addresses two- and three-dimensionality. To make her acclaimed Fold paintings, she twists and bends raw canvas, unfurls it on the ground, and sprays an industrial spray gun directionally at an angle so the creases catch the paint as they would raking light. Optically, the works appear to have depth, but it's an illusion, as the cloth is actually pulled flat over the stretcher. Her Weave paintings also explore dimension, as she methodically entwines strips of canvas directly onto the support. "I just never stop thinking about patterns," she says, smiling.

Leaning against a desk in her kitchen is a work by Norwegian artist Frederik Værslev from his series of terrazzo paintings. Working to simulate terrazzo's speckled and flecked appearance, the artist layered paint, solvent, and an anticorrosion chemical on canvases before leaving them outside for six months, exposing them to the wear of natural elements. "He works on several different series often running parallel to one another," Auerbach says appreciatively. "There's a system within each series that applies to the entire sequence, and each sequence is distinct but in conversation with the others. There's something in that way of working that I really relate to."

An Anthony Pearson black-and-white abstract photograph—known as a "solarization"—depicting paint on aluminum foil, hangs above the entrance. "I like the process behind them and how cryptic the results are," she says of the way Pearson allows for accidental results in the darkroom by exposing the negative to light, relating the underlying strategy to her own Fold paintings.

Auerbach is interested in the process of making objects, and she plainly enjoys understanding how things are constructed, how they operate, and how they are related to the works she makes. Timepieces fill her apartment; in the kitchen alone, two wall clocks hang above twelve watches neatly lined up in a row on her desk. "I have really struggled with time and with punctuality," she says. "Having these is part of my effort to become friends with time. I was born late and I've been late ever since. It's like an island of craziness in what I would like to think of as an otherwise sane mind." One of the more unusual wall clocks has increments from one to twenty-four, observing military time. Fascinated by its design, she later used it as a model for a limited-edition clock that also runs from midnight to midnight.

Auerbach has deliberately arranged various bands of color throughout her home. Yellow, maroon, and green pieces of paper line the inside panes of her kitchen cabinets, playing off her vibrant ribbon constructions on the refrigerator door directly below. In the same room, above a delicate, oval wood table, is one of her many light sculptures, this one by Andy Coolquitt. Titled *hold on to me* (2008), the colorful, welded metal piece hangs above a Memphis-style table lamp (the artist has Google alerts for any Memphis-style items that come up for sale). The piece and lamp share a similar palette—planes of yellow, red, and blue—that is also reflected in one of Auerbach's longest-held pieces, a 2005 work on paper by her friend Kamau Amu Patton that hangs nearby. Here, stenciled strips of airbrushed pigment relate to a color strip that runs across the top of the paper and echoes the color in the lamps and the light sculpture.

In her narrow living room, works by Josh Smith and Alex Hubbard hang above a cobalt-blue custom-made sofa. At one end is the first published image of Snoop Dogg, by photographer Shawn Mortensen, depicting the young rapper kneeling behind a large dog, aiming a gun toward the viewer. "[Mortensen] was the person who would photograph a person before they would become famous—he just had this sense that there was something special about them," Auerbach explains of her friend

who passed away in 2009. "I feel super privileged to have this particular piece." She proudly points out two collaged works by the pioneer of industrial music, artist Genesis Breyer P-Orridge. *"Sunflowers" for Vincent V.G.* (2002) is a collage of fractured photographs of a traditional meal—eggs, sausages, a cup of tea— interspersed with fragmented body parts over a grid of Union Jack flags, employing the form of Van Gogh's iconic painting.

In addition to her extensive collection of books, Auerbach's shelves are filled with objects that further reflect her interest in patterns and systems, many of which were gifts: dice, hourglasses, more clocks and lamps. One

particularly sentimental gift is from her father, a lighting designer, whom she describes as "a real tinkerer, a great engineer." Several years ago, while discussing a sculpture construction, they sketched out a diagram together on a round napkin. Her father saved the napkin and framed it in plastic, and it now sits on her shelf.

Though small in size, Auerbach's animated home reflects her complex aesthetic. "I think that all of the objects that you live with, from banal things to furniture and paintings, are just coordinate points. They put you in a certain state of mind," says Auerbach, "and so you cultivate a particular state of mind by curating your space."

Tauba Auerbach in her raised bedroom cubby, with shelves of works and gifts from friends behind her.

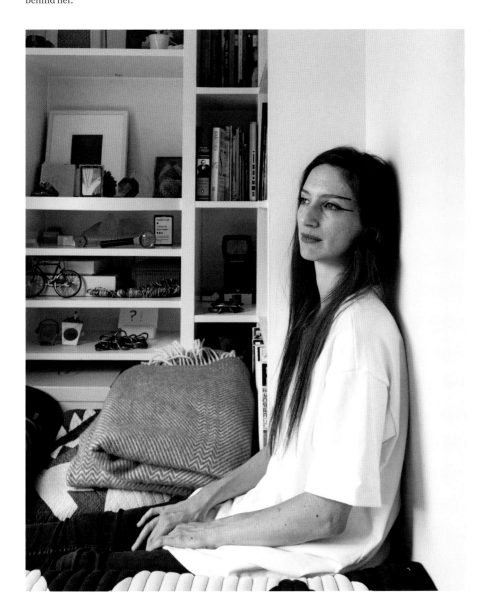

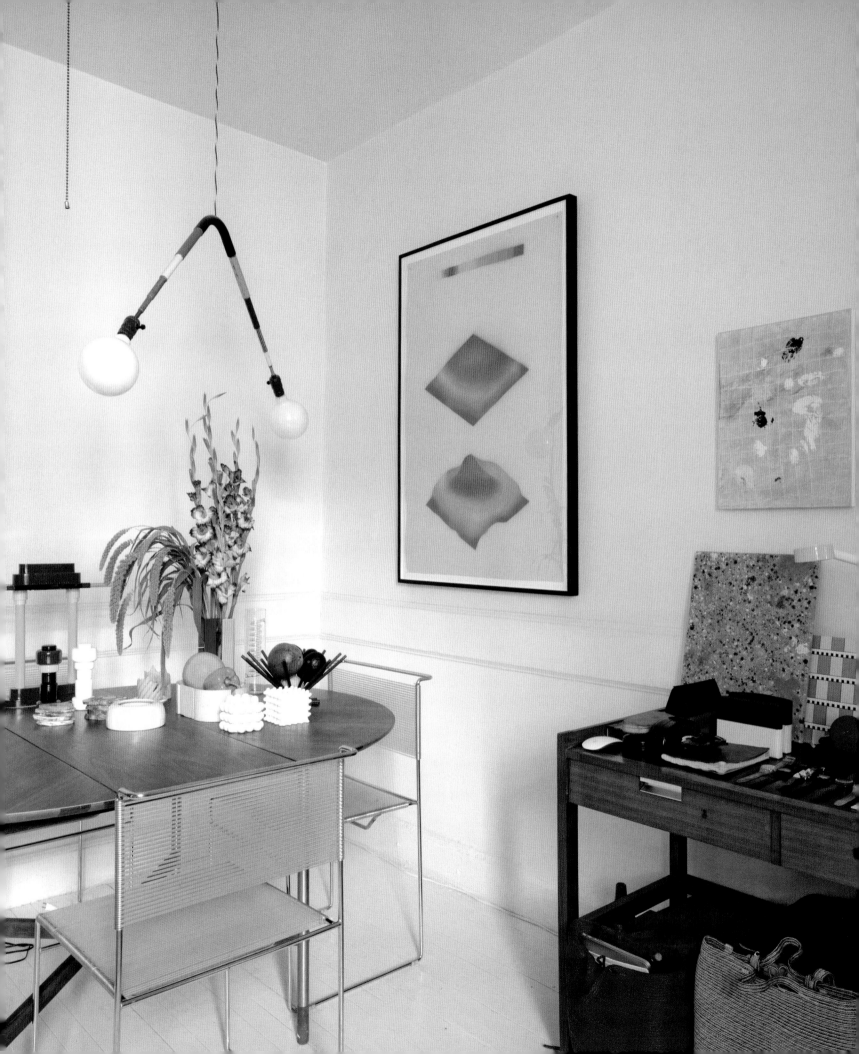

Opposite: A harmoniously colorful arrangement in the kitchen includes Andy Coolquitt's 2008 light sculpture *hold on to me*, Kamau Amu Patton's 2005 work on paper *Topological Grid of Elevations with an Implicit Linear Surface*, and a Memphis-style table lamp. On the right, Alex Olson's 2010 painting *Plot* is hung above a work by Frederik Værslev.

Above: Auerbach's collection of watches—all of which she occasionally wears—is lined up on her desk in the kitchen. "I'm not into collecting anything that I don't use or want to look at," she says.

Right: Auerbach has lined her cabinet doors with boldly colored paper, referencing the palette of ribbons she has made on the refrigerator below and the color schemes that appear throughout her kitchen.

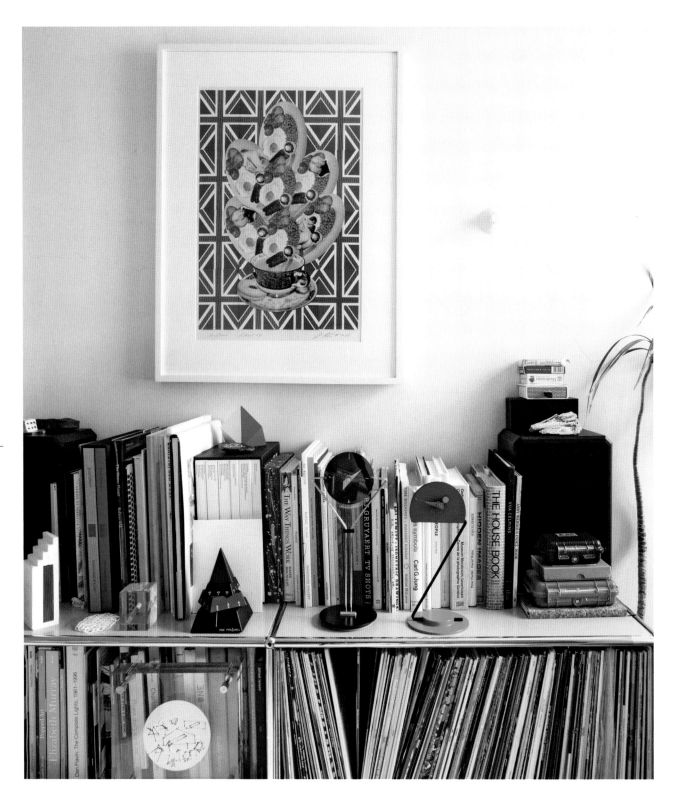

Above: A 2002 collage by
Genesis Breyer P-Orridge,
*"Sunflowers" for Vincent
V.G.* hangs above a variety
of timepieces in Auerbach's
living room. On the shelf
below is the plastic framed
diagram that she made
with her father while dis-
cussing a complicated
sculpture construction.

Opposite: In the living
room, a 2010 abstract
painting by Alex Hubbard
above the custom-built
sofa is adjacent to
Shawn Mortensen's 1992
photograph of Snoop
Dogg. "I feel super-
privileged to have this
particular piece," she
says of the photograph.

Tauba Auerbach

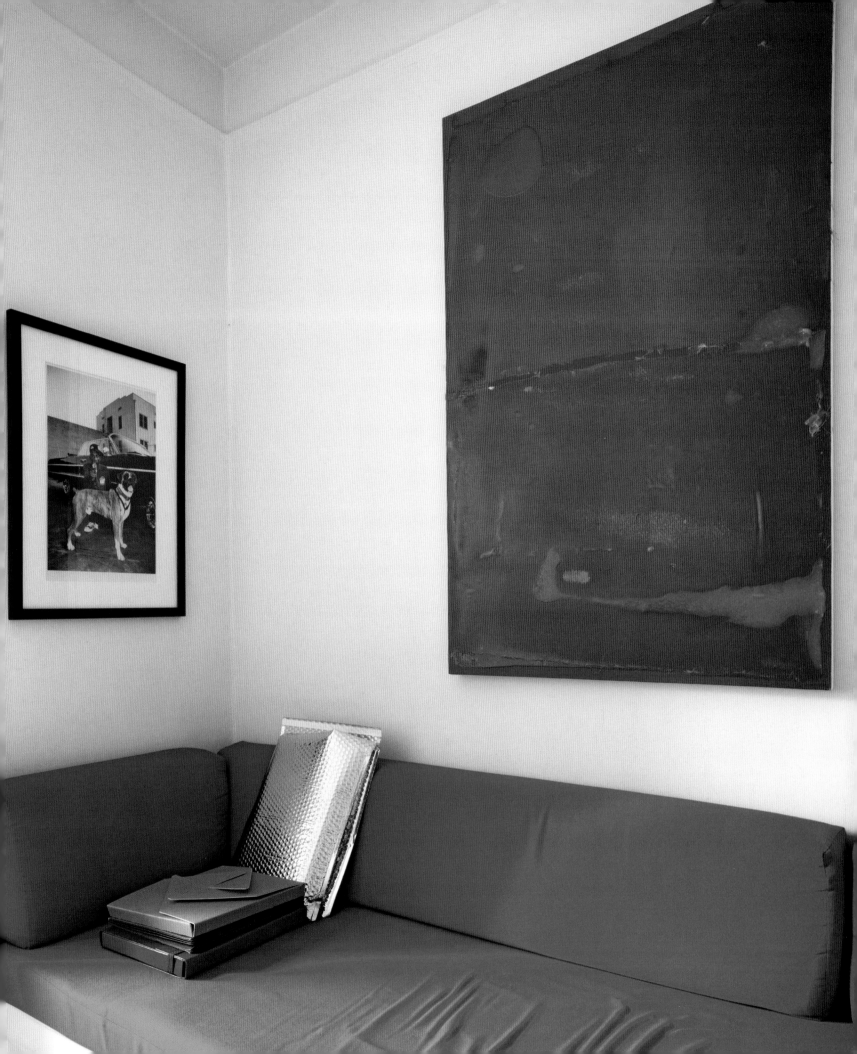

FRANCESCO
—
CLEMENTE

Jean-Michel Basquiat's portrait of Francesco Clemente, a Christmas gift from Basquiat, hangs in his dining area.

CLEMENTEF.RANCESCO

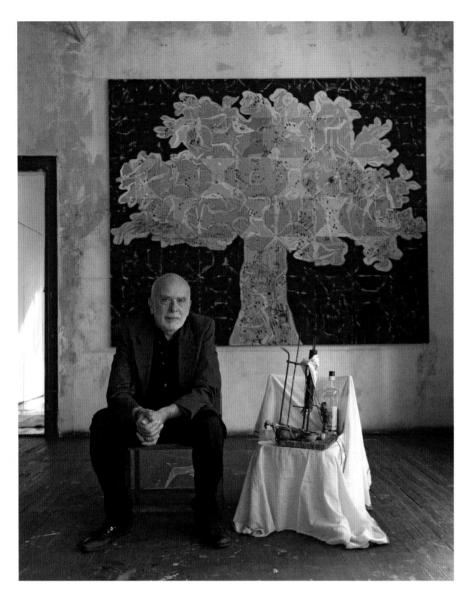

Francesco Clemente at his studio with his 2013 painting *Tree of Life*.

"The works I make are related to the vast field of emotions and desires that finds no suitable expression in the bland and sentimental language of contemporary life," says Francesco Clemente as he walks around his Greenwich Village townhouse, painted in the warm colors of Tuscany. Both the townhouse and his painting studio, formerly his home, are filled with art and objects that have a similar sense of mysticism: ceremonial pieces and drawings from India, paintings by friends like Jean-Michel Basquiat, and sculpture from Oceania.

"I don't think I am a collector," he says. "In the first half of my life I had no money, so I made work inspired by all the things I couldn't buy," recounting how he and his wife, Alba, lived in the empty studio without even a bed. "In the second half of my life I bought things no one wanted almost out of a sense of duty and respect. One forgets that Twombly, Frank Lloyd Wright, Mollino were, for some stretch of time, completely overlooked."

Originally part of the neo-expressionist group that emerged in the 1980s, Clemente is best known for his self-portraits and his dreamlike images that showcase the human body, often produced in large-scale watercolors. Though born in Italy, he first started exploring Eastern spiritual and intellectual traditions in the mid-1970s, during an extensive and profoundly influential stay in India, a country where he often returns. Today, he retains a warehouse of Indian religious implements and ritual objects, such as incense burners in the shape of heads and statuaries, some of which have found their way to his studio, where they are displayed on top of various ornamental trunks as if on altars. These sacred objects, as he explains, are "meant to remind us of the fundamentals of experience, namely life and death," which he compares to similar themes in his own work.

When it comes to the Indian pieces, Clemente is particularly interested in the symbiotic and creative relationship between the country's many diverse regions: "The cultural wealth of India has been generated for millennia by the dialogue and the attrition between urban and rural India." He has a vast collection of richly colored, naturalistic flora and fauna drawings of artists from both types of backgrounds. Lighting a candle for atmosphere, Clemente spreads a selection by one of his favorite tribal artists, Jangarh Singh Shyamon, on the studio floor, noting their intricate patterning and commenting that he finds the work from remote villages to be just as contemporary as that from the

Francesco Clemente

metropolis. His admiration extends so far that, while in India, he often employs local artisans to assist with some of his larger-scale and installation pieces.

Clemente has referred to Cy Twombly and Joseph Beuys as his patron saints. In fact, on a Frank Lloyd Wright coffee table in his townhouse is a two-part cast piece by Beuys, while Twombly's green scribbles hang over the fireplace in his dining room. Clemente humbly recalls how he used to see Twombly in Rome: "I was an aspiring young artist with not much to show. I didn't want anyone to know me, especially someone I admired so much." He did actually meet Beuys, whom he describes as a shaman, adding that he still remembers every word of their conversations. When asked why these two seemingly dissimilar artists are so meaningful to him, Clemente matter-of-factly replies: "Twombly and Beuys talked about history but found a way to make the past a living thing." In particular, Clemente admires the way both artists create surfaces that appear to be weathered by time, "but alive with the seduction of the present."

In the 1980s, Clemente's studio was across the street from Jean-Michel Basquiat's workspace, and as Clemente puts it, "we both disliked the same things and easily became friends." In fact, Clemente says that the painting *Flats Fix* (1981), which now lives in his studio, was the first canvas Basquiat ever painted. One Christmas, the Clemente family and Basquiat were at the home of their mutual gallerist, Bruno Bischofberger, in Switzerland, and Basquiat gave out paintings to everyone in the house, even the children. The gift for Clemente was the characteristic Basquiat portrait that now hangs in his dining room, among furniture designed by Ettore Sottsass. Though they were friends, Clemente maintains that it is also the literary aspect of Basquiat's work that appeals to him. "Basquiat is the heir on one end of the great literary tradition of the Caribbean, and on the other end is the Beat poets who continue to inspire me."

Clemente is proud of what he calls the "somewhat out of fashion" artists that also adorn his townhouse, alongside works by more contemporary artists like Keith Haring and Eric Fischl. These include Henry Fuseli, an eighteenth-century artist who explored the portrayal of the supernatural, and whose haunting *Head of Satan* (1790) presides over the living room along with a portrait believed to be of surrealist poet André Breton by Francis Picabia. Both appeal to him because, as he explains, "I am fond of the rebels. If the rebels have a sense of humor, that's even better. When they manage to be 'in' and 'out' at the same time, they show that they don't take themselves too seriously." Clemente found the Fuseli through a London antiquarian, and only learned later that it had been officially "lost" since 1905.

Large wooden sculptures from the South Pacific and more pieces of Indian statuary and objects for worship add to the aura of soulfulness and spirituality emanating throughout the Clemente home. The enormous carved, wooden, figure-like sculpture looming over the living room is in actuality a drum from the South Pacific. Clemente explains that the drum, which his children used to call "Grandpa" when they were young, is a ritual image representing the voice, the last trace of the body as it dies. "Objects and friends are really how I get my education," says Clemente. "I have no interest in history; I am interested in human experience."

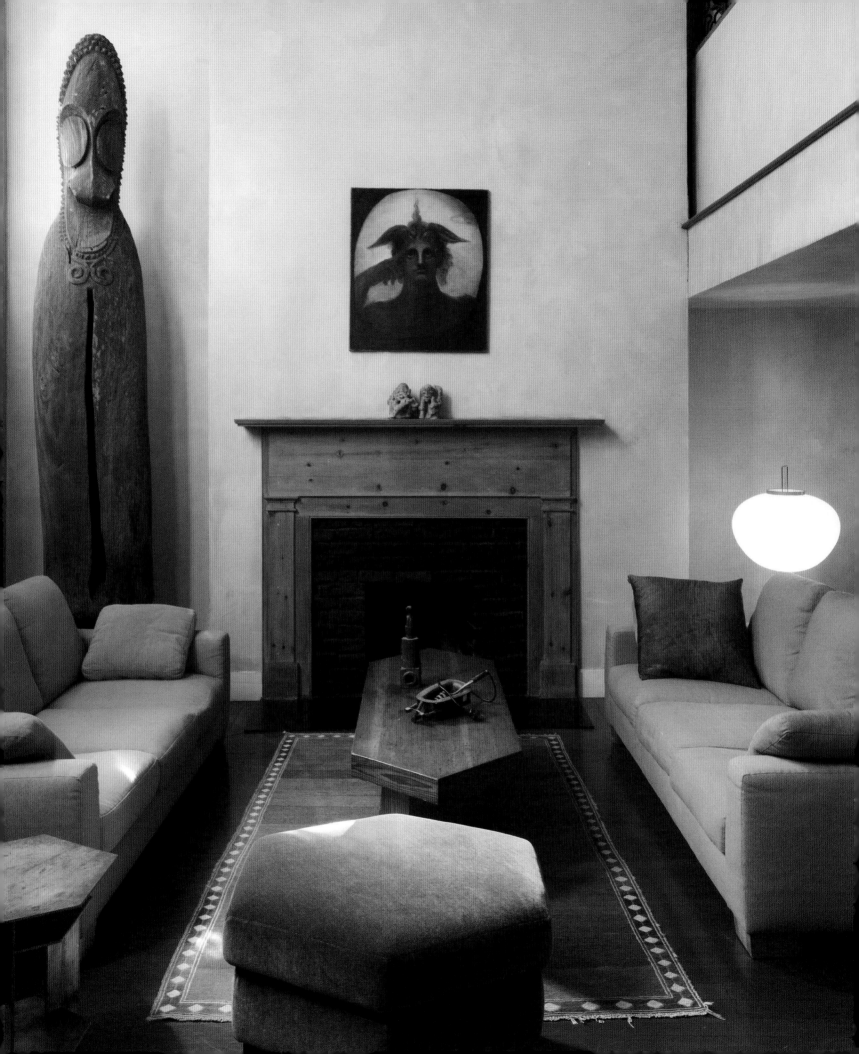

Opposite: The townhouse's
living room features a
Joseph Beuys sculpture on
a Frank Lloyd Wright table
and *Head of Satan* (1790)
by Henry Fuseli. The
tall wooden sculpture is
actually a drum from
the South Pacific.

Above: A 1985 painting
by Clemente is shown
over portraits of
Clemente's four chil-
dren by Eric Fischl,
the result of a trade
between the two artists.
The bookcase is by
Italian architect and
designer Ettore Sottsass.

Left: An Ettore Sottsass
"totem" presides over a
corner of the dining area
near two prints by Jasper
Johns. Sottsass was a
close friend of Clemente's
and the godfather to one
of his children.

Opposite: A drawing
by Cy Twombly over the
fireplace is flanked by
a Jean-Michel Basquiat
drawing and a painting
by Clemente in the
dining area. The furni-
ture includes tables
by Isamu Noguchi
and wooden chairs by
Frank Lloyd Wright.

Francesco Clemente

CHUCK
—
CLOSE

In a corner of Chuck Close's living room, a seventeenth-century copper-plate engraving by Claude Mellan that Close calls "a technical tour-de-force" of printmaking is placed above one of his Gerrit Rietveld chairs.

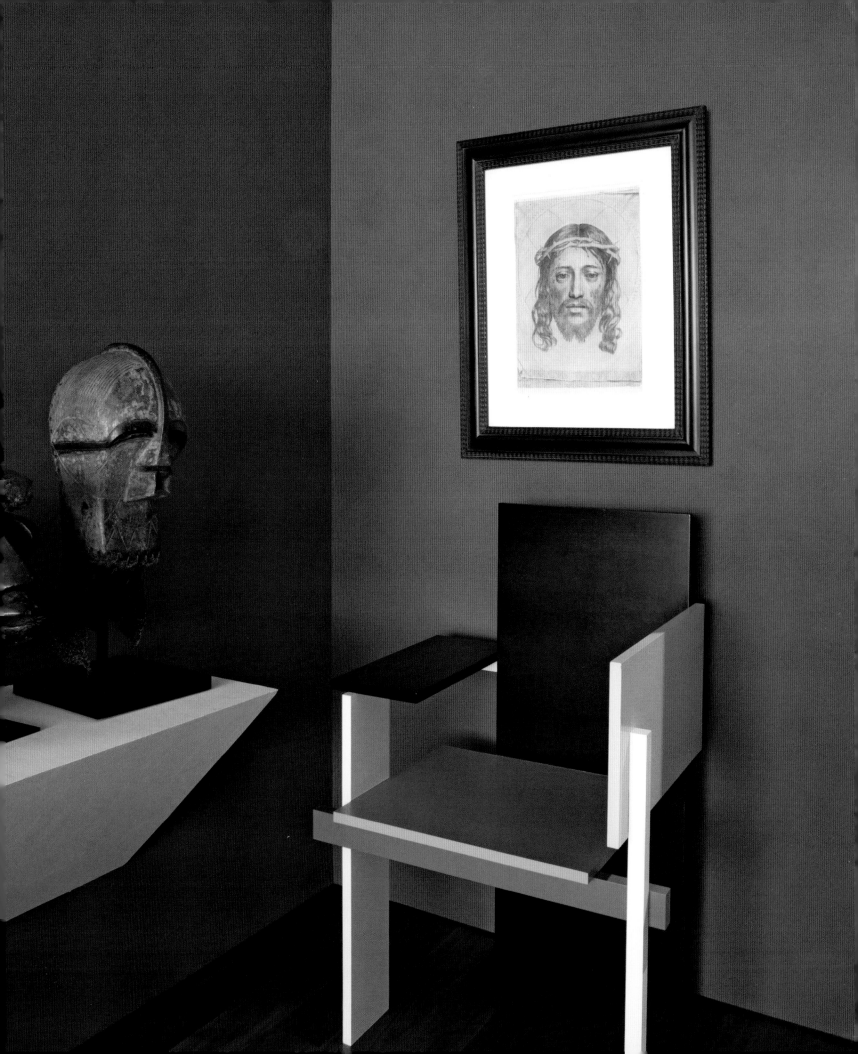

Until relatively recently, the living room walls of Chuck Close's NoHo penthouse were gallery-white, a pristine backdrop for a vast collection of contemporary art that included several large Sol LeWitts and a Richard Artschwager. Now Old Master paintings in heavy, gilt frames adorn deep red walls. The change in decor is a reflection of Close's curious mind and restless aesthetic. "I am plagued with indecision," he laughs. In fact, the apartment almost seems like two separately fashioned spaces: a formal area displaying traditional Old Master religious and historical subjects and a modern foyer filled with contemporary art. The one constant throughout the apartment is Close's concentration on portraits from all eras.

Close, who suffers from prosopagnosia ("face blindness"), is world renowned for reinventing the genre of portraiture with his photorealist-style paintings and for his use of media as varied as silkscreen, etching, crayon, and even fingerprints. In the 1960s, he developed his trademark practice in which he breaks a master photographic image into a grid of incremental parts, each individually painted so that, combined, they re-create the original image, often blown-up and oversize. Subjects have ranged from luminaries such as Barack Obama to fellow artists Philip Glass and Cindy Sherman, as well as his many self-portraits over the years.

Close began collecting Old Master paintings nearly five years ago, almost by accident. A friend at a European auction house had started sending him catalogs, and Close spotted the seventeenth-century Antonio Molinari painting of St. Bartholomew that now hangs over his fireplace. Close has a deep background in classical art history and remembers studying Molinari; in fact, part of the appeal of the Molinari was Close's realization that he could own a piece of art that he had actually learned about in school. So, trusting the expertise of his friend, he bought the painting sight unseen, a move that surprised him. "I am offended if someone buys one of my paintings while looking at it on a computer screen, [yet] here I am doing the same thing I don't believe in," he says, mentioning that he believes the frame alone is worth what he paid for the painting.

Thus started a string of purchases, including a Rembrandt self-portrait, a Van Dyck, a Tintoretto, and several other Dutch masters—many bought sight unseen from catalogs. Close explains that the relatively reasonable price of Old Masters in comparison to

today's contemporary art has kept him busy and amused. "It just turned out to be a lot of fun. It became a project," he says.

Current favorites include Jan Jansz Westerbaen's seventeenth-century *Portrait of a Lady*, "beautifully painted as if the paint got blown onto the canvas by some divine breath of air," and a seventeenth-century head of Christ by Claude Mellan that Close knowingly describes as a "tour de force" of printmaking. "If you've ever tried to make an engraving, it's the hardest thing in the world to do, just to engrave a straight line," he says, detailing how Mellan started at the nose, spiraling one long line that gets thicker and darker or thinner and lighter as he went around.

A second-century bust of Hadrian rests next to his fireplace in the living room and inspired Close to begin studying the Roman emperor's life; he now easily rattles off newly acquired facts, declaring Hadrian "pretty much a pacifist." A Kiki Smith "meat head" sits near the ancient sculpture, a result of a trade between Smith and Close. The sculpture is modeled from an actual flank steak that Smith cast in plaster, its bumpy finish a notable contrast with the sleek marble bust.

Masks of all kinds—another representation of the human face—are also on display in Close's living room. A variety of African masks, some received in lieu of payment from his gallery, are lined up on a sideboard, including a large 1,300-year-old mask of a woman's face that reminded Close of his wife, artist Sienna Shields. Another recalls one of the faces in Picasso's *Les Desmoiselles d'Avignon*, and a third appealed because Close thought it looked like him. A complete collection of 1940s welders' masks, bought in one set at an antiques store because Close thought they resembled his African masks, hangs in the kitchen along with a mixed set of vintage washboards acquired at various Hamptons tag sales.

The arrangement of the more contemporary works on shelves in the foyer was inspired by a 1991 exhibition that Close curated from the Museum of Modern Art's collection; the only way he could include approximately 170 chosen portraits in the designated space in the museum was to build shelves and overlap the frames. "Now everyone does shelves, even the Gap," he says. "It was sort of radical when I did it. But when you bring things together cheek by jowl like I did, you are much more aware of relationships or the absence of relationships."

Now his foyer is teeming with layers of photographs, paintings, and prints by friends

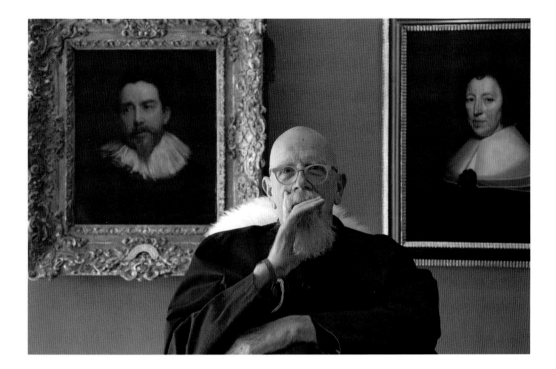

Chuck Close, with works
by Anthony van Dyck and
Jan Jansz Westerbaen
in the background.

and other artists he appreciates, including Berenice Abbott, Alex Katz, Robert Mapplethorpe, Roy Lichtenstein, Willem de Kooning, Duane Michals, Irving Penn, Man Ray, Diane Arbus, and Cindy Sherman—including a photograph of Sherman dressed as a nurse, a gift to Close when he was in the hospital. In addition to the unifying theme of portraiture, other similarities with Close's work emerge: a Picasso consisting of finger-prints; a Weegee photograph of Nikita Khrushchev made of incremental units; and a Mark Greenwold portrait of Close positioned, appropriately enough, in front of a grid.

Close also has most of a portrait collage that he bought from Ray Johnson: When he asked for an artist's discount, Johnson took 20 percent off the purchase price but also ripped off a chunk of the piece to compensate for the deduction.

Close enjoys looking at the works in the foyer while waiting for the elevator and claims that it all "aggregated without me even knowing it. I would trade someone a piece, or someone would draw me, and even if you are not actively looking for it, stuff makes its way to your life," he says, reflecting on more than fifty years immersed in the art world.

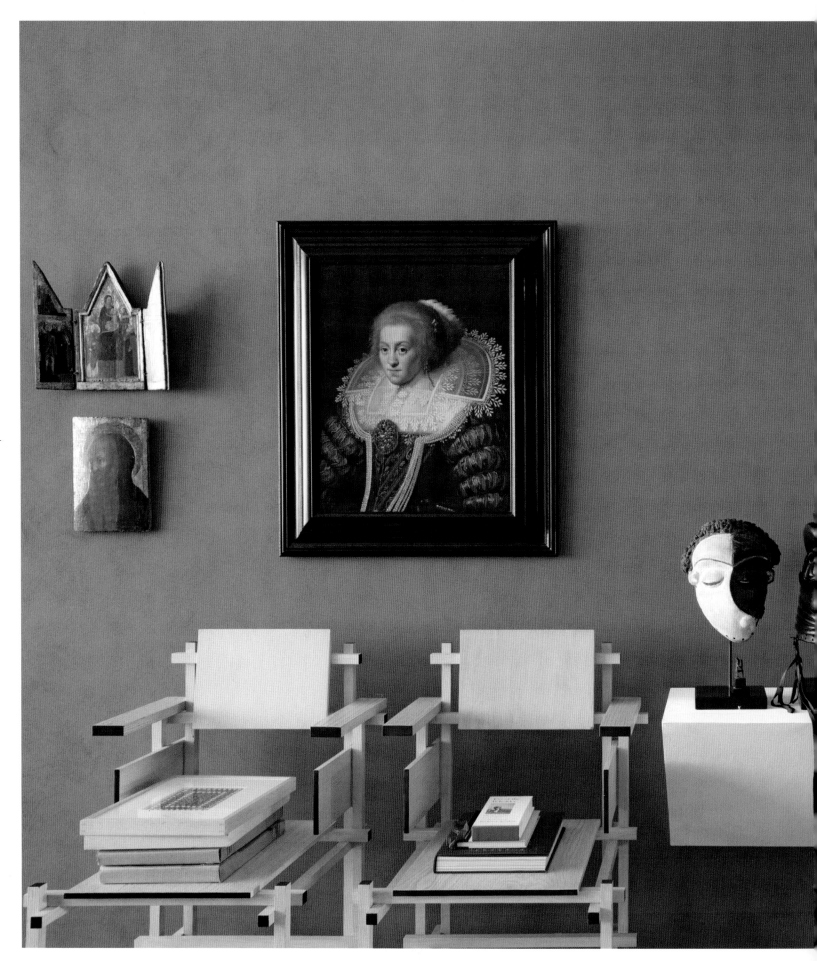

Chuck Close

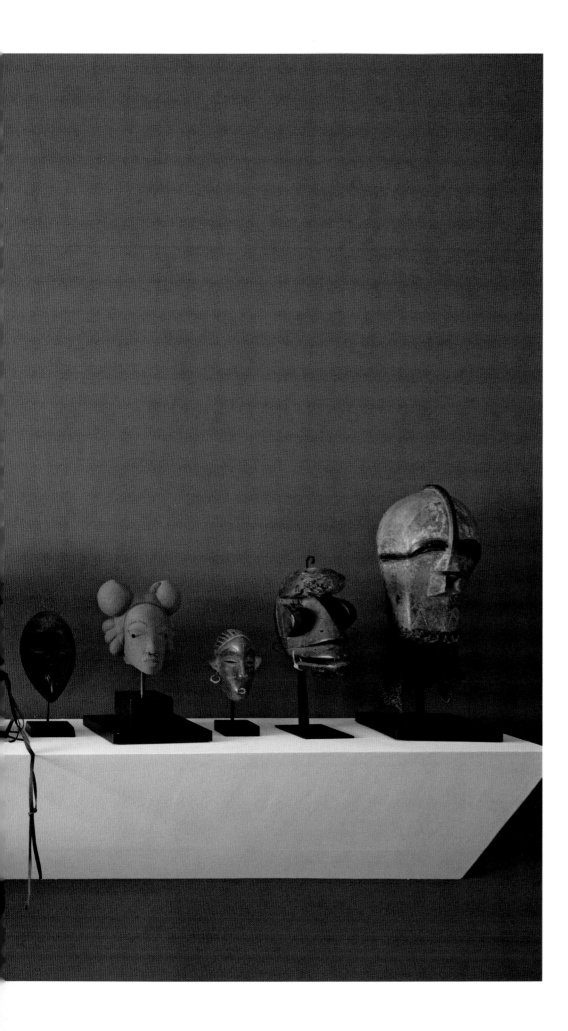

Left: Close's collection of African masks sits on a living room shelf next to Gerrit Rietveld chairs and examples from his Old Master collection, including Paulus Moreelse's *Portrait of a Lady* (1623). The mask on the far right reminds the artist of himself.

Following spread: Ancient stone pieces, including an Egyptian limestone bust relief of a high official (5th–6th Dynasty ca. 2498–2181 BCE), sit on a Gerrit Rietveld cabinet in Close's living room, accompanied by a Rembrandt still-life drawing on the far left and a large seventeenth-century oil portrait of Cleopatra by Thomas Willeboirts Bosschaert. Johann Tischbein the Elder's official eighteenth-century portrait of Frederick II hangs near the dining table.

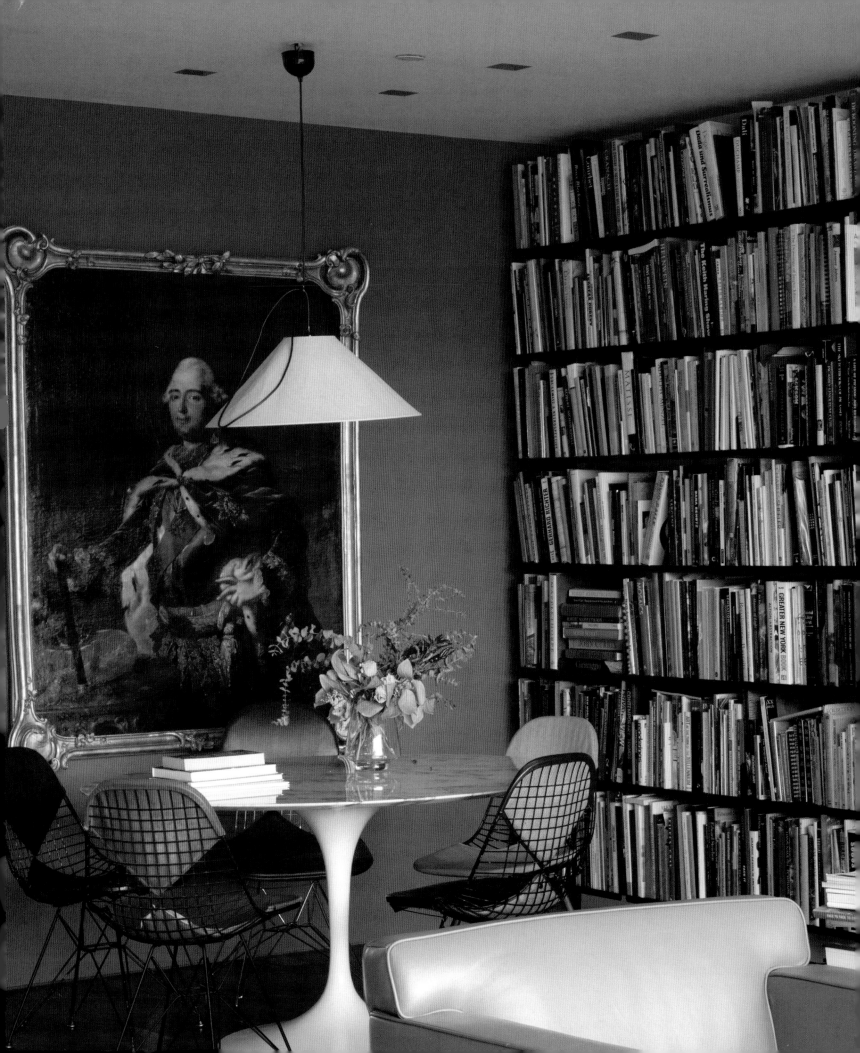

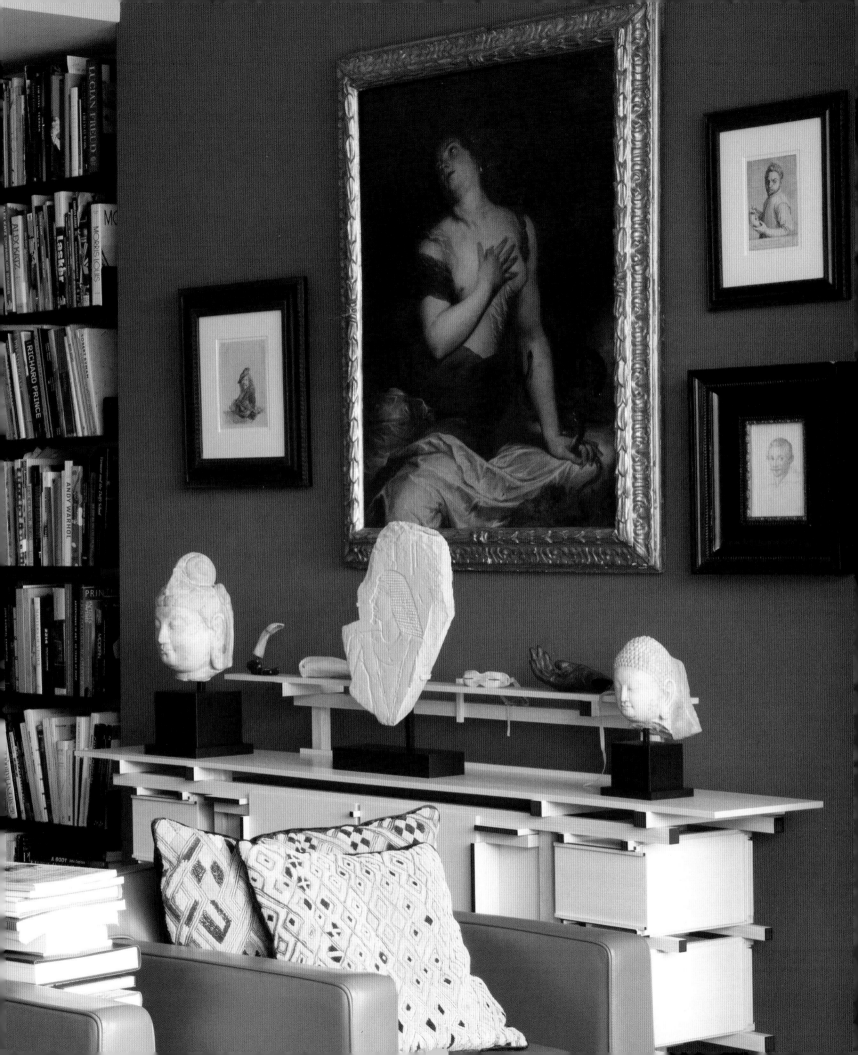

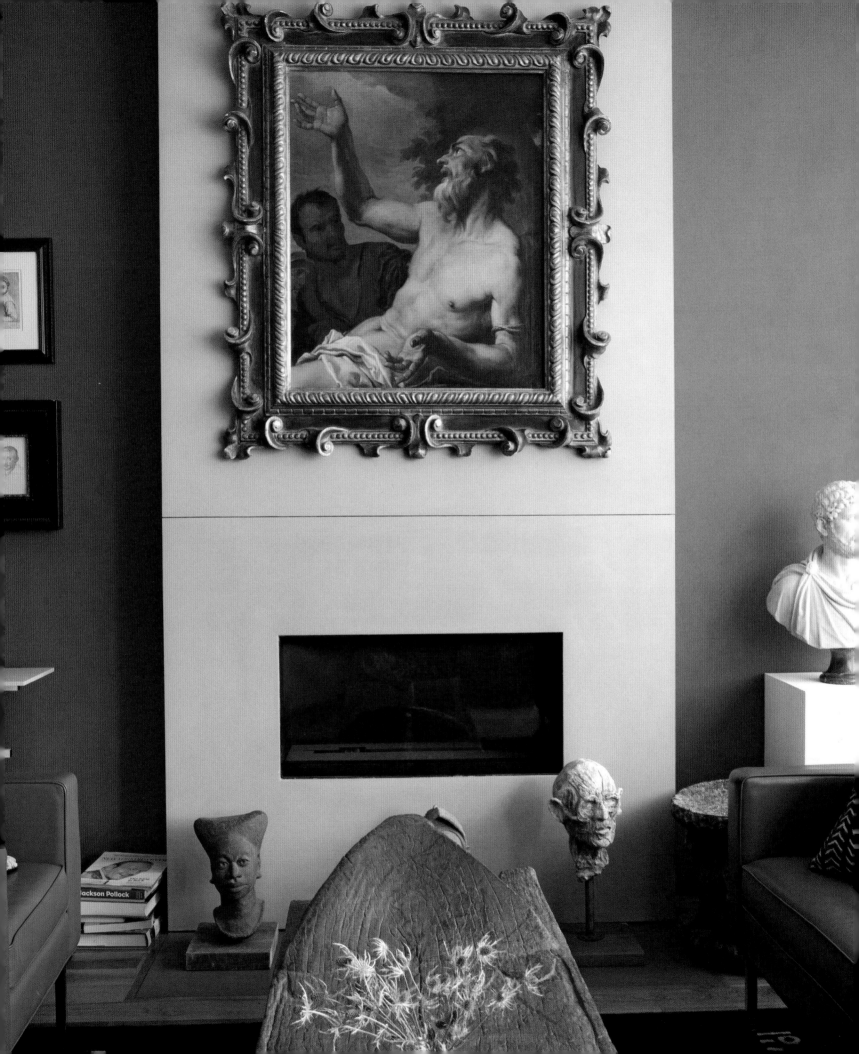

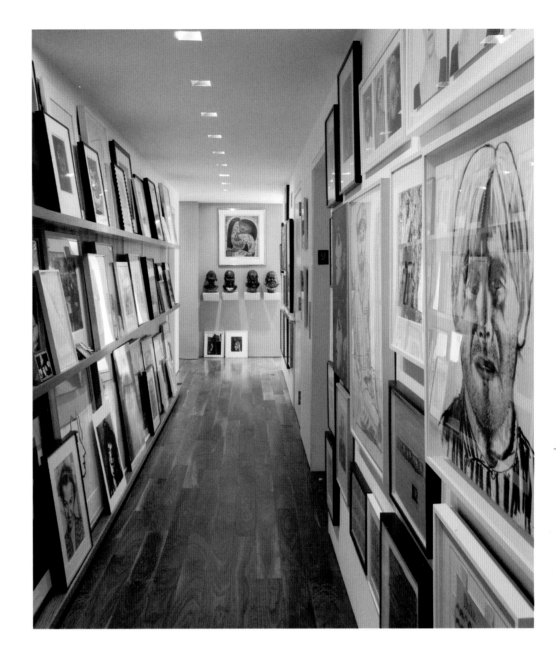

Opposite: Antonio Molinari's seventeenth-century portrait of St. Bartholomew is seen above the fireplace in the living room. Close traded work with artist Kiki Smith for the "meat head" sculpture that rests on the floor to the right, and he spotted the second-century bust of Hadrian at an antiquities store.

Right: A view of Close's foyer, where approximately twenty-five-foot-long shelves are filled with contemporary artwork, many of which are portraits.

Following spread: A close-up of one of Close's shelves. The portrait of artist Lucas Samaras on the bottom shelf, positioned next to a self-portrait by Close, is a Polaroid shot by Close himself.

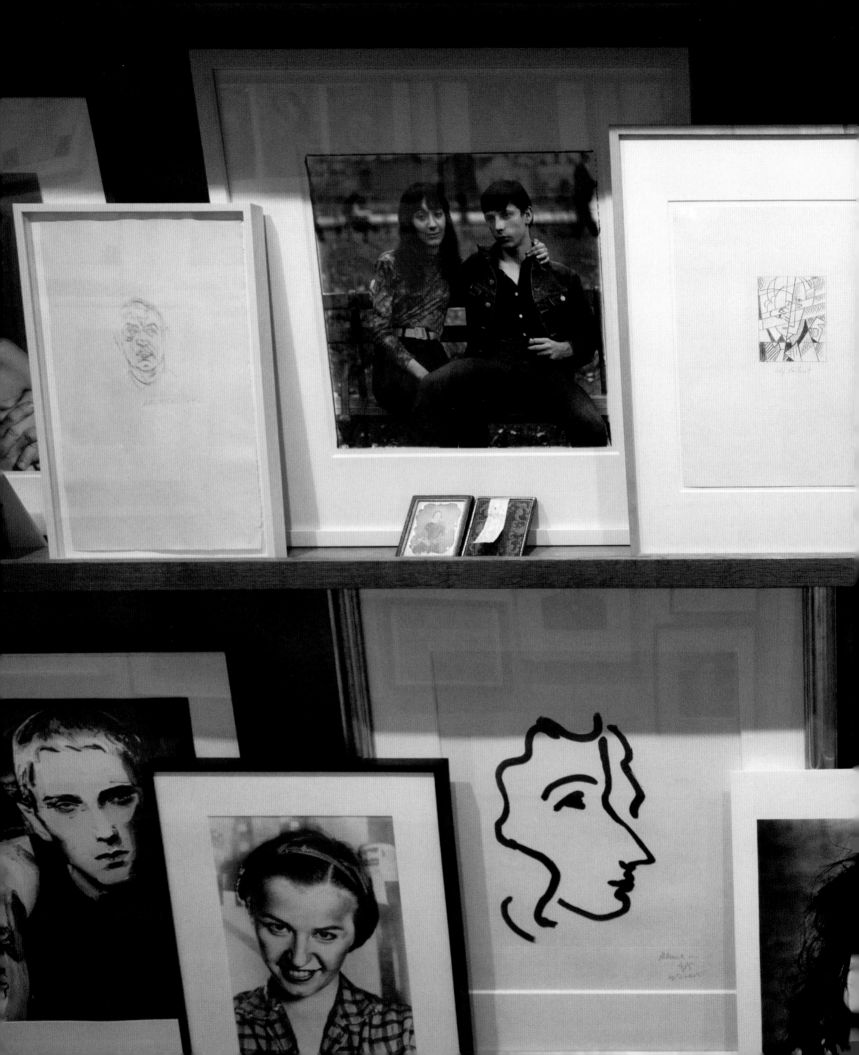

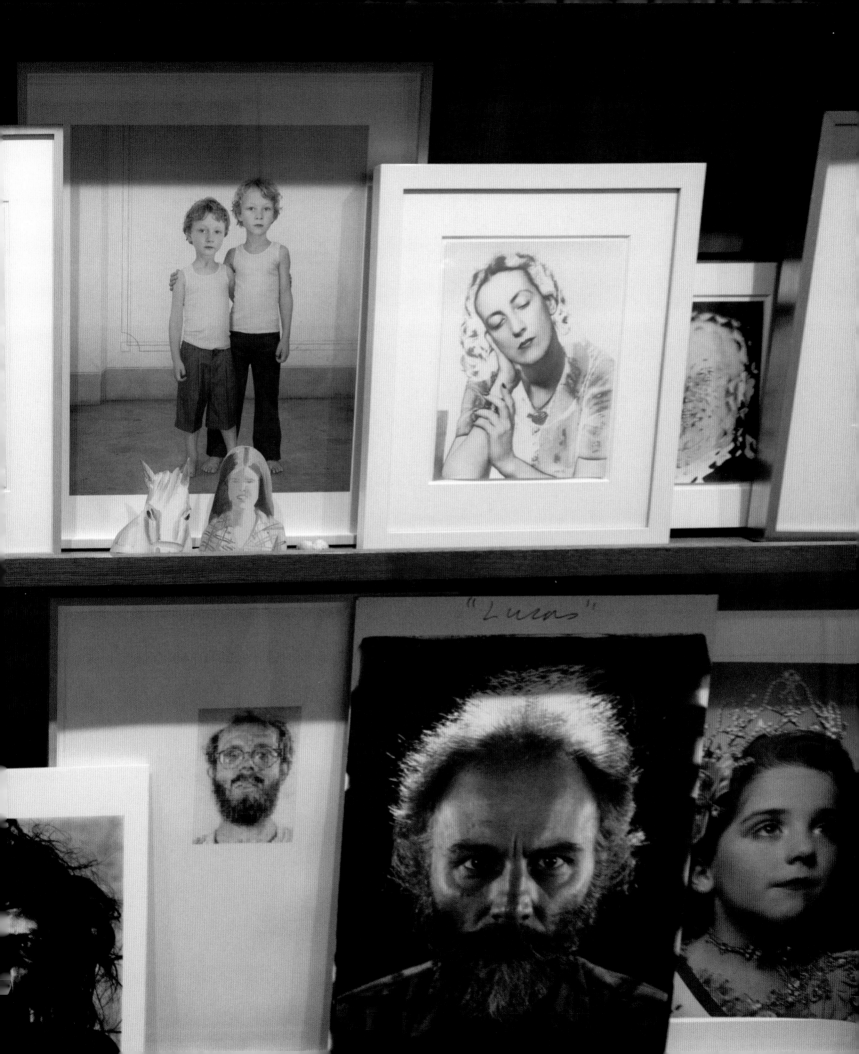

"Lucas"

WILL
—
COTTON

A 1956 charcoal drawing by Gil Elvgren, a midcentury illustrator known for his pinup girl imagery, hangs over Will Cotton's bed.

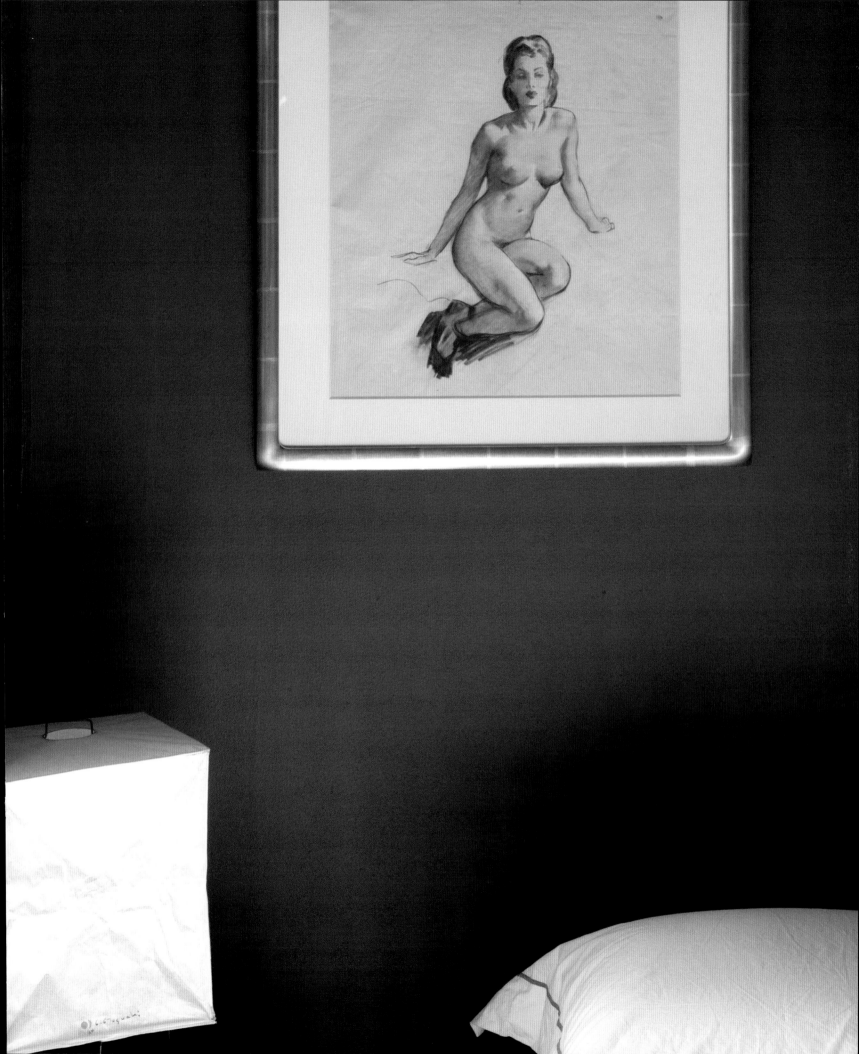

Some of the first things you see when you enter Will Cotton's light-filled TriBeCa loft are a sculpture of stacked, life-size plaster cakes; a dressmaker's dummy wearing white lattice made to look like frosting; and small tufts of cotton candy on a drafting table—all of which Cotton, a skilled pâtissier, has modeled himself. As part of his process, Cotton bakes real-life sweets before he paints them, working out of the loft's tidy kitchen, which, like the rest of the carefully furnished apartment, is a neutral backdrop for the vibrant props, canvases, and artwork on display.

Cotton made his name in the late 1990s with his stylish, large-scale paintings of landscapes dotted with lollipop trees, gingerbread houses, and other delectable bonbons that reflect a world built on appetite and consumption. Cotton later moved into portraiture as further commentary on the subject, often depicting beautiful women scantily clad in marshmallows and cake. Among his better-known projects is the artistic direction for Katy Perry's 2010 video "California Gurls," where the pop singer seductively lounges among cotton-candy clouds.

Cotton lives with Rose Dergan, of Gagosian Gallery, so residing here are also the big-name contemporary artists you might expect to find in the home of two people so deeply immersed in the art world, including Andy Warhol, Jasper Johns, and David Salle. But Cotton admits that he "almost never" actually buys art. Rather, following a centuries-old tradition, Cotton has accumulated much of the art he lives with through friendly bartering.

In 2002, Cotton started hosting a drawing group with fellow artists, who would routinely swap the works they produced in their weekly meetings. Flat metal file cabinets in Cotton's office area store folders thick with more than a decade's worth of these sketches, including Hilary Harkness's delicate, sinuous, barely recognizable nudes, as well as sensual, seductive figures by E.V. Day. The artists sometimes draw from a nude model, and what interests Cotton are the different interpretations of the same source. "I can walk around the room and see what everyone is getting out of the same experience," he notes, going on to explain that the drawings represent an "intimate, distinct moment in a person's thought process."

The David Salle print of a cancan dancer kicking up her leg, revealing layers of skirt underneath, came to the loft on Harrison Street through a more roundabout trade. At a New York charity event, his friends Cynthia Rowley and Bill Powers had hoped to win one of the drawings Cotton donated but left with the Salle instead. Salle, a leading postmodernist known for stripping images of their meaning and mixing iconography from high and low culture, had a considerable impact on Cotton's early work and his formation as an artist. When Cotton learned that Rowley and Powers had the Salle, he swapped one of his own drawings for the work. The print now hangs above his desk, near two Reginald Marsh studies of a woman also lifting her skirts, albeit in a more suggestive manner.

Though Cotton feels passionately about all the art he owns, he purchased some of it—mostly works on paper—for very specific and personal reasons. Among these are dozens of 1960s rocket ship drawings that NASA auctioned off at the Swann Galleries in New York. Cotton flips through the folder of drawings, pulling out various schematic and cartoonish rocket ships rendered on drafting paper. Each NASA drawing is like a private view into the engineer's mind and thought process, explains Cotton, mentioning a rocket with built-in escape towers that Cotton believes was drawn in the late 1950s. "This is not any rocket that NASA ever made," he says, "but I just love that this is somebody's early conception of what it could possibly look like."

One of his favorite NASA sketches is from a series that explores the various ways an astronaut might exit the lunar module onto the surface of the moon. Pointing to one particularly imaginative iteration, he chuckles and says, "This one looks like a fishing pole that will pick up one of the astronauts and deposit him on the ground."

Cotton's most beloved piece hangs quietly above the bed in his sparsely furnished, brick-walled bedroom. It is a 1956 charcoal nude, sitting with her legs crossed casually to the side, by Gil Elvgren, a classically trained, mid-century illustrator known for his calendar pinup girls. If she seems familiar to those who know Cotton's portraiture, it is not by chance.

After several years of success with confection-filled canvases, Cotton felt he needed a human presence among his signature candy sticks and gumdrops. "I had been wrestling with the question of how I could integrate figures into these landscapes," he reveals. "Were they going to be gingerbread people? Were they going to be real people? What would they look like?"

It was around this time, on a trip to Paris, that Cotton accidently discovered Elvgren's work. He was browsing at a Left

Bank bookstore when he spotted a cover with a terrific pinup painting. "I just thought, 'That's it,'" he recalls with a large grin. "'That's the sort of feminine archetype that needs to be in my paintings: the over-the-top sweetness—saccharine—and beauty.'"

He debuted his first figured landscape, *Cotton Candy Cloud*, at Mary Boone Gallery in 2004, a path that later led to more and more portraiture. Almost as a tribute, Cotton set out to buy a real Elvgren for himself, and he found this example at the online auction house Heritage Auctions. "Sometimes I like to imagine the artist I would be if I could be any artist," Cotton says. "In my fantasy self, I know I would like to be the artist who's in the studio drawing this girl."

Sitting at his dining table, Cotton says that while his collection of drawings isn't nearly as valuable as other media, that's not important to him. "My attachment does go toward drawing. My paintings are my ambassadors going out into the world; they are supposed to be out there. On the other hand, I get very attached to drawings; my own drawings as well. I find it very hard to let them go."

Will Cotton in the front of his TriBeCa loft.

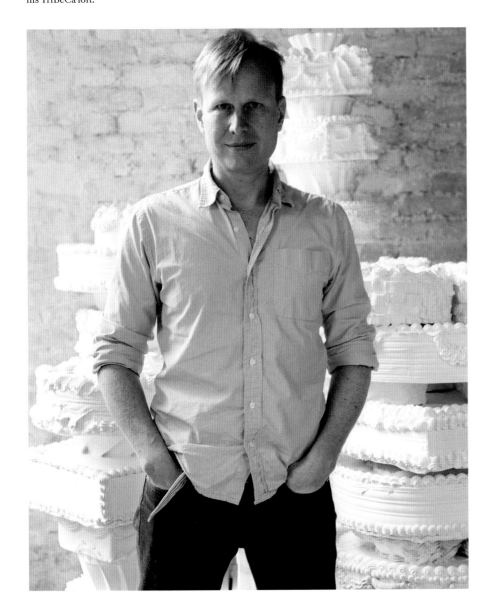

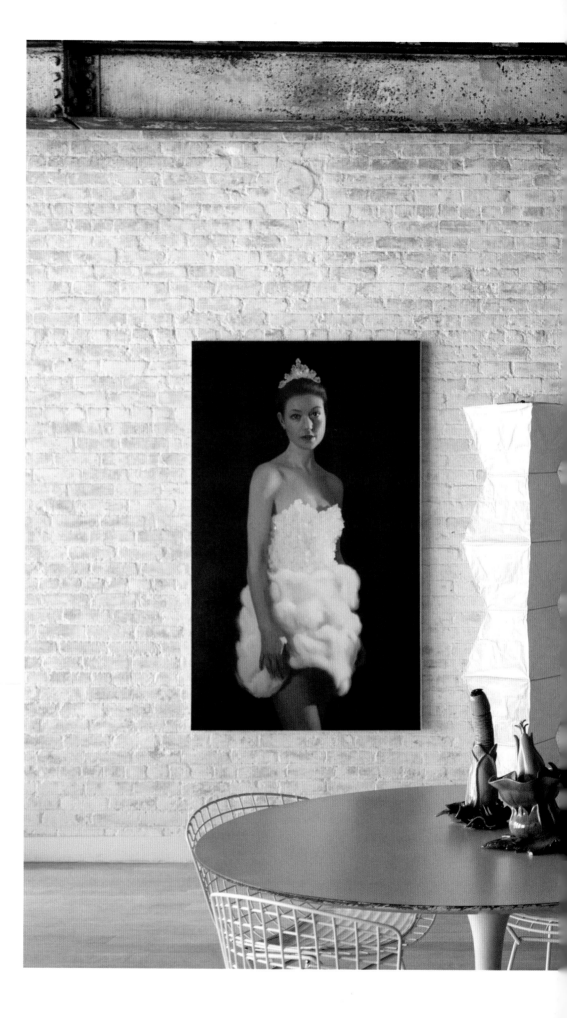

Cotton's 2010 painting of his partner, Rose Dergan, coexists with works by Andy Warhol and Ryan McGinness. Ceramics by artist Linda Lighton, who happens to be Dergan's mother, are on the table.

Will Cotton

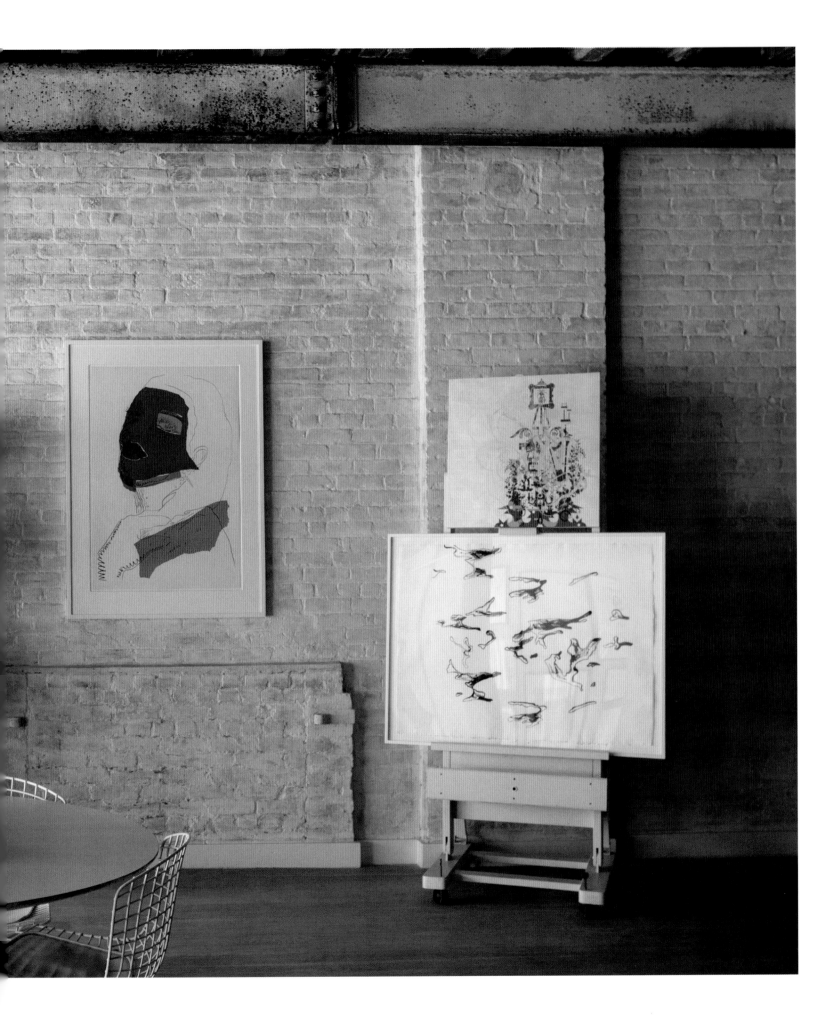

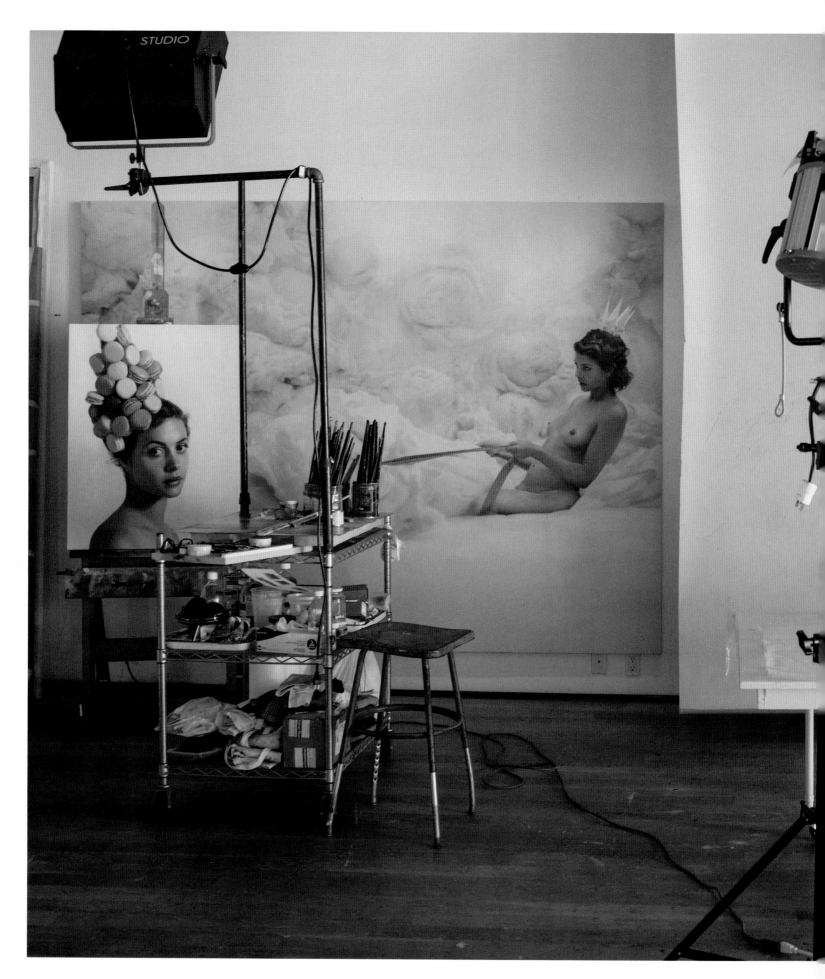

Will Cotton

Props, paintbrushes, lighting equipment, and paintings are all in place on the studio side of Cotton's home.

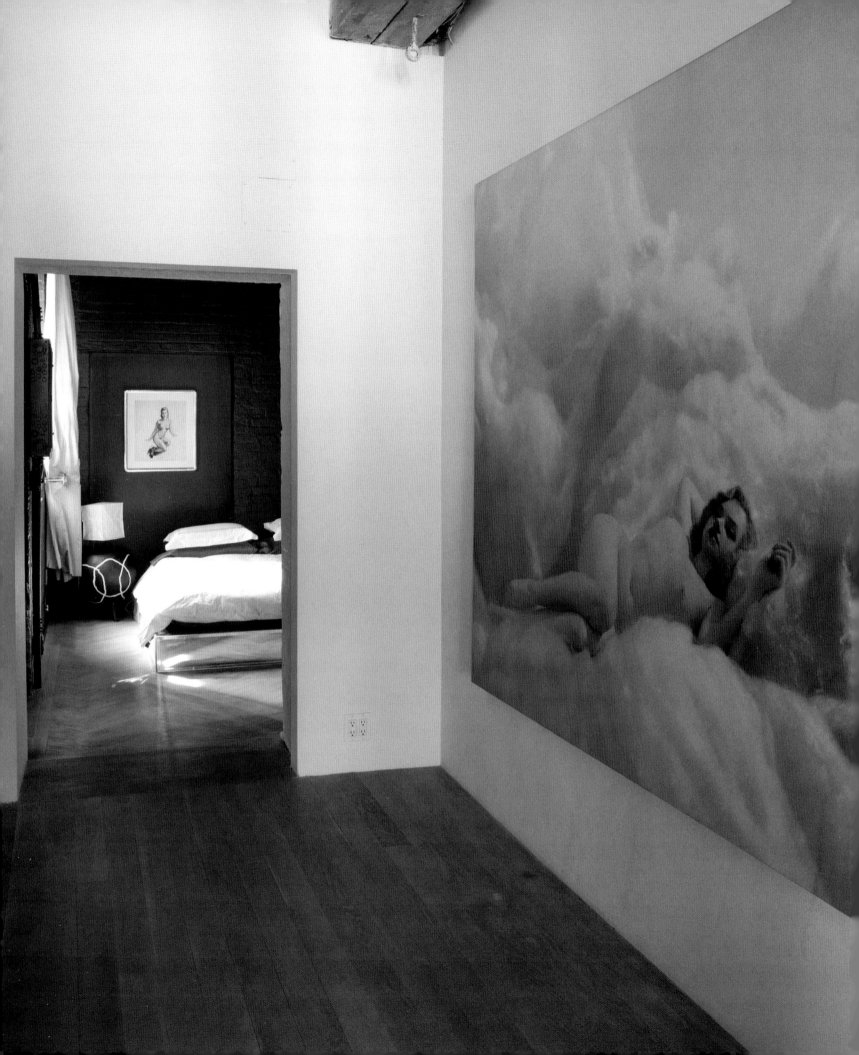

Opposite: A view of Gil
Elvgren's drawing from the
living space, with Cotton's
2006 painting of a nude
woman lounging in a cloud,
Cotton Candy Sky (Mona).

Above: An array of Cotton's
collection of original NASA
rocket ship sketches from
the 1960s, which he found
at the Swann Galleries in
New York.

Above: Cotton's 2012 large plaster cake sculpture, *Against Nature*, awaits visitors when they get off the elevator.

Opposite: A wall of favorite works on paper features participants in his drawing group, including a 2001 Guy Richards Smit (top left), a 2002 Inka Essenhigh (middle row second from right), above Hilary Harkness's 2005 watercolor. A 1995 etching by David Salle is bottom middle, two circa 1949 drawings by Reginald Marsh are stacked on the bottom right, and a 2012 Jasper Johns lithograph is on the bottom left.

JOHN CURRIN

RACHEL FEINSTEIN

A 2010 painting by John Currin titled *Flora* after the goddess of flowers and spring. Currin and Rachel Feinstein also named their daughter after this goddess.

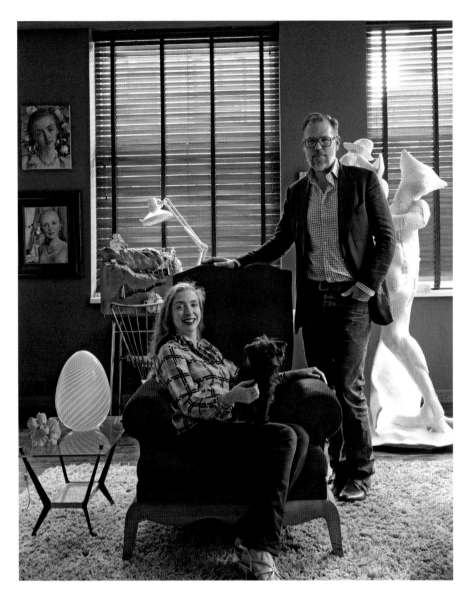

John Currin and Rachel Feinstein in their SoHo loft with their puppy, Mr. Green Jeans. Feinstein's large white sculpture *Punch and Family* (2009) is behind them.

Rachel Feinstein and John Currin's SoHo loft manages to be at once a grand, theatrical statement and a comfortable family home. Many of the fanciful baroque elements found in Feinstein's artistic practice are seen here: brass-plated columns inspired by the London nightclub Annabel's; midcentury Italian sideboards and light fixtures; and boldly colored sofas and chairs. Several of Currin's paintings of Feinstein and their three children also appear throughout the space, and, when asked about living with the pictures, Feinstein says without hesitation: "They are like family snapshots. People have photographs of their wedding, and that's what these are for me. Every single one is a hallmark of what was happening at that time in our lives."

Like the specific associations recalled with each family portrait, Feinstein kept her own white resin sculpture of the commedia dell'arte figure Punchinello for its personal significance. Throughout her career, Feinstein's inspirations for excess and indulgence have also included the Ballets Russes, rococo architecture, and Grimm's fairy tales. Punchinello, the hunchbacked fool, sits poised where two walls of windows in their corner loft intersect. He's a fantastical creation posing with his wife and child—in this case modeled on small Meissen porcelains—deconstructed and reimagined so that the figures have strangely angled and pointed features, becoming barely recognizable in the process. Feinstein created the figures while pregnant with her daughter, and she admits that she forced herself through the complicated construction, so it now serves as a nice reminder of that sense of accomplishment.

Feinstein thrives on work that is technically complex, and she forged a new sculptural process for her widely praised 2014 public art exhibition *Folly* in New York's Madison Square Park. The installation played off historical notions of "follies," the fanciful structures with no practical function other than visual indulgence that have graced parks and gardens for centuries. To create the three sculptures, Feinstein first fashioned small paper maquettes, including a rendering of Punchinello's ship; she then enlarged and constructed larger aluminum structures based on the small models. After magnifying her initial drawings of each structure, she directly adhered the enlarged sketches to the aluminum surface, so that the resulting sculptures faithfully replicated the small models. The final product was monumental in size while simultaneously rooted in Feinstein's distinguished drawing practice.

The stories behind two of the couple's favorite works, both installed in a glossy, red-lacquered hallway, share in this same kind of theatricality. A postcard-size Old Master drawing by the early baroque painter Ludovico Carracci was Feinstein's extravagant gift to Currin for his fortieth birthday. At the time, they were living in a street-level apartment off the entrance to the Holland Tunnel and just beginning to have commercial success. Feinstein visited an Old Master dealer and, knowing that Currin's favorite painting was Carracci's *The Lamentation* (circa 1582) at The Metropolitan Museum of Art, was delighted to discover she could afford one of his works. She splurged on the small, late-sixteenth-century study, borrowed an antique frame for it, and wrapped the framed piece in white nesting boxes overflowing with paper. She presented Currin with the huge package ("At first I thought it was a large pillow," he says), and when he finally found the drawing, he believed the gift was the ornate frame, rather than the drawing, which he assumed was a reproduction. "I thought it would be so poignant for him to have something by Carracci," Feinstein explains, "because he was obsessed with his painting at the Met." Currin laughs. "I think the Met agrees with me: When they rehung the galleries, they put their Carracci at the center," he says of the painting.

On the same wall is a graphite portrait of a woman by Francis Picabia, another artist Currin reveres. The 1942 drawing is from a late body of work when the revolutionary artist began copying depictions of women from erotic magazines, a shocking transition for an artist known for his commitment to abstraction and the avant-garde. The piece was an impromptu gift from a friend, art dealer Aroldo Zevi, at the opening party for Currin's 2003 exhibition at the Serpentine Gallery in London. Currin still remembers the scratching noise of the pen on the frame's cardboard backing as Zevi wrote hastily: "To John and Rachel and Francis," referring to their soon-to-be-born son, whom they planned to name Francis in tribute to both Currin's own middle name and Picabia.

Taken together, these two drawings—at first glance so unrelated—provide a window into Currin's own figurative paintings. The painter is world renowned for his carefully layered and beautiful Old Master–style paint application, a technique that seems entirely at odds with the provocative, sometimes pornographic, subjects of his work. This contrast is something that interests both Feinstein and Currin and drew them to their first major acquisition, a large painting by Cornelis van Haarlem. While installing the 2011 exhibition *John Currin meets Cornelis van Haarlem* at the Frans Hals Museum in the Netherlands, the couple resolved to acquire a work by the influential Dutch mannerist. After this show, Currin was inspired by a Van Haarlem title for a later painting of his own: *A Fool with Two Young Women* (2013). So it was a happy coincidence when this exact painting came up for auction two years later. It depicts a grotesque figure in the yellow costume of a fool sitting beside two women; a long, gray sausage inexplicably curls under the leering man's hand, gently caressed by one of the women as it drapes over her arm. Feinstein reveals that at one point, the lewd, clearly phallic form was painted over, although it has since been restored to the original imagery. "It's obscene, basically," concludes Currin.

Feinstein explains that, for an artist, owning the works of Old Masters feels like a way of harnessing their energy. "When you live with something like that, you gain the artist's strength and power," she notes. "I don't look at that little drawing [the Carracci] every day anymore, but every once in a while when I come home, I'll just stand in front of it and see a lovely little interlude that I'd forgotten. And that's the incredible thing about living with art; you don't get to do that in a museum."

Following spread: Family portraits by Currin of Feinstein and their three children overlook the dining room table. On the bottom right, Currin's painting of a bald woman immortalizes their beloved dog Chewy, depicted in the background. The 2001 painting is called *Portrait of Chewy*.

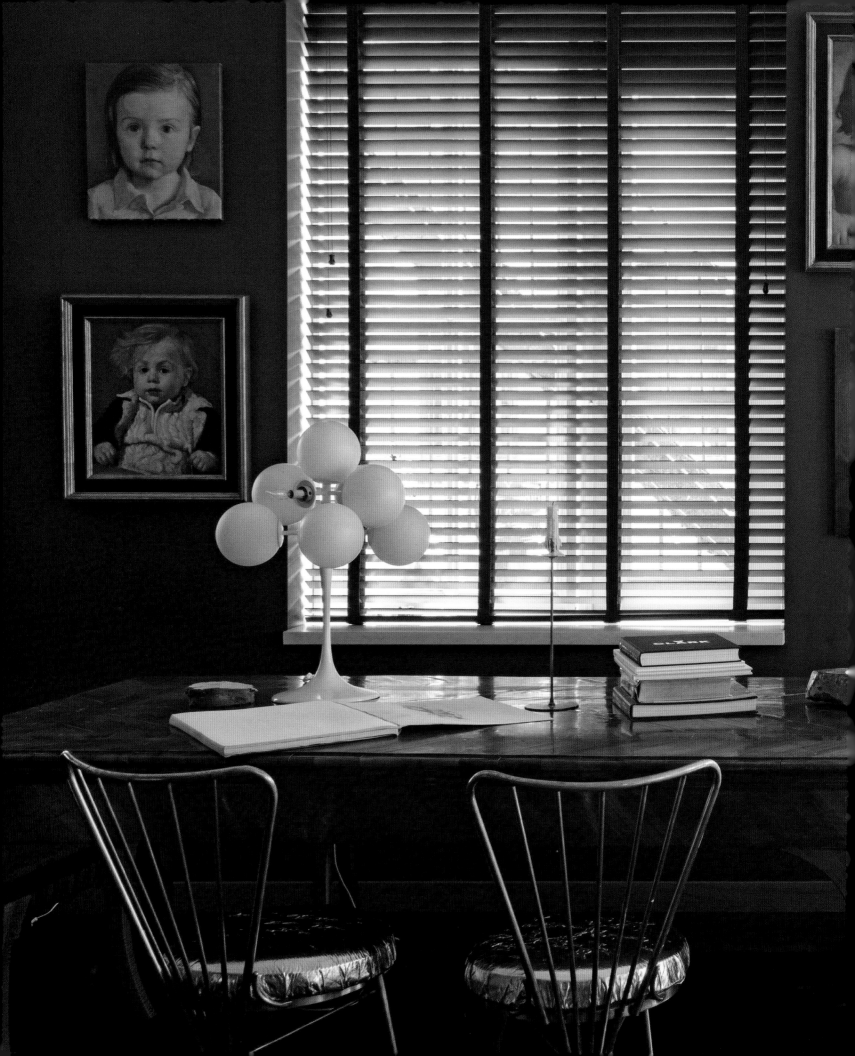

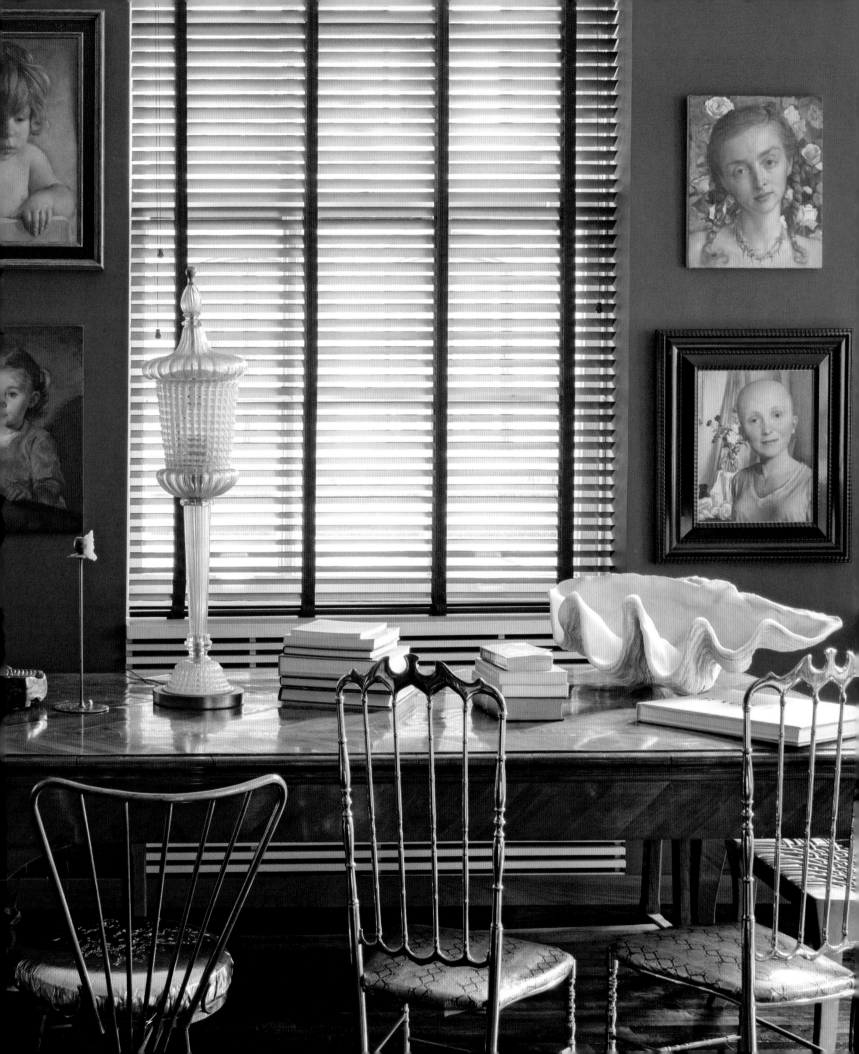

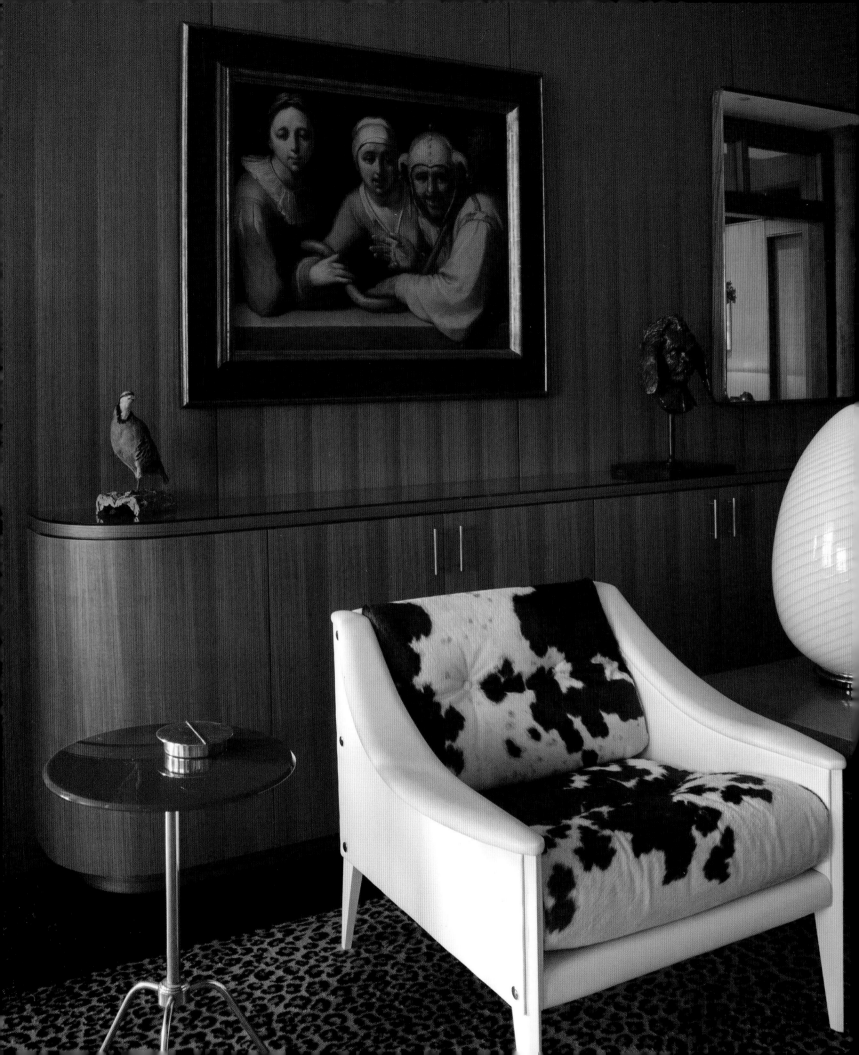

Opposite: In Currin and
Feinstein's front hall,
Cornelis van Haarlem's
A Fool with Two Women,
circa 1595. To the right is
Mr Rabbit (2003) by Sean
Landers, Currin's class-
mate at Yale School of Art.
Van Haarlem's title influ-
enced Currin's small 2013
painting *A Fool with Two
Young Women*.

Right: A 1942 drawing by
Francis Picabia hangs in a
red lacquer hallway.

The couple's gold baroque-style bed complements Currin's paintings: on the left *Rachel Asleep* (2012), and on the right *The Dane* (2006).

John Currin / Rachel Feinstein

E.V.

DAY

Bondage/Bandage (2008), made from an unraveled Hervé Léger classic bandage dress, dominates E.V. Day's live/work space in Williamsburg. Fishing line and steel chains connect the pieces to the frame.

E.V. Day in her studio.

Based on her provocative work, it might come as a surprise that sculptor and installation artist E.V. Day hand-presses flowers, collects shoes, and lovingly cultivates herbs and plants in the garden of her Williamsburg apartment. Day is known for her deliberate deconstructions of such laden symbols of femininity as Barbie dolls, wedding dresses, and lingerie in order to critique issues of power and society's expectations of women; in fact, in certain cases she creates the illusion that some of these objects are actually in the process of exploding apart.

These two seemingly contradictory sides are on display at Day's live/work space in a converted jute factory, where one of her signature Exploding Couture pieces, *Bondage/Bandage* (2008), is propped up on blocks, dominating the oversize living room. For this work, Day "unwrapped" a classic Hervé Léger bandage dress; she then extended and stretched the various mummy-like pieces with fishing line and steel chains within an oversize plexiglass vitrine that stands next to the sofa. Day often infuses humor into her other, equally dramatic suspension pieces: for *Divas Ascending* (2009), she strung used costumes from well-known operas across the ceiling of Lincoln Center's opera house; and in the more recent *Catfight* (2011–2014), two resin, silver-leafed, saber-toothed-tiger skeletons are poised as if to do battle in midair. Yet an underlying sense of beauty is inherent, especially in her series of flower-based works: richly colored, supersize scans of floral reproductive organs (Seducers), and cast aluminum sculptures of water lilies (Pollinator). *Waterlily Transporter* (2014) repeats the theme of suspension with 3-D laser etchings of a water lily on plexiglass, layered so that they simultaneously resemble both the flower and the patterns of fishnet stockings—another loaded and emblematic Day motif.

Day's experimentation with plants—both in her home garden and in her art—emerged from a seminal time she spent in 2010 as the artist-in-residence at Claude Monet's Giverny Gardens. Day evokes this experience with a very personal vignette in her front hallway that she calls "a monument to the garden." Above a console table hangs a large-scale print of performance artist Kembra Pfahler, who is body-painted crimson and holding two wheelbarrows filled with cut flowers. Day collaborated with Pfahler on a series of photographic works at Giverny, but especially likes this one because it offers a behind-the-scenes look at the gardeners' daily chores, which included deadheading flowers. "It was

otherworldly—glamorous in the sense that I felt like I was backstage at a rock show or the opera," she says of watching the gardeners at work, adding that those same cut flowers in the image were the ones she later used for her Seducers series, also on display in the foyer.

"I loved being in Giverny so much, and I wanted to have things that were about that, the colors and this picture," she says of designing her foyer. Day has also dedicated a small room to growing indoor plants that she jokingly calls her "lady cave." There, a pair of post-pop artist Rob Pruitt's first panda prints hangs, framed in bamboo, which echoes Day's collection of bamboo furniture, tracked down in vintage stores and on eBay. Day and her husband, well-known food writer Ted Lee, wanted furniture that didn't appear too hard-edged and angular for the formerly industrial space and happened upon the Paul Frankel–style bamboo sofas, chairs, and mirrors now sprinkled throughout the house. "I'm obsessed with bamboo; I want it everywhere," she says, mentioning her desire to plant it in her back garden.

Past the foyer, works by Luke Butler and Matthew Benedict line the hallway leading to the bedroom above a bench covered in fabric designed by the late punk artist and fashion designer Stephen Sprouse, who had been a dear friend of Day's. In the bedroom, another of Sprouse's word-based works, a knockoff Louis Vuitton bag, is tucked in with a watercolor by Will Cotton and a drawing by Elena del Rivero. *Blown-Up Baby-Doll* (1993), a Vito Acconci screen print of a doll's face fragmented into a kaleidoscope pattern, hangs over her bed, recalling at once the Barbie dolls that Day has worked with and her methods of deconstruction. It is part of a larger series that Day first discovered while working at the Margarete Roeder Gallery; each piece of the kaleidoscope image has a Velcro backing so that it can be rearranged.

Back in the living area, heavy pocket doors separate the domestic space from Day's 1,200-square-foot studio, where one finds her collection of antique, handblown-glass bed-pans, some shaped for the female anatomy, while others are distinctly for males. Like many of Day's own pieces, these stylized urinals are at once edgy and beguiling; one particularly vase-like model currently holds flowers in the front hall. Day has even been experimenting with incorporating them into future work.

Also among the art supplies and urinals piled throughout the studio is her collection of platform shoes, started when Day was in high school and began buying 1940s Carmen Miranda–style heels. Day has recently been exploring the sculptural possibilities of Lucite "pleasers," taking apart and putting back together the transparent, tippy stiletto heels that she jokingly refers to as "Frederick's of Hollywood stripper shoes." "They are the ultimate elevation, and I am into things that levitate," she says, relating her interest in the structure of the shoe to the way she has raised her own sculptures up on plinths.

Coincidentally, back on the residential side of the apartment, Day has an Eric Doeringer bootleg work that replicates a shoe painting by Marilyn Minter, another artist who explores the dark side of beauty. "I don't really need the original," she says of owning the bootleg version. "I want to look at it, I want to think about it, but for me, I don't really need to have that thing—it's a lot of energy to hold on to."

Work and home life consistently overlap throughout the warm, well-nurtured space. In addition to being able to work at home, Day considers living among her artwork an added benefit. "It's the first time I have had enough space to live with art. Some things are too powerful to have out all the time, but it's fun to finally have an opportunity to live with some of my art, and it's nice to share it with people who might not have seen it in a show."

Opposite: A look down
the hallway toward the
entrance of Day's home,
with an example from
her Seducers series and
her bamboo furniture
collection in sight.

Right: The photograph of
performance artist Kembra
Pfahler was created while
Day was the 2010 artist-
in-residence at Monet's
gardens at Giverny. "Living
in Monet's gardens for
a summer was surreal,"
she recalls. A bowl of sea-
shells silver-leafed by the
artist—reminiscent of her
silver-leafed sculptures—
sits below.

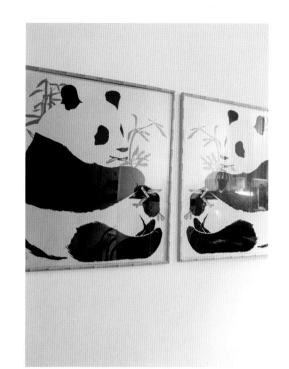

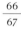

Opposite: Day discovered the chandelier over the dining table at a Florida thrift shop. The ornate light fixture had previously been in a hotel, so Day refashioned it in a way that resembles the radiating arms and concentric circles of the suspension pieces she's known for.

Above left: The Matthew Benedict still-life *Untitled (Charlie's Mantle)* was a gift, while Day found Luke Butler's *Star Trek*–themed *Uhura* (2010) at a Miami art fair. The bench is covered in Stephen Sprouse fabric. The late designer was a close friend.

Above right: Rob Pruitt's panda prints *Alone (Facing East)* and *Alone (Facing West)* (2000) hang in the makeshift greenhouse that Day calls her "lady cave." The two pandas' bamboo leaves create a heart shape in the middle.

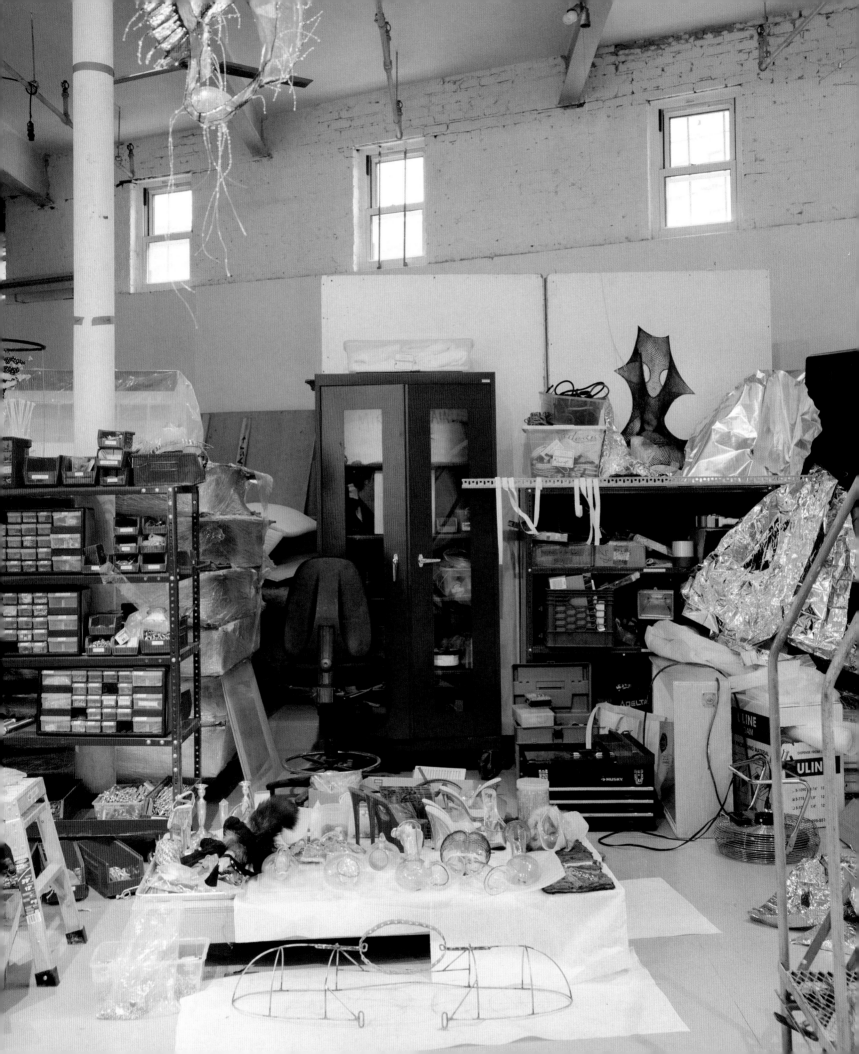

Opposite: Day's studio is connected through heavy panel doors to her living area. On the table is a selection of the handblown glass urinals and platform shoes that she's been collecting. "I've been trying to incorporate them into my artwork for years," she says of the urinals.

Right: Vito Acconci's *Blown-Up Baby-Doll* (1993) lives over Day's bed. The piece is comprised of six equilateral triangles that Velcro to the wall so that the configuration can be changed. It reminds Day of *Flesh for Fantasy* (1999), her suspension explosion piece with inflatable sex dolls.

CARROLL DUNHAM
—
LAURIE SIMMONS

The 1995 photograph *Allegory of the Arts* by the late Sarah Charlesworth, one of Laurie Simmons's closest friends, hangs in the living room. Simmons "rescued" the cherished photograph from eBay. On the table are Carl D'Alvia's *Egret* (2012) and a clay head by Simmons and Carroll Dunham's daughter Grace.

Carroll Dunham and Laurie Simmons purchased their redbrick Georgian house in the small town of Cornwall in northwestern Connecticut in 2007. Previously used as administrative offices for the Marvelwood School, the home has open, airy rooms and a welcoming feel. "I was really intimidated by the scale of the house. How do you decorate a house?" says Simmons, who is well known for exploring the relationship between women and domestic spaces, most famously through her photographs of dolls and dollhouses. "And then I thought, maybe I'm thinking about it the wrong way. Maybe it's better to think about it the way you would think about decorating a hotel and make a motif."

Simmons found black-and-white 1950s textiles designed by prominent artists such as Alexander Girard and Verner Panton, and decided to build the house's interiors around this color scheme. "We decided we were going to put nothing but black-and-white photographs in the front hall, which has gotten a little flexible," says Dunham. Finishing his thought, Simmons says, laughing: "We proceeded to break that rule—we break all our rules."

Yet, their generously proportioned front hall is almost solely lined with black-and-white photographs chosen by Simmons, including an early Richard Prince; an almost doll-like, distorted visage of Marlon Brando by Weegee; a photograph by Morton Bartlett of his meticulously constructed and appointed dolls; and other anonymous doll images given to Simmons by friends over the years. "I do feel an affinity to photographs," she explains, "as Carroll does to painting and drawing. We both love both, but I feel more conversant with photography and better able to make those choices." Among the assortment is one of her own early black-and-white photographs that hints at the work she would later become known for. Taken while visiting a home in Connecticut in 1976, it's an image of a sink angled to appear diminutive. "I think it's so cool that I have a picture of a sink that I made to look like a toy," she says. "Then I began taking photographs of toy sinks, and now I live in a house in Connecticut."

Simmons began working with photography soon after she moved to New York City in 1973, and several years later started making images of miniature houses staged with 1950s doll furniture, eventually inserting dolls to complete the domestic scene. She photographed these small-scale rooms, finished with wallpaper and lighting, with a sense of nostalgia that seemed to invoke childhood memory. Simmons has gone on to photograph three-inch plastic Japanese figurines, ventriloquist dummies, life-size sex dolls, and other human surrogates. In one series, The Instant Decorator (2001–2004), she photographed an out-of-print 1974 decorating book collaged with figures cut from magazines.

Throughout the home are works by friends—including Terry Winters, Mel Bochner, Carl D'Alvia, and Jackie Saccoccio—as well as drawings and ceramics by their daughters, Lena and Grace. In the living room the couple has hung a photograph, *Allegory of the Arts* (1995), by Simmons's late friend Sarah Charlesworth that depicts a classically sculpted bust, painter's palette, and dust-covered violin against a lush maroon wall. Simmons found the still life by accident. She was looking at a seller's inventory on eBay and found, for a bargain price, this piece. Charlesworth was one of her best friends and Simmons consulted her before actually buying the photograph. "I cherish it. I feel like I rescued it," say Simmons. "And, it's meant to go with this house because it's all about old and new." She explains that, in another coincidence, Charlesworth made the work in her Williamsburg studio located in the same building where Simmons and Dunham have recently moved. "It's really amazing; it's a full circle," she concludes.

While Simmons has curated the ground-floor entry hall, Dunham has ownership over the gallery-like second-floor hall. Dunham is renowned for his bold, graphic drawings and paintings depicting bodies and forms in primitive shapes, often delineated with heavy black strokes. His work veers between abstraction and figuration, often with cartoonish, surreal characters boasting accentuated sexual organs. The artist is also a celebrated printmaker and has explained that he's used the printmaking process to push forward ideas in his own painting.

A pink, abstract watercolor by Lucio Fontana is at the top of the stairs—a work Simmons says visitors sometimes mistake as her husband's—among drawings by Markus Lüpertz, Bendix Harms, and A.R. Penck. The installation's look and feel is expressive, with colorful, abstract works, including several by twentieth-century and contemporary German artists. "I like the idea that there's this other Western painting culture that is very complete and has a slightly different value system from ours," he says, explaining his interest. "Drawing and printmaking have been a big part of German art, and they tend to be less

foregrounded here, but they are things that I am very interested in myself."

With the exception of a large David Salle canvas, most of the work they own is small scale, which allows more of their extensive, and still growing, collection to be on display. "I kind of like all these different voices around," Dunham says. A beautifully appointed guest room displays the wide range of work they own where a sunset print by Richard Prince, a folded drawing by Dorothea Rockburne, an abstract butterfly painting by Mark Grotjahn, and a drawing by Dieter Roth preside among other works. "Everything is a visual decision—for a big house we have very little wall space," says Dunham, describing these installation choices.

Dunham and Simmons, both accomplished art writers, have countless stories about the art and objects they own. "I think that if you spend a lot of time looking at art and being influenced or stimulated by art, it's nice to have artworks by others in your personal space," Dunham explains. "I like figuring out how art should be in spaces, and I think it's interesting to try to make art live with furniture and decorative objects." Not surprisingly, given their exploratory natures, Dunham and Simmons often shift their art and furniture. "There's a fluidity and a flexibility that comes from just moving furniture around and understanding how things can change," says Simmons, noting that she learned about domestic space through moving small furniture for her photography. "There are rooms in our house that look like they could come right out of one of my dollhouse pictures."

Carroll Dunham and Laurie Simmons in their sitting room in front of Marilyn Minter's 2003 photograph *Vomit*.

In the home's generous entry hall, Simmons has installed primarily black-and-white photographs from their collection. On the left is a 1995 photograph by the late conceptual artist Robert Blanchon, who often explored gay identity by employing cultural symbols such as the black-and-white bandana pictured here.

Carroll Dunham / Laurie Simmons

0 1 2 3 4 5 6 7 8 9 10
11 12 13 14 15 16 17 18 19
20 21 22 23 24 25 26 27
28 29 30 31 32 33 34 35
36 37 38 39 40 41 42 43
44 45 46 47 48 49 50

Opposite: Leaning on a
mantle in the couple's bed-
room is a Mel Bochner
painting—a gift to Dunham
on his fiftieth birthday—
next to three African
baskets that "just seem to
embody some universal
truth," says Dunham wryly.
On the right, below one of
Simmons's ventriloquist-
dummy photographs is
a self-portrait from the
early 1960s.

Right: *Homespun (fancy
middle)*, from 1998, by
the couple's close friend
John Newman, echoes
the black-and-white
"squiggle" theme of the
dining room. Simmons
immediately loved this
sculpture when she saw it
in his studio, despite her
fear that the patterning was
too similar to the wallpa-
per. Newman was actually
delighted when he saw the
placement. A glass work,
also featuring squiggles,
was a gift from Dunham's
German dealer.

Carroll Dunham / Laurie Simmons

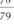

Opposite: Drawings selected by Dunham line the stairway up to his studio. From left to right, the artists represented are A. R. Penck, Hans Hofmann (from his 1930s driving series), Erich Wegner (from 1925), and Terry Winters (from 1982).

Above: Dunham selected these colorful, expressive drawings for his installation on the second floor: from left, a 1991 drawing by Terry Winters and two 2007 works on paper by German artist Bendix Harms. "I'd love to own a painting," says Dunham of Harms's work, "I think he's a terrific artist."

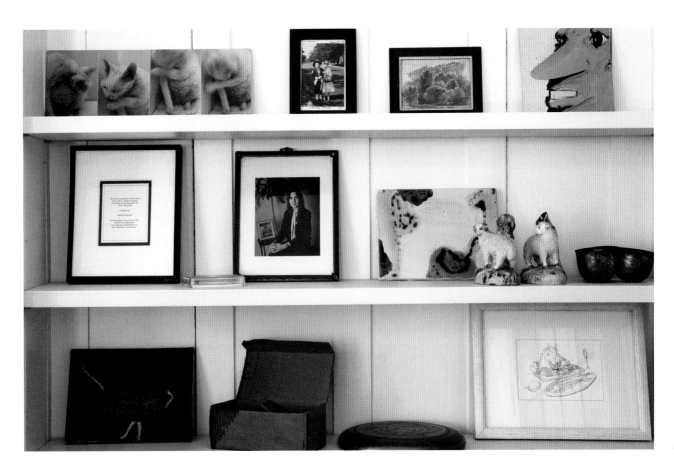

Opposite: A 1980 photo-
graph by Richard Prince,
an anonymous doll image,
and a blurry photograph of
a ventriloquist dummy given
to Simmons by her husband
further the black-and-white
motif in the entry hall.

Right: An art- and memen-
to-filled cabinet in the living
room includes Kiki Smith's
photograph of the couple's
late cat, Guy, next to Cindy
Sherman's gift to Simmons,
inscribed: "Lifelong friends!"
To the right are paintings
by Samuel Colman and
Richard Allen Morris.
Porcelain lambs owned by
Simmons's mother are next
to a painting by Bobbie
Oliver on the middle row,
while the bottom row
includes a teapot painting
by Franco Mondini-Ruiz,
a multiple by Dieter Roth,
a bronze Frisbee by
Matthew Weinstein, and
a Susan Hall print.

ERIC FISCHL

—

APRIL GORNIK

An assemblage of Auguste Rodin and Gustav Klimt drawings found in Paris and New York hold a place of prominence in the sun-strewn library of April Gornik and Eric Fischl's Long Island home.

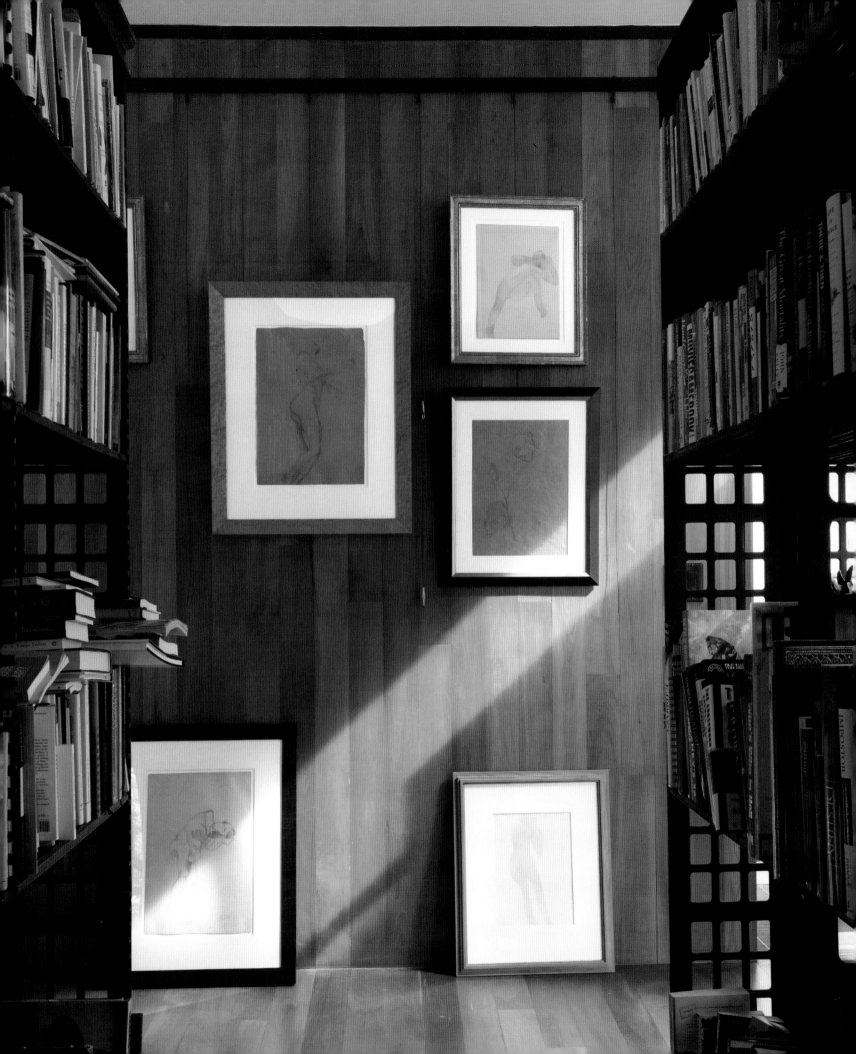

April Gornik and Eric
Fischl in their living room.

Eric Fischl and April Gornik's sumptuous,
Asian-inspired contemporary house, set
among reeds and marshes in North Haven,
New York, seems as if it was designed with a
consideration of both the exterior views and
the interior installations. Inside are a scholar's
rock picked up in France, a glass owl sculpture
perched on a plinth, a life-size African wood
sculpture of a mother and child, and even an
Amish bonnet constructed from hundreds of
white-tipped hat pins, a work that Fischl calls
"terrifying and beautiful, a hard combination
to pull off." Then there are the drawings, paint-
ings, and photographs by Susan Rothenberg,
Diane Arbus, friends such as Alex Katz and
Sally Gall, and local Hamptons artists, not to
mention the works by Fischl's former painting
students at the New York Academy of Art.

The couple, who met forty years ago at the
Nova Scotia College of Art and Design, work
in matching studios facing the Peconic Bay and
seem quietly in tune with each other's sensibil-
ities and rhythms. While many of their pieces
were bought together or carefully selected
as gifts from one to the other, there are some
distinct thematic differences within the collec-
tion that reflect their particular artistic styles.
Gornik is a poetic landscape painter, and
her emotive compositions include light falling
through trees, moody skies merging with
oceans, and clouds gathering over fields. "Any-
thing pantheistic is hers," Fischl says of their
collection, referencing her interest in the natu-
ral, such as the Jeanette Montgomery Barron
photographs of flowers and sea sponges that
adorn the library. Gornik protests. "It's not an
even divide. I like figures and abstracts too."

Fischl's psychologically charged paintings
reintroduced the figure to painting and post-
modern discourse in the 1980s, and he tends to
be drawn to works that address the body. Not
coincidentally, an impressive assemblage of
drawings by Auguste Rodin and Gustav Klimt
hang in the treehouse-like library, on a back
wall across from large picture windows. Fischl
speaks knowingly about the Rodins, though he
is careful to explain that he looks to the nine-
teenth-century master for insights on tech-
niques, rather than as direct source material.

"Rodin was pretty much the last great
sculptor of the body, and he actually believed
that even a small part could express emotions,"
he says. "You could cut his sculptures into little
pieces and [still] feel the passion and the tor-
ment, and so I go back to him over and over
again," he says. A semierotic nude drawing
by Klimt, an artist equally admired by Fischl
for his inimitable drawing skills, hangs in

the master bedroom alongside traditional Japanese prints and Fischl's large, wall-size nude painting of Gornik. "Klimt often holds his pencil in such a way that can be so incredibly delicate that you get the sense he's holding it from the eraser; he's just sort of touching the paper, tickling it, coaxing the human form into being," says Fischl, commenting that the line seems "minimal" and "unfussy." Adds Gornik, "I just like the touch of this drawing, I think that's what he's known for; even if the subject matter isn't seductive and beautiful, the line itself is."

Down the hall hang a series of abstract Ralph Gibson photographs of nude women—cropped details of a folded leg or a crossed elbow—one of many trades Fischl and Gibson have made during the course of their friendship. "There is work I like because it is along the lines of what I do, and then there's work I like because I can't do it," says Fischl modestly. "Ralph fits into the 'I can't do it' category. That level of erotic and abstract—the sophistication is just profound."

On the other hand, a black-and-white photograph of a nude sitting in a chair by British photographer and photojournalist Bill Brandt that hangs in the dining area has served Fischl's talents on at least one occasion; he incorporated the figure into his 1985 painting *Bayonne*, as well as other works on paper. "I've used that figure a lot," he remarks.

Although art is on display on nearly every surface of the house, Fischl and Gornik, like many artists, don't consider themselves formal collectors. "I started off buying or trading with my peers," Fischl explains. "I had gone to the Picasso Museum and seen Picasso's collection of other artists and thought, 'What a nice way of remembering your time.' It wasn't that he collected the best of Cezanne or the best of Matisse, but he had examples." Thus inspired, Fischl didn't have far to look. His peers at the time included fellow art stars such as David Salle, Cindy Sherman, and Francesco Clemente, who were soaring to fame in the 1980s, the same time that Fischl came into prominence.

One of Clemente's large-scale yellow-and-red watercolors hangs on a long living room wall among other works. A visit with the Clementes in St. Barths led to a trade: portraits of the Clemente family painted by Fischl in return for this work, a mystical supine figure floating under grape leaves.

A smaller Clemente watercolor with a similar palette shows a man bowing his head and holding a hat in one arm while the other arm twists behind his back as a mysterious smiling face, a figure eight, and an infinity sign dance along the top border. Both Fischl and Gornik appreciate the drawing's almost lyrical imagery. "I always loved his pastels and watercolors. He's the greatest poet of our generation," says Fischl. "His juxtaposition of things is so resonant and strange; he speaks through the body."

Despite the sprawling house, the artwork feels at once intimate and personal, perhaps because there's a connection behind each piece. "I look at everything all the time," says Gornik, gazing at a series of Thomas Joshua Cooper's photographs of the Atlantic Basin, a gift from Fischl. "It's necessarily accumulated; it is the accumulation of all these presences. I believe that in art, the artists live, so it is like having people and friends and spirits with you. It exponentially expands our living space to have these artworks here."

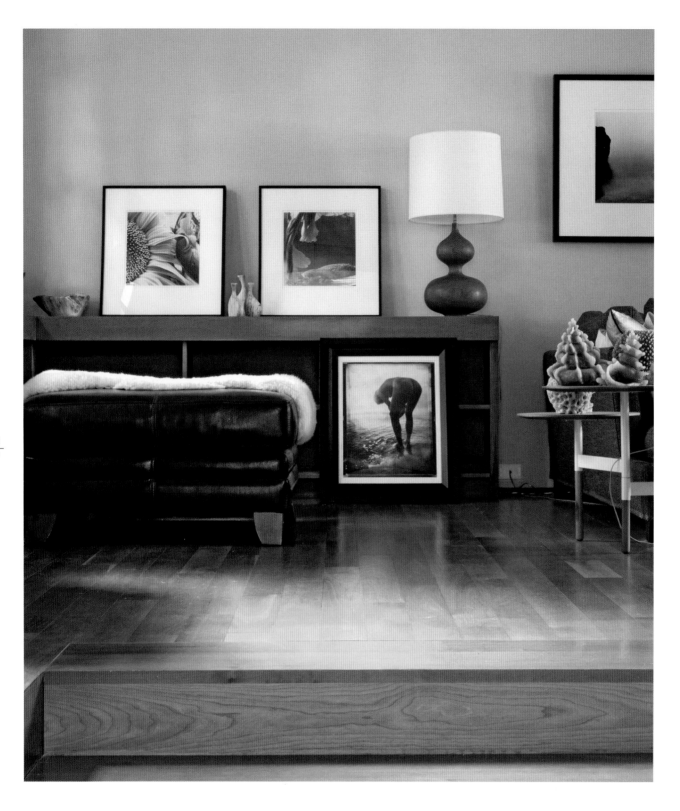

Above: Two photographs by Jeanette Montgomery Barron lean on a cabinet in the sitting room above a work by Paul Rosin. "If I fall in love with something, if something is mysterious in some way, and I can't get to the bottom of it, that's when I find it really compelling," says Gornik.

Opposite: In the glass-walled, double-height living room, Gornik and Fischl display, from left to right, a drawing by Richard Diebenkorn, a charcoal by Susan Rothenberg, and a large watercolor by Francesco Clemente, among other works. The bonnet on the top shelf, by artist Angela Ellsworth, is constructed of hundreds of hatpins and is a riff on the bonnets worn by Amish women.

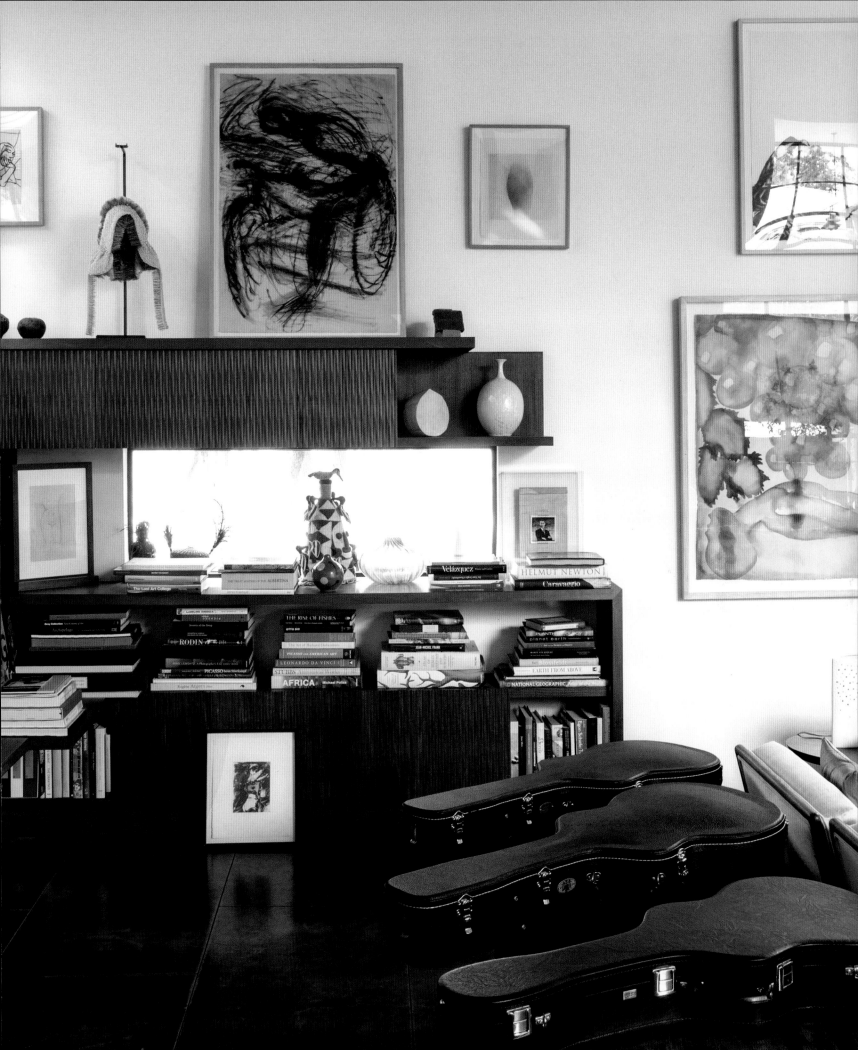

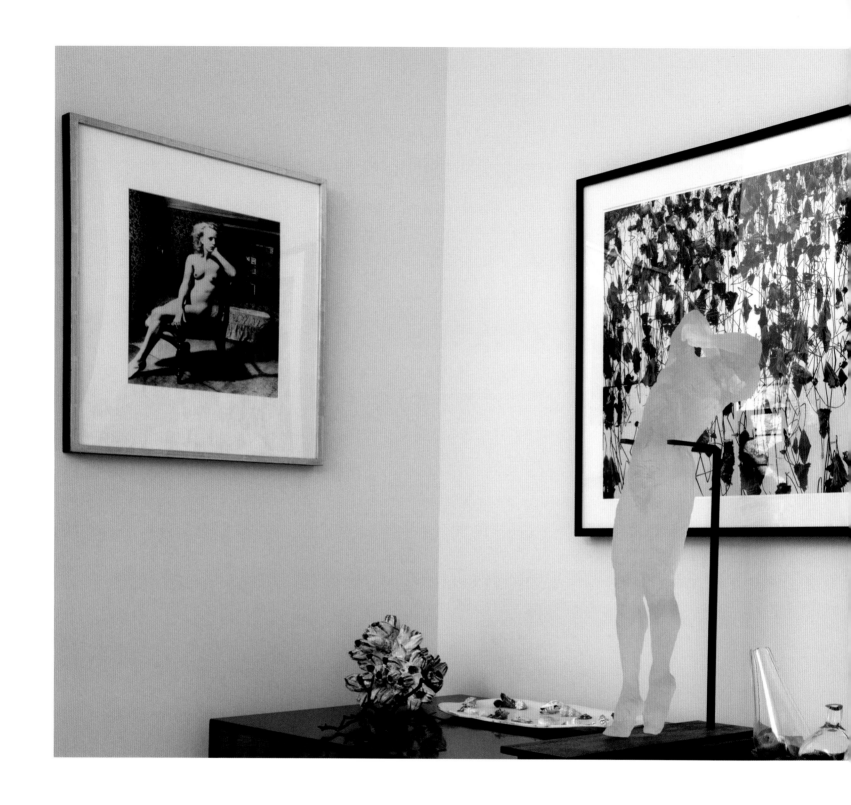

Above: In the dining room, a nude photograph by Bill Brandt completes a delicate vignette with a Laurie Lambrecht photograph and a glass sculpture by Fischl. Fischl has incorporated Brandt's nude figure in some of his own work, most notably in his 1985 painting *Bayonne*.

Eric Fischl / April Gornik

Right: Gornik and Fischl bought this African sculpture of a mother and her son in Victoria Falls, Zimbabwe. "I love this piece," Fischl says. "The tenderness on both of their faces is just phenomenal."

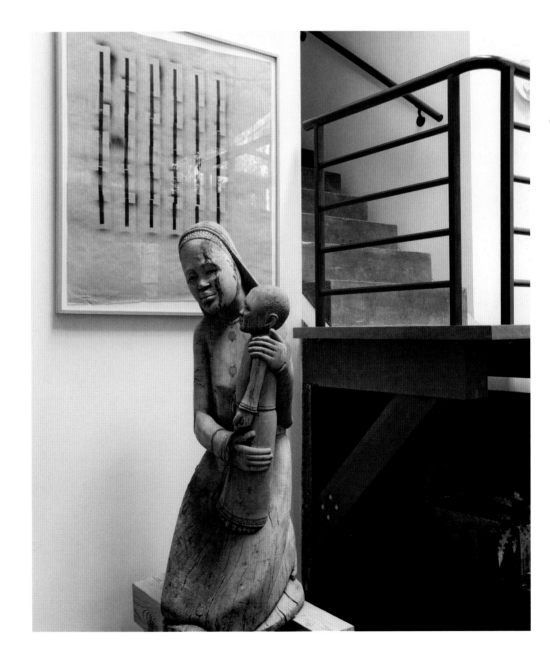

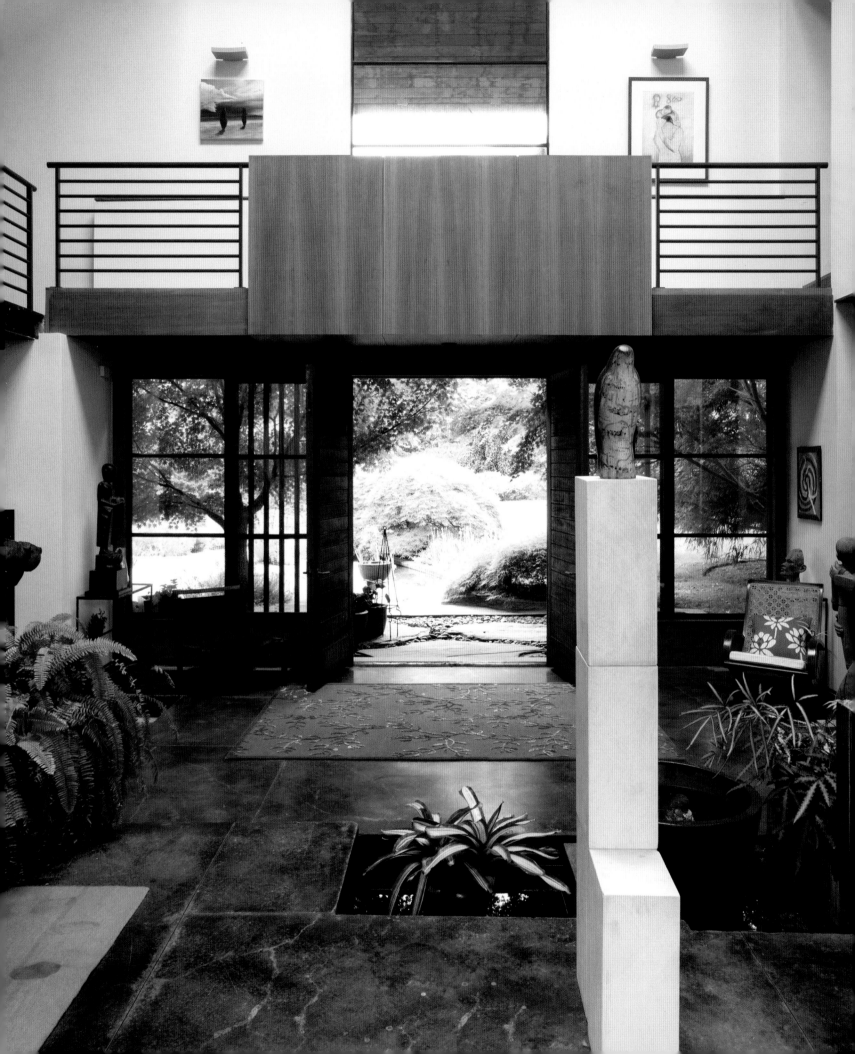

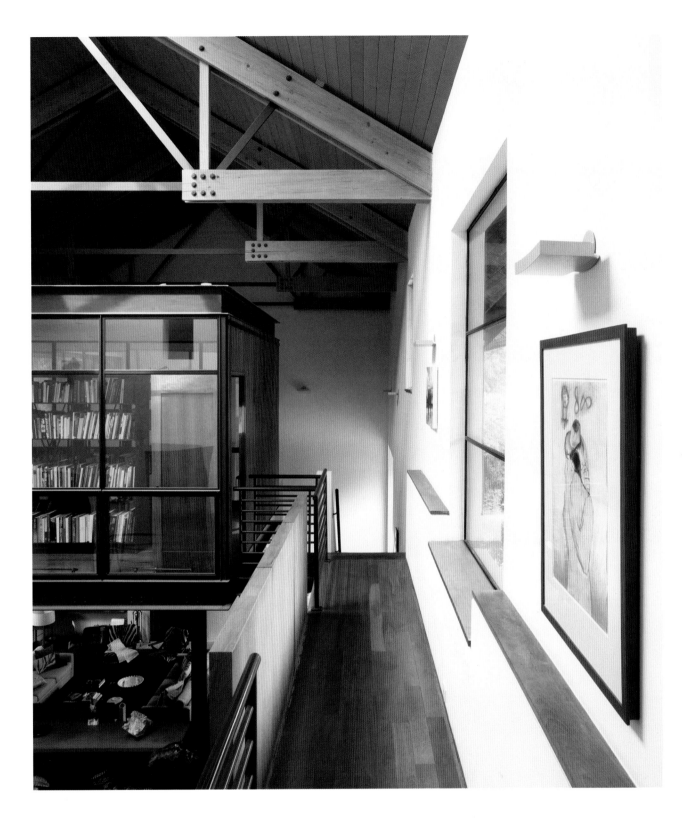

Opposite: Looking out
from the inner courtyard of
Fischl and Gornik's Asian-
inspired home emphasizes
the inside and outside
views. A watercolor by
Francesco Clemente is
visible on the second-floor
walkway.

Above: The elevated walk-
way leading toward the
treehouse–like library on
the second floor.

TIMOTHY
GREENFIELD-
SANDERS

A collection of works over a large farmhouse sink in Timothy Greenfield-Sanders's kitchen includes, from top left, Elaine Sturtevant's *Warhol's Flowers*; Joop Sanders's 1955 portrait of his wife, Isca; and Elaine de Kooning's 1945 portrait of Joop Sanders. A 1977 painting by Milton Resnick—a wedding gift to the Greenfield-Sanderses—is on the right.

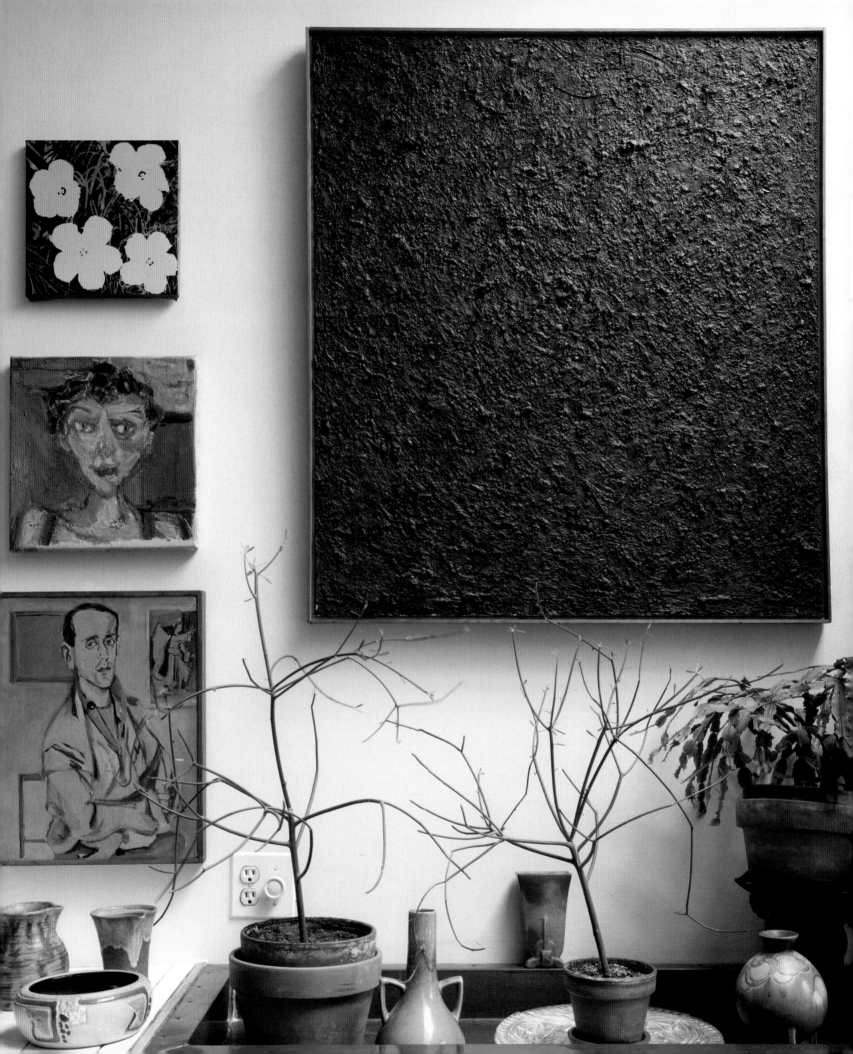

Timothy Greenfield-
Sanders in his studio
at the rectory.

Timothy Greenfield-Sanders and his wife, Karin, purchased the former rectory of the German Roman Catholic Church of St. Nicholas in 1978 when its still-quiet East Village location was not yet in vogue. In the nearly forty years since, the historic red-brick building has served as his home and studio and has witnessed a parade of some of today's most luminous figures in the worlds of fashion, culture, and politics. "The building itself was special," observes Greenfield-Sanders. "Artists knew of the other artists who came here before them, there was art on the walls, and a sort of self-fulfilling snowball effect occured." As a result, the house serves as a warm homage to this art world, a world that also includes the family of artists who grew up here.

"The East Village exploded right in front of us; we found ourselves living in what became the hottest art scene in years," he explains of the location. "Starting in 1983 or 1984 there were seven galleries that opened up in the neighborhood, including Gracie Mansion, Fun Gallery, Piezo Electric, and Civilian Warfare. We would take the kids to the galleries in strollers on Sundays. We'd meet the dealers, who were our age or younger, and then we started to meet the artists." They became close friends with many of the local crowd, including Doug and Mike Starn, Annette Lemieux, Peter Halley, and Francesco Clemente; work by each of these artists is now represented in their home.

Greenfield-Sanders is today recognized internationally as a top portrait photographer and filmmaker, who often shoots in his ground-floor rectory studio using a large-format camera. His award-winning documentaries—including *The Black List*, *The Latino List*, and *The Out List*— are "living" portraits of prominent and diverse individuals. He began taking still portraits in the mid-1970s while in graduate school at the American Film Institute in Los Angeles. The organization needed to document for the school archive the Hollywood legends coming through to lecture, and Greenfield-Sanders happily volunteered to take the photographs, unknowingly setting the course of his future career.

Greenfield-Sanders moved with Karin from Los Angeles to New York after graduate school, and Karin's father, first-generation abstract expressionist Joop Sanders, began introducing his new son-in-law to his peers, including Willem de Kooning, Lee Krasner, and Robert Motherwell. The following year Greenfield-Sanders began photographing this

Timothy Greenfield-Sanders

generation of artists, a project that resulted in the widely traveled show *NY Artists of the '50s in the '80s*. Greenfield-Sanders eventually expanded his scope, and set out to record the broader art world—dealers, collectors, curators, and critics. Twenty years later, in 1999, he exhibited seven hundred portraits of art world luminaries at Mary Boone Gallery, an entire set of which was later purchased by the Museum of Modern Art.

Soon Greenfield-Sanders's artist friends sought to trade their own work for his portraits. "Early on I realized that works on paper were expensive to frame; I quickly preferred [having] a small piece on canvas that I could just hang on the wall," he recounts with a laugh, surveying the many unframed paintings hung salon style on his walls or leaning against surfaces throughout the home. On the parlor floor, examples include Andy Warhol's small yellow poppy painting hung above a shelf piece by Haim Steinbach, a crosshatched Jasper Johns work on paper, a Richard Prince joke painting, and a black-and-white-dot pumpkin painting by Yayoi Kusama. But not all the work is instantly recognizable or as prominently displayed. When making their way up the stairs to the second floor, visitors are greeted by a black painted figure lurking in an airshaft overlooking the landing; the installation is by Richard Hambleton, who was at one time well known in the neighborhood for his haunting graffiti.

"I think this is a historically important collection because there are works here by most of the key people in the eighties and into the nineties," says Greenfield-Sanders. "I think at a certain point artists wanted me to have a good piece because they knew it was going to be in a good place," he continues, referring to the rectory and adding that he's never sold any of the pieces he's received.

The Greenfield-Sanderses' artistic legacy is seen throughout the home, and works they already owned by Joop and by Karin's brother, the sculptor John Sanders, gave their collection a head start. A dark, thickly textured abstract painting—a wedding gift from Joop's contemporary Milton Resnick—hangs above the large farmhouse sink in their skylighted kitchen. It lives beside Joop's portrait of his wife, Isca (known as "Big Isca" to differentiate her from granddaughter Isca), done in broad brushstrokes. Another wedding gift, a fine-lined portrait of Joop by Elaine de Kooning, resides below.

The artistic tradition continues into the third generation. Several large figurative canvases by Timothy and Karin's daughter, painter Isca Greenfield-Sanders, who had breakout success in her twenties, appear throughout the house. Isca scans found vintage photographs, often of generic summer settings or family trips, and creates small, reworked watercolors. She then grids the watercolors and transforms them into larger-scale oil paintings that seem at once immediately recognizable while not familiar. "Isca became an artist because it was in her DNA," notes Greenfield-Sanders. "But a part of it was that she grew up around artists and maybe saw that it could be a profession for her. It was really a privilege growing up with great art, always meeting interesting people." He recalls with a chuckle how on a typical day at the rectory, his younger daughter, Liliana—now a filmmaker—came home from second grade dressed in her formal school uniform and entered the studio as he was photographing the drag-queen star of *Paris Is Burning*, Dorian Corey. "She's this nearly seven-foot-tall drag queen in nothing but pasties, and Lily just shakes her hand and says, 'It's a pleasure to meet you.'"

In the parlor, Greenfield-Sanders has built an impromptu shrine to his close friend, the legendary music icon Lou Reed. A stylized portrait of Reed by Isca's husband, artist and musician Sebastian Blanck, flanked by candles, leans above an issue of *New York* magazine opened to Greenfield-Sanders's full-page photograph of the artist; it's the last portrait taken of the musician before his death. Next to this installation, Greenfield-Sanders has arranged the Grammy Award for his documentary *Lou Reed: Rock and Roll Heart* perched on an ebony and zirconium plinth by artist Toland Grinnell.

As the neighborhood and art scene have continued to change, so have the walls of Greenfield-Sanders's home, accumulating more works by family and friends. "It enhances [my living space] enormously," he says about living with artworks. "I have such admiration for these artists." And the house is already inspiring the next generation: Just to the left of Lou Reed's shrine sits a charming painting of the rectory by Hudson Blanck, Isca and Sebastian's seven-year-old son.

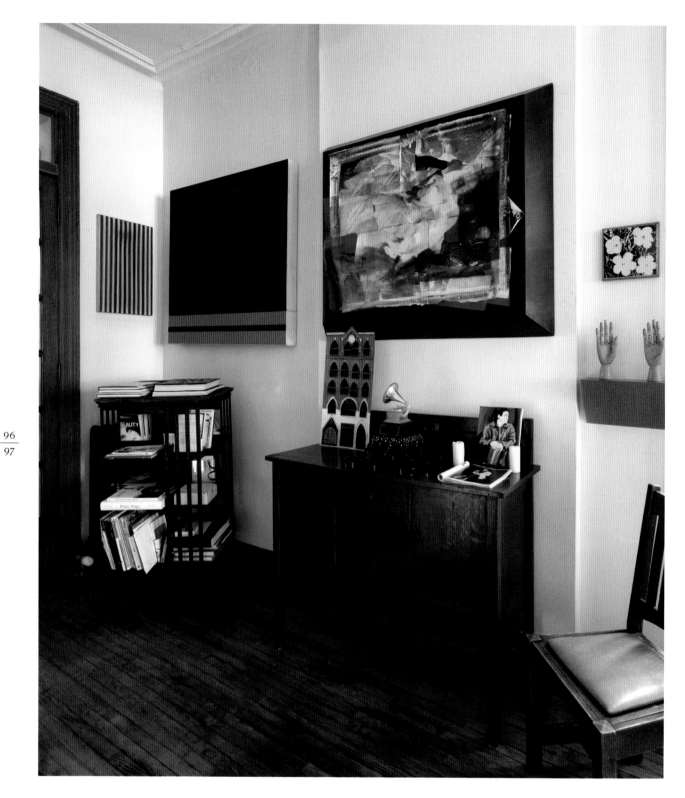

Above: Paintings fill a corner of the back parlor, including, from left, a 1988 Ross Bleckner and a 1986 Peter Halley. A Gustav Stickley sideboard displays, from left, a drawing of the rectory by Greenfield-Sanders's seven-year-old grandson, Hudson Blanck; a plinth by Toland Grinnell designed for Greenfield-Sanders's 1999 Grammy Award; and an impromptu shrine to the late Lou Reed with a portrait by Sebastian Blanck. Hanging above is a 1986 work by Mike and Doug Starn. On the right, a 1964 Andy Warhol lives above a 1991 Haim Steinbach shelf piece.

Opposite: Outside the ground-floor studio, Francesco Clemente's portraits of the family include, from left, Karin, Isca with her baby sister Liliana, and Greenfield-Sanders. Two chairs designed by Le Corbusier, a bench coffee table by George Nelson, and a rare Hans Wegner swivel chair are arranged in front. On the left is a side table by Joseph Kosuth.

Timothy Greenfield-Sanders

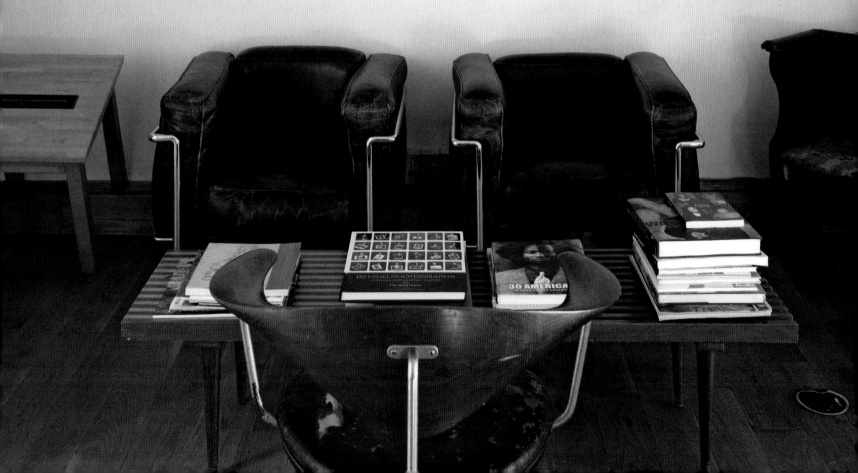

Previous spread: An arrangement inside the first-floor parlor includes Andy Warhol's 1969 flower print beside Cecily Brown's 2003 monoprint. A 2001 portrait of Greenfield-Sanders by Mimmo Paladino is below. On the sideboard, from left, are two works by Christian Haub, Charles Spurrier's gum painting, Isca Greenfield-Sanders's *A Walk with Daddy* (2004), and a small painting by Julian Lethbridge.

Above left: A large tondo painting from 1979 by Joop Sanders hangs above chairs and tables by Gustav Stickley in the dining area. Isamu Noguchi designed the hanging lamp.

Above: A drawing of a shadowy figure, by graffiti artist Richard Hambleton, haunts the airshaft outside the third-floor landing.

Opposite: In the main sitting area is Isca Greenfield-Sanders's 2003 painting *Alice and Stinky (Silver Beach)*. On the left is Richard Prince's small 1989 joke painting *How's Mom*, and below is John Sanders's 1990 forged and flame-carved steel sculpture. On the floor is a rare 1920s Chinese art deco rug, a gift from Joop Sanders.

Timothy Greenfield-Sanders

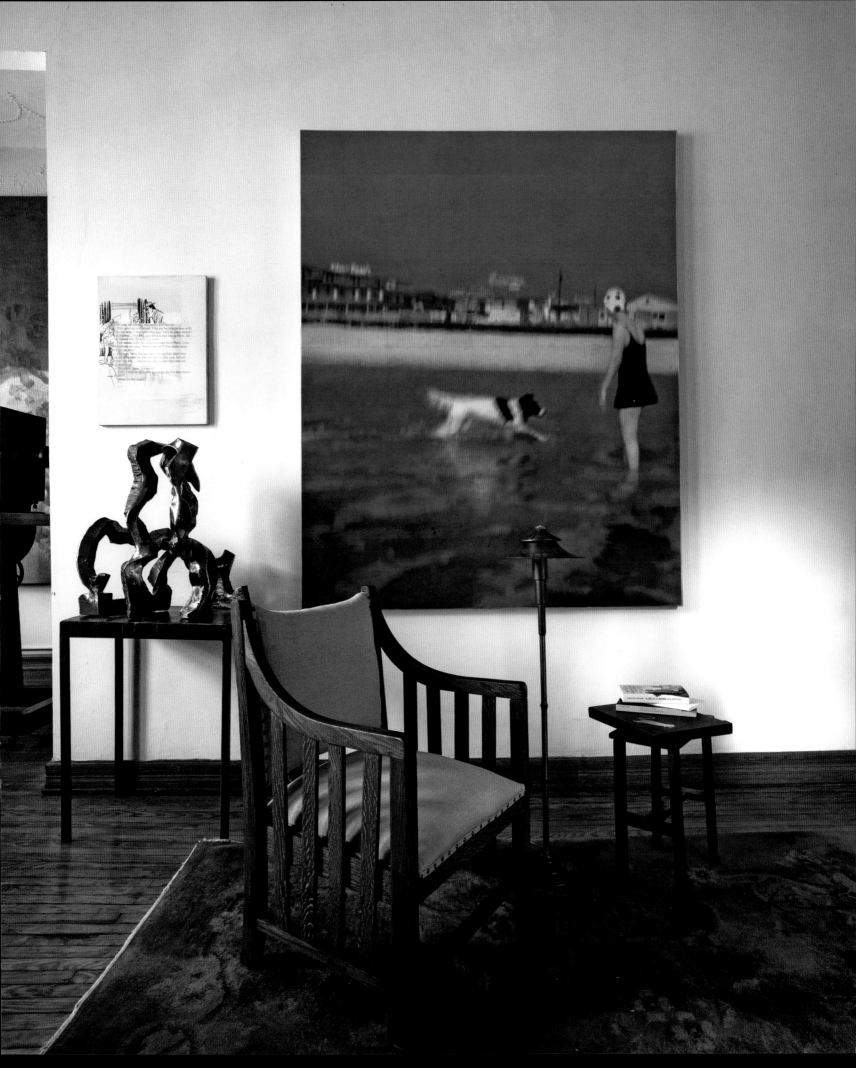

MARY
—
HEILMANN

A living room wall in Mary Heilmann's Bridgehampton farmhouse exemplifies the color themes apparent throughout her collection. Here, a large Roy Fowler painting of a wave anchors the other pieces, including Don Christensen's painting on the top left and two oval canvases by Heilmann's studio assistant, Sarah McDouglas Kohn. The round disc underneath the Fowler is a painting by Paul Gabrielli, and two watercolors on the top right are by Stephen Mueller. "I always like work that looks like mine," says Heilmann.

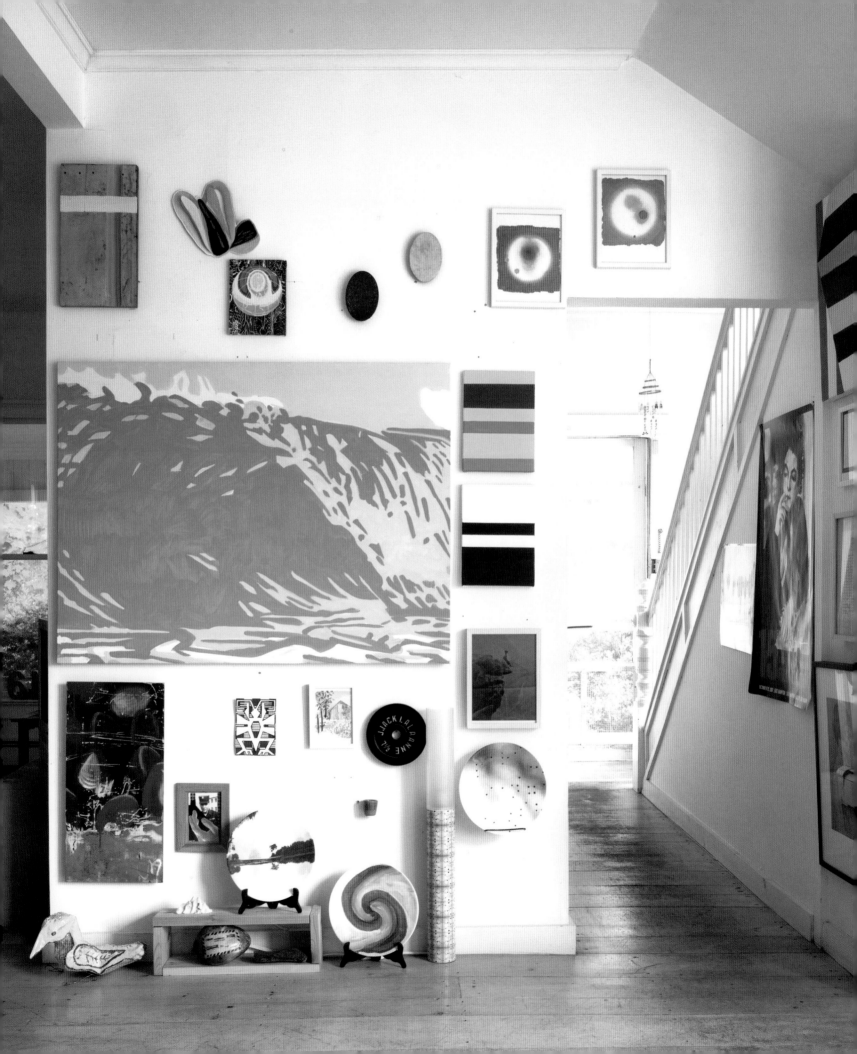

At seventy-five years old, Mary Heilmann is still a young bohemian at heart. The groundbreaking painter, furniture maker, and ceramicist has crossed paths with some of the most legendary twentieth-century artists: She studied with David Hockney at UC Berkeley and was friends with Bruce Nauman, Robert Smithson, and Philip Glass in the rollicking downtown New York art scene of the 1970s. "We all knew each other. It was a very small, cliquish, closed scene," she says. But twenty years ago, the California native decided to settle down and bought her first home: a circa 1910 farmhouse bordering a field in a quiet section of Bridgehampton, New York, just miles from the beach. It was only at this point that she felt that she had a proper place to display her collection of art, which she has arranged in meaningfully curated vignettes throughout her home.

Fellow artist Ross Bleckner describes Heilmann as a painter's painter, commenting that her paintings "contain a joy so contagious, one smiles upon seeing them." Heilmann trained as a ceramicist in the late 1960s, and her use of brilliant, saturated colors evolved from this background. Her abstract paintings are often playful, sometimes composed on multiple canvases to create an irregular shape. And though she uses a geometric vocabulary, her line is loose, with distorted edges and drips of paint. The poetic titles of her works, such as *Save the Last Dance for Me* (1979) or *The Kiss (Saturday Night)* (1986), imbue them with larger, evocative meanings, often referring to songs or significant places and experiences in Heilmann's colorful past.

Maintaining a dialogue between artists and art is important to Heilmann, and the furniture she crafts—similarly colored and reminiscent of the forms seen in her canvases—emphasizes her desire to engage in conversation. Her woven-back, ribboned chairs invite visitors to sit and address the art and environment, and in fact, she often positions one next to her paintings as part of the overall installation.

Until Heilmann found her house in 1995— originally built from a Sears kit, the parts of which were sent out by train in boxes—she primarily lived and worked in a one-room TriBeCa studio, which, she admits, wasn't the most suitable setting to show art. But once she decided to spend more time in the country, her walls began to fill up with work by friends, neighbors, and fellow artists.

There's little on display that Heilmann can't trace back as a gift or a trade from a friend, a memory process that she clearly enjoys. "You do sort of sit and listen and think of the stories and some of the people who aren't there anymore," she muses. The decor's overall effect conjures a scrapbook come to life, albeit one with eye-catching art by major artists in lieu of family photos.

In the living room, a large John Waters collage—"He's genius; I love John"—featuring enlarged returned-to-sender envelopes stamped and addressed to celebrities such as Andy Warhol and Diana Ross is paired next to a similarly themed, much smaller framed postcard, a classic piece of mail art from the early pop artist Ray Johnson. Heilmann has deliberately placed these two mail-based pieces side by side to invite a dialogue. "I like that about curating, how curators know how to make art out of other people's art," she explains.

On an adjacent wall, a pen-and-ink drawing by her great friend and Bridgehampton neighbor Billy Sullivan is based on a photo of her with friends at a wedding and brings her back to that memorable day. The drawing is arranged among other Sullivan works, including a sketch of artist Jack Pierson, also a Heilmann peer. As suggested by the care with which she titles her pieces, Heilmann is interested in stories, and writing is a crucial part of her artistic practice. Looking at the wedding sketch, Heilmann describes how she reads it: "like a story, like a narrative, and that happens here with my own story." This leads her to mention her desire to make a film of her life as a follow-up to her 1999 memoir, *The All Night Movie*, which she illustrated with her own paintings. The book is yet another mingling of the many media she is so comfortably working in.

Standing solidly on her living room floor is a knee-high Peter Voulkos pot. Heilmann went to Berkeley in the 1960s to study sculpture and ceramics. "There was a big scene around 'the pot shop,'" she explains, recalling how she learned to throw pots under the tutelage of Voulkos, the seminal abstract-expressionist ceramicist. The large, heavy, brown Voulkos piece, with its swirls of white and black glaze, looks more contemporary than midcentury. One can see the influence of its form and patina in the brightly glazed plates, cups, and saucers that Heilmann still creates today, examples of which line her living room bookshelves. Heilmann recently exhibited some of her cups arranged on shelves to deliberately evoke the way Donald Judd would install objects.

Above the Voulkos vase is an especially memorable gift, a skateboard painted by her

friend Marilyn Minter, depicting a cropped close-up of luminous pearls spilling out of heavily painted lips and inscribed "Happy Birthday 2009." Nearby hangs a small Cory Arcangel print of a road, which was a gift for a weekend visit. "We bonded because he does these road paintings and I do road paintings. I like how it relates to space in a very basic childlike type of way."

Heilmann admits that she hangs "by intuition," a talent she attributes to her mother's home-decorating style. Another vignette features a painting by Minter, rows of rosy-colored, uncapped lipsticks, graffitied with slashes of white. Above the lipsticks piece hangs a large painting of a curling, surfer-ready wave by her friend and fellow Californian Roy Fowler. Heilmann was showing the work to a collector on Fowler's behalf, but when the collector turned it down, she bought it. It now resides among decorated ceramic plates by Teresita Fernández, April Gornik, and Heilmann.

Back in her freestanding studio, examples of her own road paintings and new ceramic wall pieces in vibrant olives and rusty reds are installed among even more mementos. There are also Heilmann-designed chairs and tables sprinkled among the paintbrushes and palettes. Like the arrangement of paintings in her home, it's another considered scene, one more example of the artist thinking and creating on many levels and dimensions.

Mary Heilmann in the field of her farmhouse.

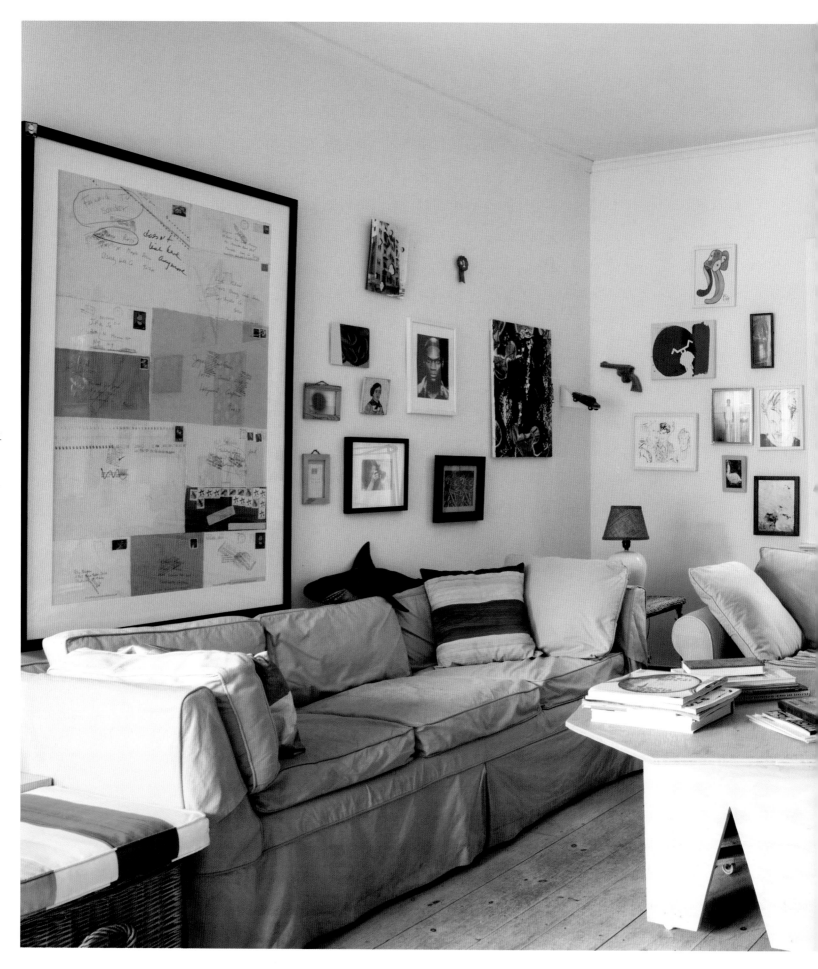

Mary Heilmann

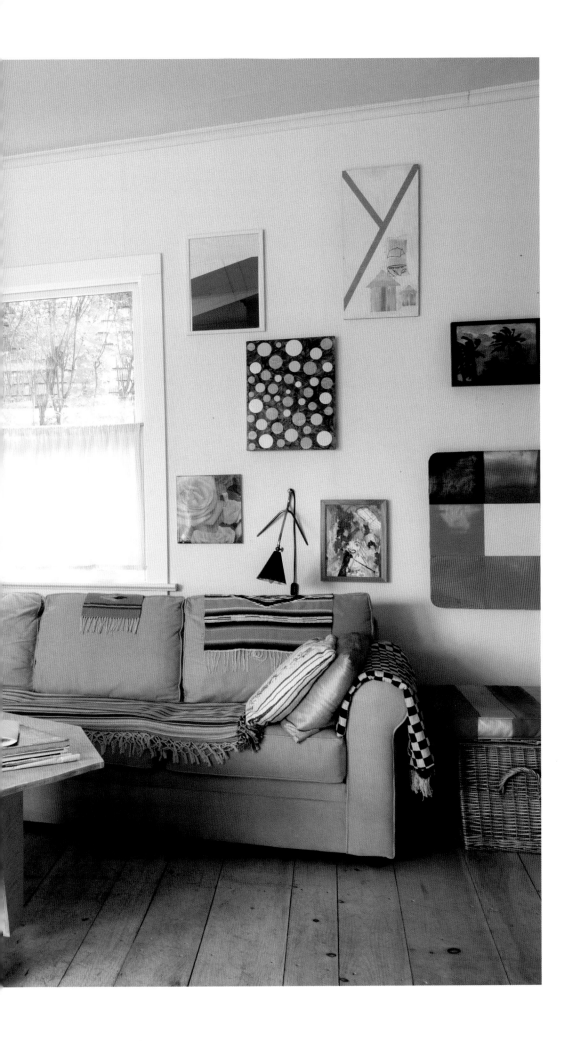

Left: A corner of Heilmann's living room, with a large collage by John Waters, comprised of returned letters on the far left. "John Waters's personality is such a part of his art," says Heilmann. A small Ray Johnson mail-art piece that the artist sent to Heilmann is paired to the bottom right of the Waters piece. A variety of Billy Sullivan's drawings hang to the left of the window, while Cory Arcangel's road painting hangs high to the window's right. The pale, aqua-hued octagonal table is by Heilmann.

Following spread: A knee-high vase by Peter Voulkos sits underneath a grouping that features two paintings by Marilyn Minter, including a skateboard deck on the top right inscribed "Happy Birthday 2009." Rick Liss's colorful square-shape grid and an untitled painting by Candace Hill-Montgomery on the top left are among other works by friends. To the right, Joanne Greenbaum's ceramic sculpture sits on top of the green Heilmann-designed table.

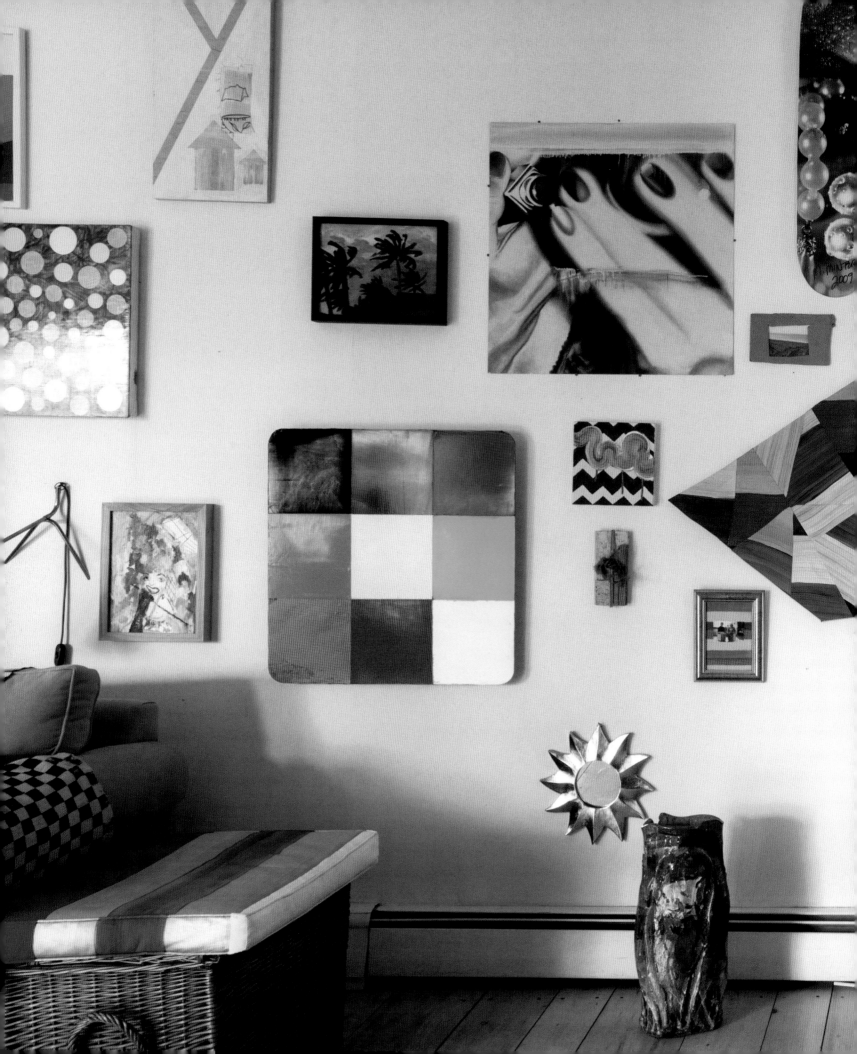

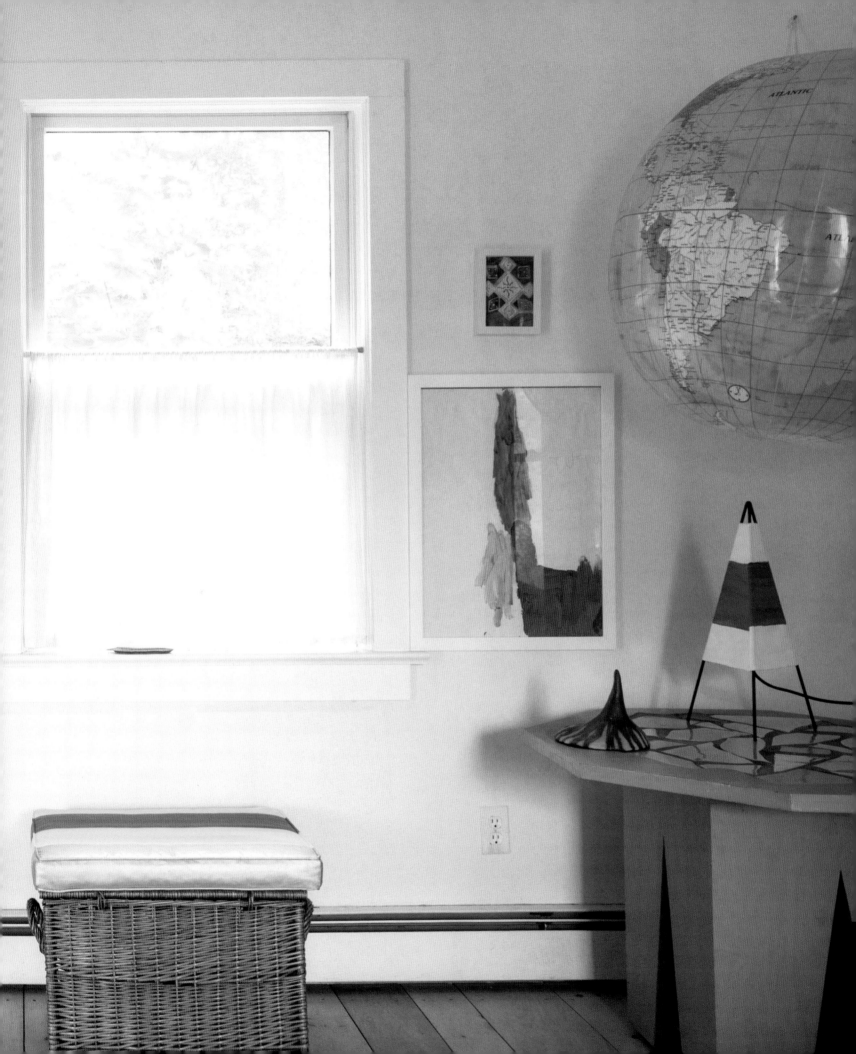

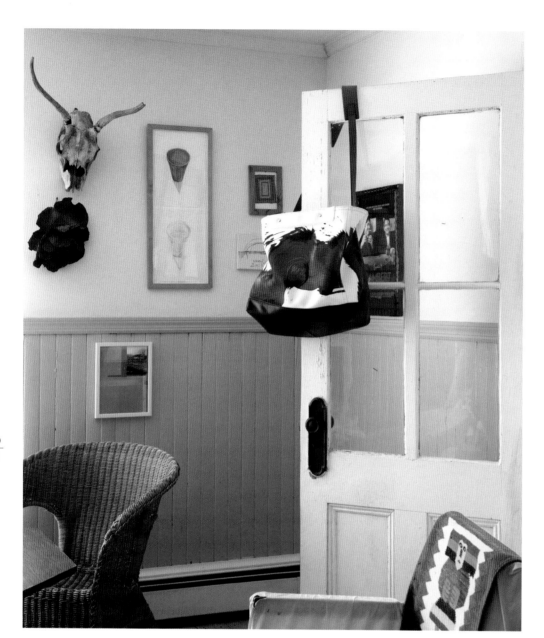

Left: A carefully curated corner in Heilmann's kitchen includes a diptych by Jan Hashey (next to the skull) with a small painting by Elizabeth Cannon below. Heilmann has elegantly draped a bag designed by James Nares in 2012 over the back door.

Opposite: A peek into Heilmann's back studio reveals some of her newer ceramic wall pieces as well as chairs she's designed. Leaning on a bench is a collage she's assembling in honor of her friend, the late music manager and producer Chris Stamp.

Mary Heilmann

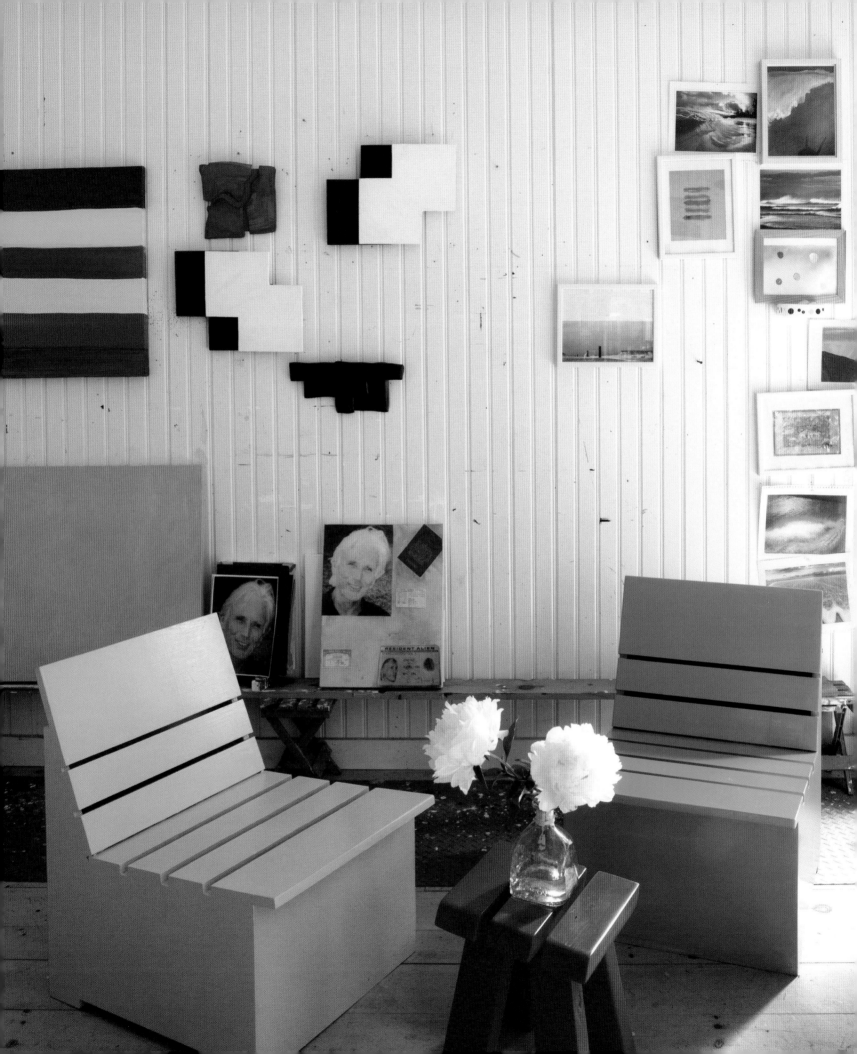

RASHID

—

JOHNSON

A 2010 "puddle painting" by Swiss artist John Armleder in Rashid Johnson's second-floor living room is installed above Margaret Lee's *Tangerines and Bench* sculpture from 2013.

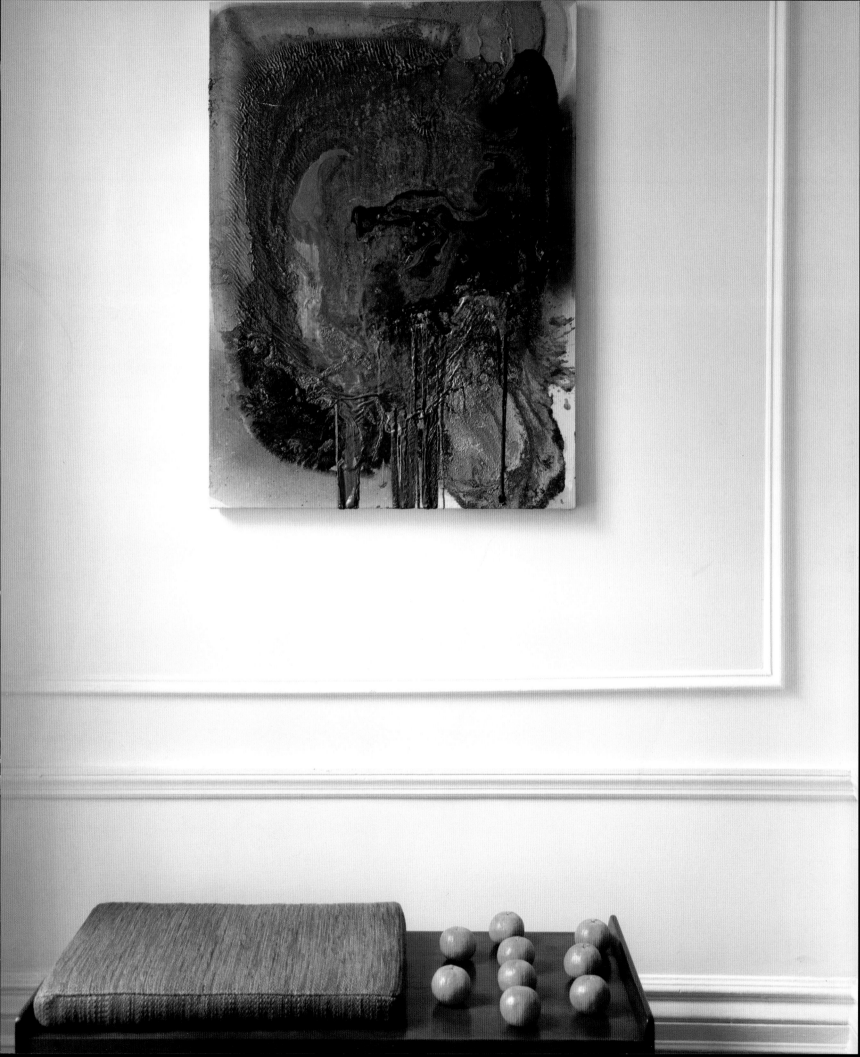

A painting of hard-edged diagonal stripes by Sam Gilliam hangs in Rashid Johnson's spacious kitchen. Gilliam's colored bands of flat paint are washed in light from the tall first-floor garden windows of Johnson's elegant, well-appointed townhouse in the Kips Bay neighborhood of Manhattan. Johnson had long admired the color-field painter when he approached him in 2012 about organizing a solo show of his work. During a subsequent studio visit, Johnson discovered early paintings never before exhibited, including this important example. "I thought it was particularly interesting because [Gilliam] was in Washington, DC, in 1964," says Johnson, "when you had the march on Washington, the civil rights movement, civil unrest. And you have an African American making these straight-edged color paintings," emphasizing the nonpolitical subject matter. "To have that time in my house," Johnson continues, "makes me feel as if I am witnessing a bit of history," an essential aspect to how he approaches collecting.

Though originally trained as a photographer, Johnson has increasingly become recognized for his painting, sculpture, and installations. He came to prominence when Harlem's Studio Museum director, Thelma Golden, included him in her seminal 2001 *Freestyle* exhibition, delineating a new generation of "post-black" artists interested in, but not defined by, the color of their skin. His more recent postminimalist, wall-hung shelf installations combine disparate objects—photographs, record albums, soaps, and books—on structural boards to create dialogues about black cultural identity. Johnson credits these explorations to his upbringing in an Afrocentric 1970s household in Chicago where Kwanzaa was celebrated and his mother, who has a PhD in African history, regularly wore an African headscarf. His parents would later unceremoniously abandon these traditions, a decision that led him to openly question his own notions of American black identity.

Unsurprisingly, works by artists that address identity head-on are also found throughout the home, where Johnson lives with his wife, artist Sheree Hovsepian, and their young son. A work on paper by Tony Lewis with "People of Color" written at the top hangs in the first-floor parlor adjacent to a white-neon Glenn Ligon piece that spells "negro sunshine" in a lowercase font. A drawing by William Pope.L that reads "Black People are Needy" lives across from the Gilliam. On the second floor, a staircase nook holds a mass-produced wooden African figure adorned with a Mercedes hood ornament by Johnson's friend Djordje Ozbolt. In the library, a recently purchased collage by Ellen Gallagher is hung above an entire vintage set of *Transition Magazine*, the East African journal founded in 1961 for intellectual discourse surrounding postcolonial politics. Though he also owns complete sets of the *Black Panther* newspaper and *October* magazine, Johnson emphasizes: "These are not decorations. I sit here and read them."

The idea of history also seeps into Johnson's thoughtfully assembled art and furniture collection. A wall-size Matthew Day Jackson from his Burned Cities sequence dominates the entrance hall. In the series, Jackson takes a bird's-eye view of a city—in this case Hamburg—builds a faithful model in wood and lead, and then chars it, leaving a blackened bas-relief. This work is titled *August 6, 1945* (2011), the date the atomic bomb was dropped on Hiroshima. "I love the association with history, the way he intervenes in history," says Johnson of his friend's work. "It lives with such a logical topography and historical notes that are born of this postwar European imagining." This work was part of a trade that included a self-portrait by Jackson of himself lying dead in a coffin, an unsettling work that Johnson's wife will not allow in the main rooms of their house.

Johnson's broader interest in materials and process is also evidenced in a darkly toned, textured "puddle painting" by Swiss artist John Armleder, installed in the living room. Armleder's performance-based process and the role of chance are important elements of the work; the artist pours paint from above onto a canvas, while laying a second canvas on the ground beneath the first to collect the paint that "puddles" as he works, creating two finished products. The piece was also Johnson's first major trade with a more established artist, a major career milestone, and came about when they were exhibiting in the same Milan-based gallery.

Recently Johnson has been interested in ceramic work, and he's acquired a columnar 1997 pot by ceramicist John Mason and a 1959 Peter Voulkos plate that rests on a large, low table in his floor-through living room. Once Johnson becomes interested in a genre, whether it's historical publications or ceramics, he is a comprehensive researcher. In fact, he fluently pinpoints the place in Voulkos's career when the revolutionary ceramicist made this specific piece. Johnson's own mark-making in melted wax on various supports of wood, flooring, and

mirror can be related to his growing interest in ceramics. "It's not dissimilar to what happens with ceramics," he says of his process. "You have only so much time and opportunity to gesture the wax and move it, and then it hardens and you are left with these firm gestures."

Johnson is an expansive thinker, engaged in contemporary art discourse and concerned about what he terms "the rituals of a now space." It's fitting that his first significant purchase, from Hauser & Wirth, the gallery that also represents him, is by Swiss artist Dieter Roth. Part of a long-term series composed of cardboard sheets that Roth used to cover his worktables, the piece shows the markings, doodles, and scratchings of everyday work in the studio, creating a palimpsest of the artist's life. "I have a real appreciation for his project and the way he lived his art. He really lived it," admires Johnson. "I just really like his aesthetic and his approach, and I think he's an incredibly important artist of the last fifty years." Johnson's dealer gave him a second work by Roth for his birthday, which he shares with his son—a drawing of a cat that now hangs in the library.

While Johnson may be intrigued by the past, he is also sharply focused on the present. "Some of the artists I'm working around today have a lot of influence on the way that I work," he says. And, as his collection illustrates, it's important to Johnson that he surrounds himself with works by his friends and other artists for reasons larger than the sentimental. "Honestly, their influence is not so much on the aesthetic concerns of my current project, but more on the concept of being a working artist today," he says. "How you live, how you work, the things that are happening around you in the art world, as well as the larger identity you have as you locate yourself in this world."

Rashid Johnson in the second-floor front parlor of his Kips Bay home.

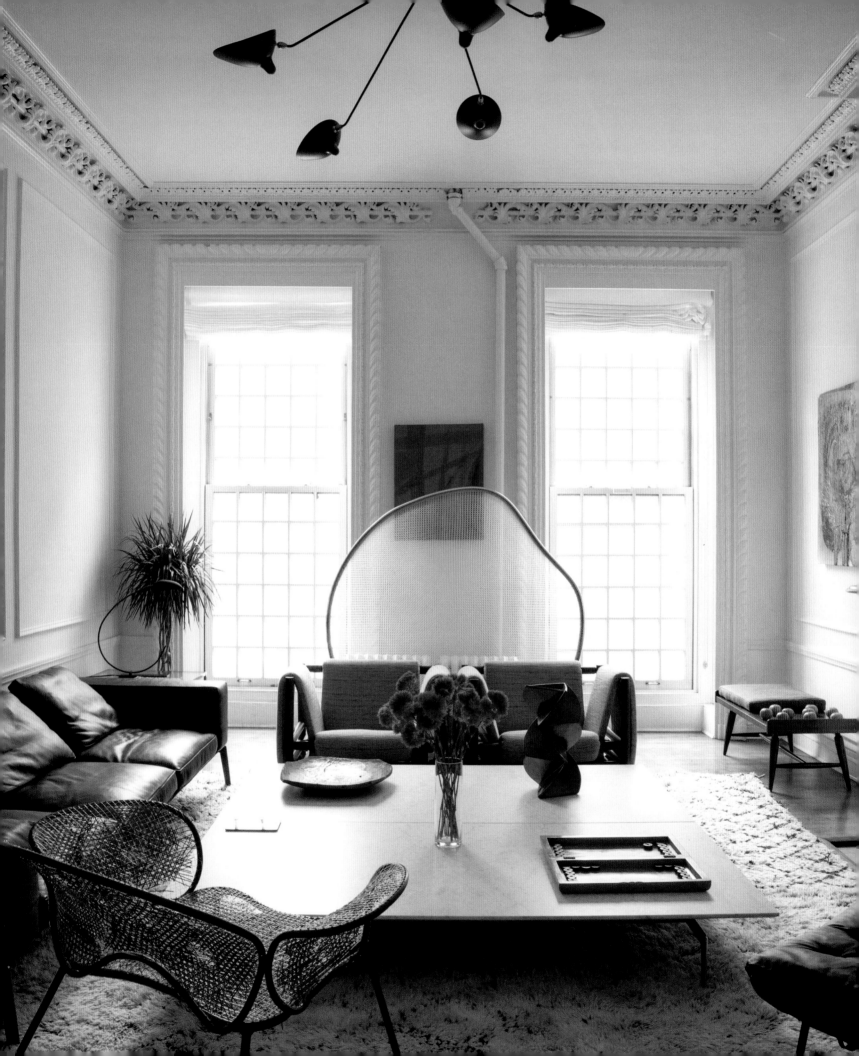

Opposite: A view of the living room showcases two 1954 loose-mantle armchairs by Joaquim Tenreiro—a pioneer of modernist Brazilian design—in front of *Racket Screen 1* by Brazilian designers Fernando and Humberto Campana, who also designed the wicker chair in the foreground. Peter Voulkos's ceramic plate and John Mason's *Small Triangular Torque, Red* (1997), sit on the table.

Above left: Placed in an alcove on the staircase is Djordje Ozbolt's 2013 *Fetish sculpture 2*, a mass-produced wooden African figure adorned with a Mercedes hood ornament and rubber tires.

Above right: Johnson researched California ceramicists extensively before purchasing *Large Plate* (1959) by the seminal abstract expressionist potter Peter Voulkos.

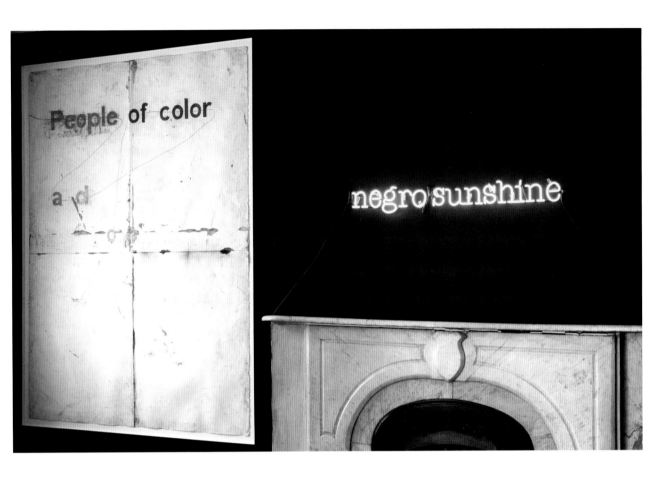

Opposite: Sam Gilliam's *Helles* (1965) was purchased from a show Johnson curated of the artist's early work at David Kordansky Gallery in Los Angeles. "This is a piece I'm very proud of owning," Johnson says, adding that he studied the artist and followed his work for years before meeting him.

Right: Tony Lewis's 2012 work on paper *People ad roloc foo* is paired with Glenn Ligon's 2005 neon piece *Untitled (negro sunshine)* above the fireplace in a first-floor parlor.

Opposite: In the kitchen, from left, a 2012 work by Anthony Pearson, a 2010 drawing by William Pope.L, and Djordje Ozbolt's 2012 painting *Gentlemen of Ngongo.* The framed piece on the far right was a gift to Johnson from Swiss artist Pipilotti Rist.

Above: In the library, Mai-Thu Perret's hand-woven wool tapestry from 2014 is flanked by Ellen Gallagher's 2005 *Abu Simbel* collage and Thilo Heinzmann's 2014 *O.T.*, which consists of cotton on panel under plexiglass. *The Kiss*, Angel Otero's 2013 ceramic sculpture, is on the sideboard, and in the foreground, Johnson's round brass sculpture is on a table of his own design.

Right: An example from the Dieter Roth series in which the artist saved workspace tablemats with the notes, scraps, and markings of his daily life. Here, the tablemat is framed and installed above the fireplace in the living room.

JOAN
—
JONAS

A self-portrait by Richard
Serra hangs on the
wall above drawings by
Lawrence Weiner in
Joan Jonas's living room.
Shelves hold paintings
of dogs, as well as objects,
photographs, and relics
picked up in her travels.

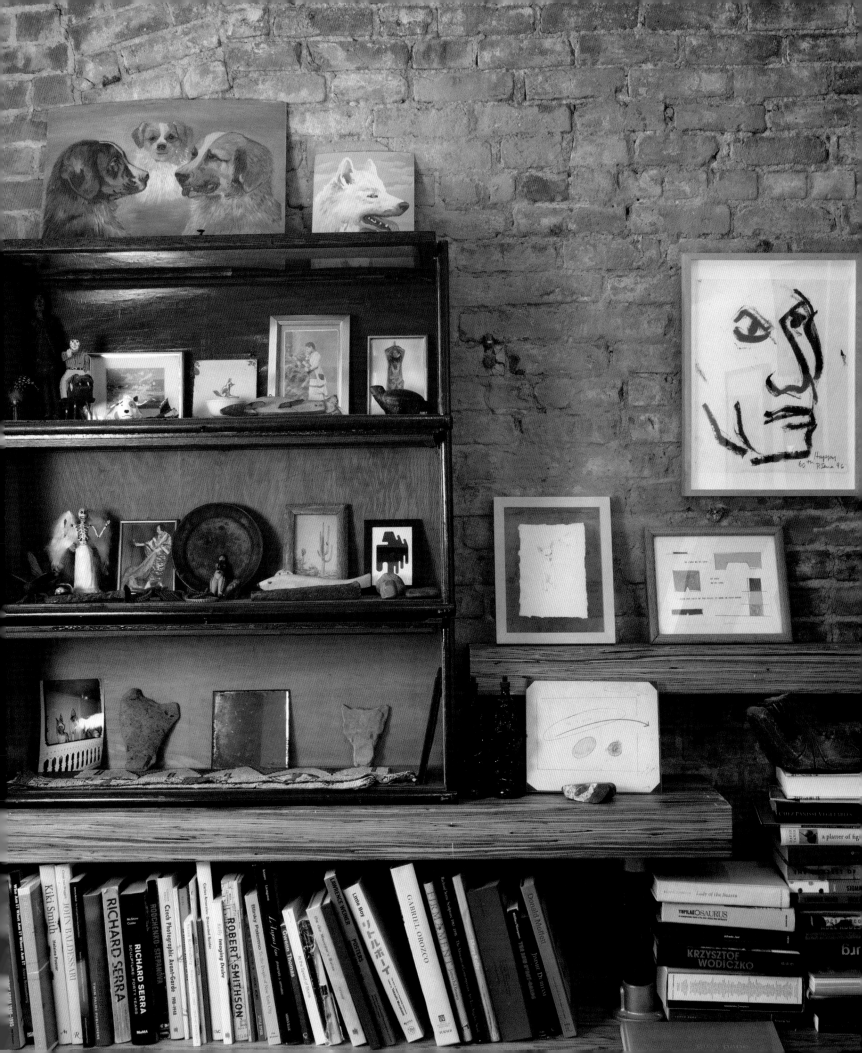

Joan Jonas in her Mercer
Street loft.

Props from the seminal performance and video
artist Joan Jonas's groundbreaking works
live on equal footing with drawings from her
celebrated friends in the SoHo loft where she
has lived and worked since 1974. Jonas is inter-
ested in art by both trained and untrained art-
ists. "I like many things; my taste is very broad,"
she explains. To this point, she loves the work
of nineteenth-century still-life painter Jean-
Baptiste-Siméon Chardin, but also treasures
her collection of Canadian folk art.

Jonas's work has been equally broad in
scope. In the 1960s, she transitioned from
a sculpture-based practice to revolutionize the
burgeoning medium of performance art by
experimenting with objects, drawing, medi-
ated imagery, and music in live and recorded
work. Beginning with her earliest pieces, she
incorporated recurring motifs, such as mirrors,
to reflect and alter perception, and began trans-
forming herself with masks and costumes.
In later pieces, video monitors took the place
of mirrors, reflecting the camera's view.

Jonas's performances have been set in
locations as varied as the shore of the Tiber
River in Rome, Jones Beach, and empty lots on
the Lower West Side of Manhattan, with the
idea of exploring space and the viewer's rela-
tionship to it. Borrowing from traditions and
myths as diverse as the Hopi Indian "Snake
Dance," Japanese Noh theater, and rituals wit-
nessed while living for a year in a small town
in Crete, she fluidly reinterprets the past and
translates it to the present. Jonas's influence
on younger artists cannot be overstated, and it
continues to endure: She's recently been cho-
sen to represent the United States in the 2015
Venice Biennale.

In the 1960s and 1970s, Jonas was
entrenched with a group of young, experi-
mental artists in the small downtown New
York art scene. A signed self-portrait by
Richard Serra that was a birthday gift hangs
on a brick wall near works by Sol LeWitt, Pat
Steir, and Lawrence Weiner—all friends since
that time. Leaning against her file cabinets
is a portrait of Jonas made by her close friend
June Leaf, whose artistic talent she greatly
admires; Leaf also made another portrait of
her, this one in tin, the only artwork by a con-
temporary that Jonas has actually purchased.

Despite her strong associations with the
established art world, Jonas is drawn to paint-
ings and sculptures found outside the main-
stream community, especially folk art. "I think
there is a thin line between what things look
like when artists are trained or untrained, and
I don't like any of the labels that go with it, like

'outsider art,'" she explains, "but I'm interested in people who aren't trained and the art they make. I am interested in how they draw, how they work."

Her taste runs from a primitive black elephant sculpture that she admires for the "strange shape" of its trunk to a pair of realistically rendered oil paintings of dogs against sky-blue backgrounds that border on kitsch.

"It's a certain kind of expression, because it's not based on a tradition," she says of these seemingly unsophisticated works, "but it's always based on some very personal obsession that I think artists have. So there are similar tendencies that are always involved with making art. One of them is being obsessed with one image or one word. I mean, I don't think any of these things are great works of art, but I like them because they're strange."

Many of the objects Jonas acquires play roles in her later performances, especially her mirrors and her large assortment of masks. Two animal masks are displayed side by side on top of a tall cabinet in the studio area. One is an orange, fang-toothed wolf head that she's used in several performances; the other she purchased recently in Philadelphia, a flecked hyena head that she admits she may never end up using. "It's very weird to wear, very strange," she explains. "But the orange one is easy."

Her interest in artists on the margin extends to art made by children. "I think I identify with it in some way; it's unrefined and slightly awkward, but very particular." The pioneering artist seems to relate with those working on the outside. "I have books about folk art and art by the mentally unstable. I am interested in all these forms on the edge," she says. "It's not the only thing I am interested in, but that's what I actually collect in relation to my own work."

Drawing is essential to her practice, and she regularly makes the act of drawing an integral part of her performances. Aside from these performative gestures, she often draws variations of dogs, and she has dozens of dog sketches throughout her home. "I became obsessed about how you draw a dog, and I keep drawing them," she says simply.

Jonas has been spending her summers in Nova Scotia since the 1970s. During her daily beach walks with her standard poodle, Ozu, she looks for rocks of unusual size and shape—a passion she thinks she inherited from her mother, who also collected stones. A tiered shelf near the front entrance hall holds some of the more striking examples; a few are so large and strangely shaped that it's hard to believe they are natural. Some also have intricate designs, but ultimately it's the forms that she responds to.

Jonas began collecting teapots while living in Dresden, Germany, and she was drawn to them for similar reasons. "I find them to be beautiful shapes, and the colors are also amazing." Other relics from the artist's constant travels are also displayed throughout the loft, including a group of belts by Native Americans of the Great Plains and a Japanese kite; she admires both for their "beautiful abstract designs." Explaining that she later made kites for a performance based on this particular kite's shape, but not its design, she says: "I just look at it because it gives me pleasure."

As an artist who incorporates a wide variety of subjects and media in her storytelling, Jonas has far-reaching interests that are reflected in the diversity of the works in her home. Whether it's a Sol LeWitt line drawing or a wooden seagull decoy, ultimately what she responds to is her own visual interpretation of each object. "I do also buy things that inspire me," she adds, "but mostly it's because I like the shapes and forms."

Joan Jonas

A wide view of Jonas's open working loft and home, where she was preparing to represent the United States in the 2015 Venice Biennale.

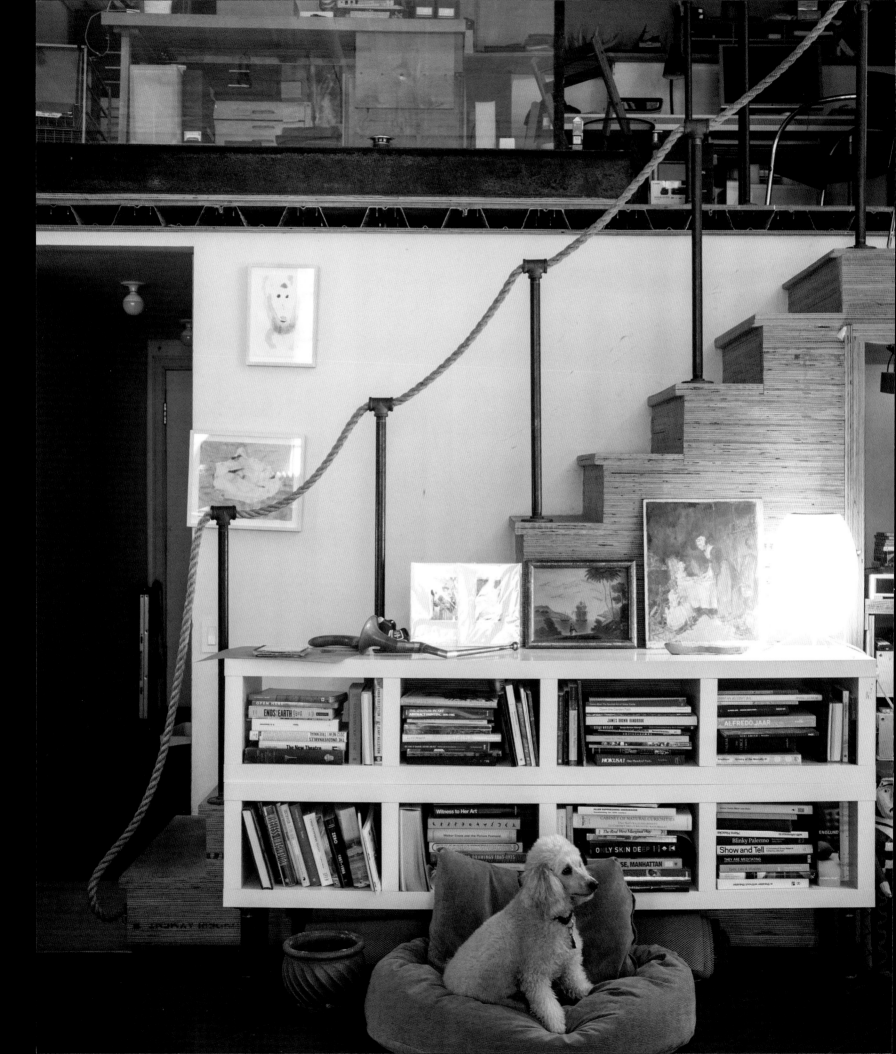

Opposite: Works by Jonas, her friends, and untrained artists lean against stairs leading to the second floor. Her poodle, Ozu, is seated in front.

Right: A close-up of Jonas's unusually shaped or formed stones, which populate shelves in her living area. She often finds the rocks while walking on the beach during summer trips to Nova Scotia.

Joan Jonas

Left: Above a white, flat work cabinet, Jonas has arranged her dog drawings among other finds.

Opposite: A stuffed coyote that Jonas has used as a prop in performances such as *The Shape, the Scent, the Feel of Things* at Dia:Beacon in 2005 sits on a top shelf. The artist has also performed in the fanged, orange wolf head on the right.

GLENN — LIGON

A tableau of works provides a colorful backdrop to Glenn Ligon's living room. Ellsworth Kelly's print *Red/Blue* (1964) stands out at left of center, and Chris Ofili's print *The Healer* (2009) hangs on the far left. Christopher Wool's silkscreen *My House III* (2000) is on the far bottom right, with an untitled David Wojnarowicz work from 2012 to its left. A pair of Hans Wegner chairs is positioned across from the sofa. "It's just a matter of wanting to live among things that are by artists that have some importance to my work," Ligon says.

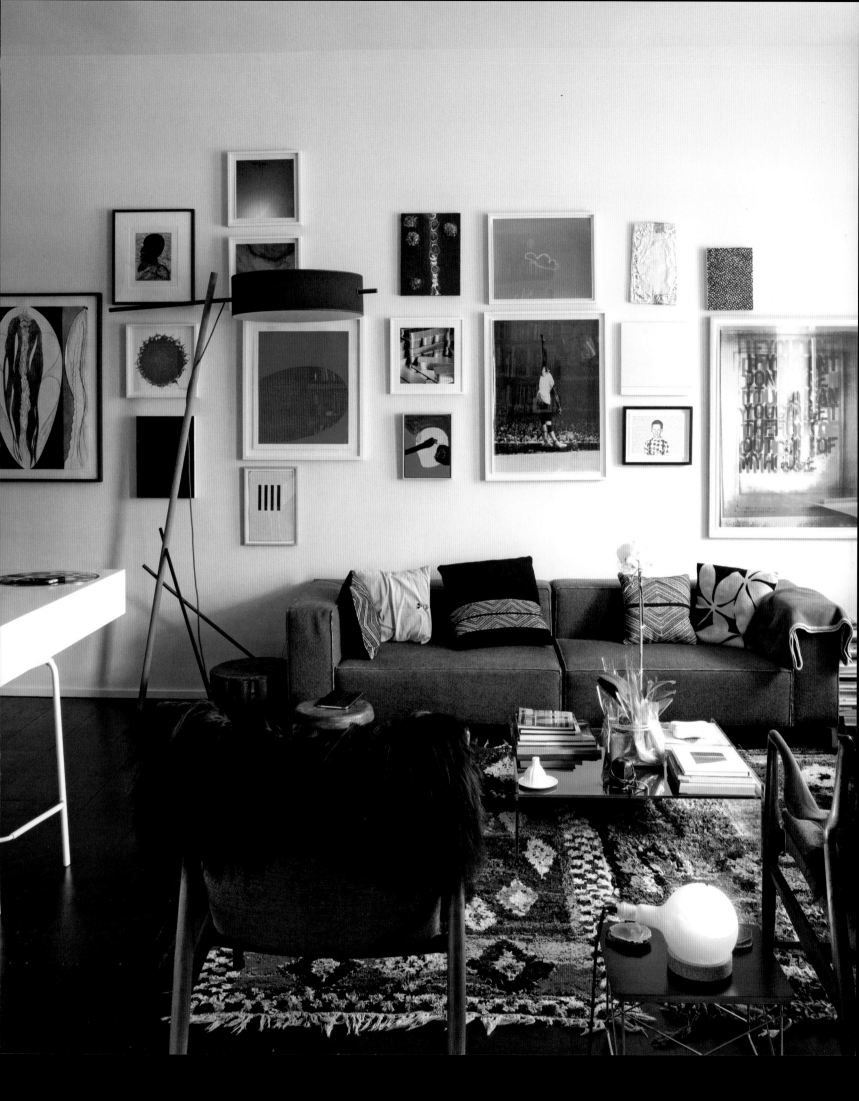

Glenn Ligon in his study, standing in front of a work by an Australian Aboriginal artist he first admired at the Documenta Kassel art fair in 2012.

Glenn Ligon

A visibly aged framed poster declaring "I AM A MAN" in crisp black capital letters hangs prominently among works by Richard Prince, Roni Horn, and Zoe Leonard in the bedroom of artist Glenn Ligon's Lower Manhattan apartment. Though Ligon rotates much of his sizable personal art collection, this placard stays on the wall across from his bed.

Its meaning runs deep, in both American history and to Ligon, one of today's foremost contemporary artists. The poster is an original from a 1968 Memphis sanitation workers' strike that came to be part of the larger civil rights struggle at the time; giving the poster further historic resonance, Martin Luther King Jr. addressed the striking black workers the night before he was assassinated. "I am a man" is also a variant of the first line of Ralph Ellison's 1952 groundbreaking novel *Invisible Man*, and Ligon's powerful 1988 painting, *Untitled: (I Am a Man)*, with the letters realized in rich black enamel, replicates the evocative words and is now part of the National Gallery of Art's permanent collection.

Untitled: (I Am a Man) is representative of Ligon's interest in history as source material, using words and images as means of storytelling. His Warm Broad Glow series of neon sculptures use the phrase "negro sunshine" from a Gertrude Stein novel, while brightly lettered joke paintings take lines directly from Richard Pryor's stand-up routines. But he's best known for his black-and-white text paintings, hand-stenciled with thick oil-stick that he intentionally smudges as he travels down the canvas. Quoting phrases from writers as varied as James Baldwin and Walt Whitman, he explores the historical and cultural layers of black society and identity in today's America. He has also addressed the legacy of slavery, exhibiting original texts written in the language of slave narratives, as well as *To Disembark* (1993), an installation that included a set of boxes referring to a nineteenth-century slave who mailed himself to the North in a crate.

Ligon is equally clear and deliberate when it comes to the art he lives with, attracted to works that both challenge and inspire him. Several years ago he even drew up a wish list of artists whose work he wanted to own. "I had had some big shows and had sold some work, and I thought, 'Okay, what's the end goal here, what will be interesting for me as an artist?'" he explains. "And I thought it would be interesting for me to be around the work that I admire."

Artists he's accumulated include Ellsworth Kelly, whose print *Red/Blue* (1964) lives among

an assemblage of works by Christopher Wool, Byron Kim, Paul Pfeiffer, Bruce Nauman, and Chris Ofili on his living room wall—some bought at auctions, others traded for. Of particular significance to Ligon is one of Kim's well-known Sunday paintings, a small skyscape with a handwritten caption underneath.

"He writes a kind of diary of what's going on that day on the bottom of his paintings," says Ligon. Kim, a close friend, painted this white-ground work on the day that Ligon's father died, an event actually noted at the bottom of the canvas. But other factors interested Ligon as well. "I always admire an investigation that is consistent," he says of Kim's approach. "And I like having a system where you can find infinite variety in the same action, that you can find an emotional power in something that's actually very simple."

Ligon had the Japanese conceptual artist On Kawara on his wish list for similar reasons. Famous for Today (1966–2013), his series of date paintings, On Kawara's installation from November 22, 1978, hangs on a separate wall in the living room, an austere painting representing the date that On Kawara created it, accompanied by a cardboard box containing newspaper clippings from the day before. The parallels with Kim's approach are apparent, as Ligon points out: "It's the same idea, a very small set of parameters about how to make a painting, but with very large implications," adding that "Byron or On Kawara are sort of reminders of how far one can go in very different ways—Byron is figurative, and On Kawara is much more abstract, but they are still about language, they are still about time, human relations."

Yet Ligon does not feel that his own work—which also deals with history and language—has a related, underpinning structure in the way that Byron Kim's or On Kawara's does. "I don't have any work that has a system that can sustain itself for that length of time. I just admire the rigor of it. I am always trying to boil things down to what's the least one can do." At the same time, other works he owns do connect back to his oeuvre: Ligon mentions that the densely painted black background of a painting by a friend, Los Angeles artist Steven Hull, is "akin to something I would make in my own work," while he credits a piece by artist David Wojnarowicz for inspiring him to think about how one uses text and image together.

The small study offers another intimate glimpse of Ligon's interests and personal history. A black-and-white portrait by photographer Roy DeCarava, whom Ligon first admired while working as an intern at the Studio Museum in Harlem, hangs over his desk with a music score from a collaboration with Jason Moran. Ligon also curates exhibitions of fellow artists, including one currently with Cady Noland, whose silver cardboard piece is on a wall opposite the desk. A rich, graphic Australian Aboriginal painting by an artist Ligon first saw at the 2012 Documenta Kassel art fair adorns an adjacent wall.

There's no unifying theme to the work he owns, says Ligon, but he is always searching for the best examples from his wish list of artists. Acknowledging that his interests have and will likely continue to change, he mentions a recent museum show of Chris Ofili that got him thinking more about the possibilities of figurative painting. Perhaps, one day, another Ofili will end up on one of his walls: "Nothing here is super-precious, but I get ideas by looking at things, so it's nice to switch things up."

NOV.22.1978

Left: One of On Kawara's date paintings resides between the oversize windows in Ligon's living room. The box below, also part of the installation, contains newspaper clippings from the day before.

Opposite: The other half of Ligon's living area, including chairs by Franz West. "I am interested in decorative arts," says Ligon. "But objects that are artworks."

Glenn Ligon

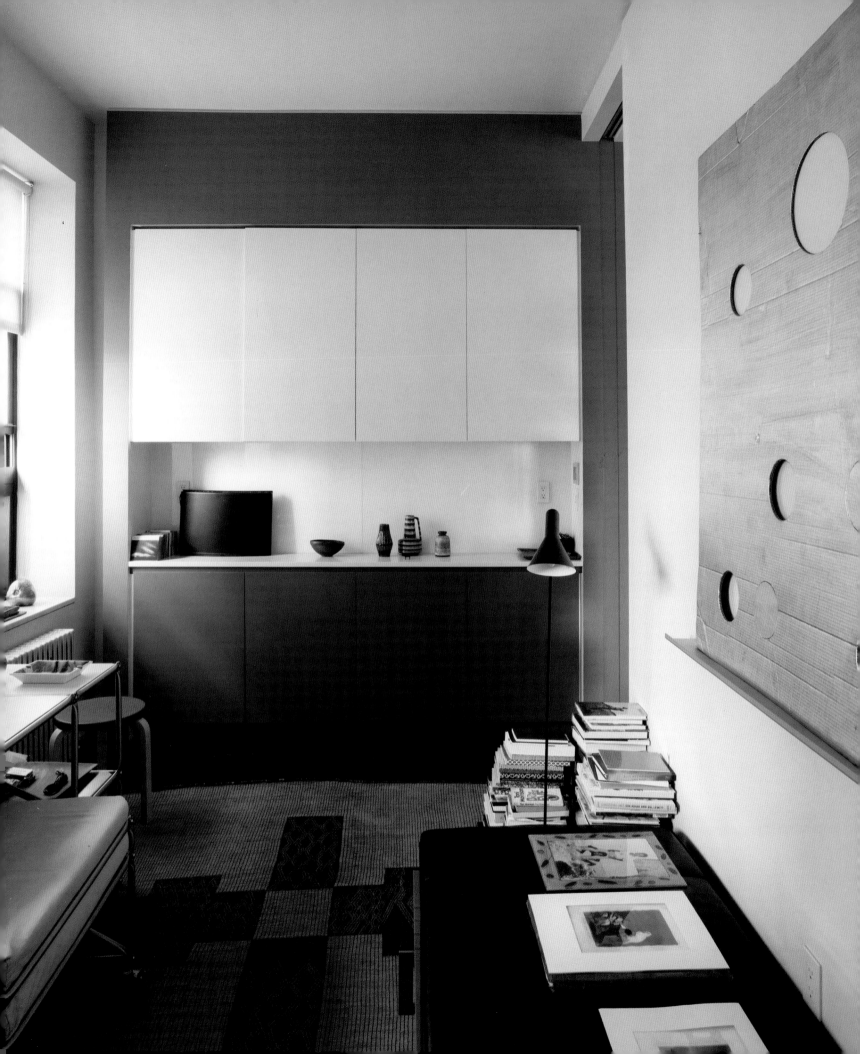

Opposite: A look at
Cady Noland's 1996 card-
board work, *(Not Yet
Titled)*, on the right wall
of Ligon's study.

Right: Beauford Delaney's
1967 watercolor *Untitled
(Cannes)* brightens a corner
of Ligon's bedroom. A
David Hammons untitled
work from 1972 leans
against the wall at left,
and a 2006 drawing by
Lawrence Weiner, *untitled
(CROSSING THE LINE)*,
stands near another Franz
West chair.

Glenn Ligon

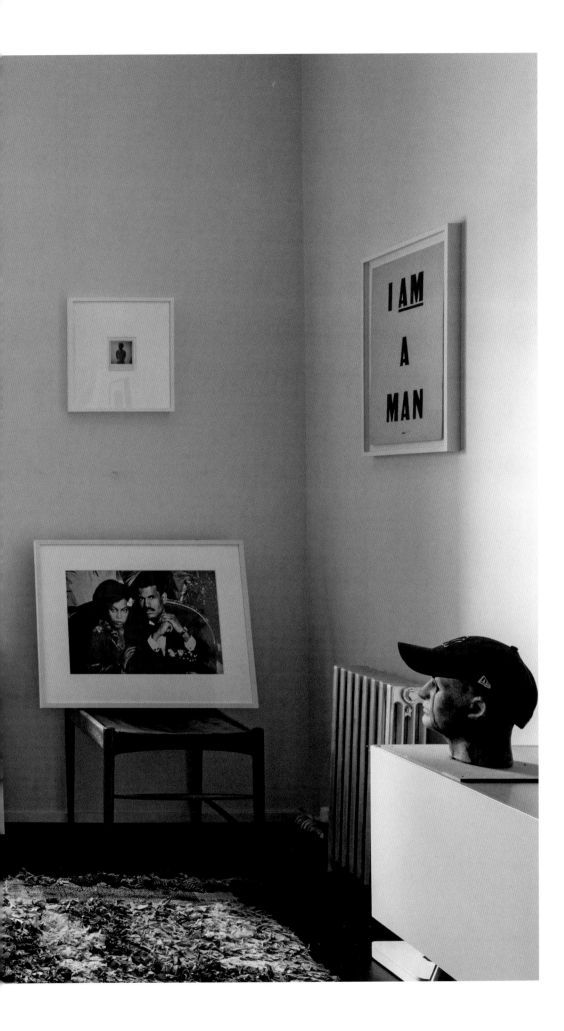

In Ligon's bedroom, a 1999 Alighiero Boetti framed embroidery sits on top of the bookshelf on the left, while Zoe Leonard's photograph *Two Windows* (2005/2010) and Richard Prince's *Untitled (Couple)* (1977–78) are propped against the wall. To the right is the "I AM A MAN" posterboard used in the 1968 Memphis sanitation workers' strike.

HELEN MARDEN
—
BRICE MARDEN

A view into the sitting room displays two works by Helen Marden; on the left, *Holi Indian* (1997), made with paint from India, and through the doorway, *Untitled* (2010), made with resin and spice. A selection of textiles from around the world contributes to the overall warmth of the house.

Painters Helen and Brice Marden bought Rose Hill estate, perched above the Hudson River in Tivoli, New York, shortly after September 11, 2001. When they began looking for an escape close to Manhattan, it was a natural choice, as Mr. Marden was raised farther down the river in Briarcliff Manor. He grew up to inherit his father's fascination with the tributary and was drawn to the location. "The whole place is so still," says Mr. Marden of the home. "You get up here and there's this whole thing about it being quiet. You can listen to the river, you can hear it going by—it's amazing."

The Italianate-style house came with a fanciful history—built by John Watts de Peyster in 1843, it became an orphanage after his death and was later purchased by Dorothy Day, who ran it as a communal farm for the Catholic Worker Movement. "There was nothing here," says Ms. Marden, recalling their first visit to what resembled a rabbit warren, "just one hanging lightbulb. [The house] looked like it was about to slide into the river." Now, after a meticulous four-year renovation, the home stands out as a work of art in its own right—the stylish consummation of a lifetime of inventive design, artistic interests, and worldly travels.

In the sunlit living room, elegant white plaster walls endow a sense of age and permanence to the architecture, while the dynamic Indian sculptures, African figures, and Berber carpets add a distinctly lively touch. "You can tell the difference, who bought what," says Ms. Marden, pointing out that her husband purchased the more understated, gently curved ivory sofa, but she selected the colorful textiles draped over it, as well as the pillow-strewn Burmese daybed in the same room.

Her vibrant taste permeates the home, where objects are as likely to come from a small shop in nearby Hudson as they are from her frequent trips to Greece or Morocco. Four of Ms. Marden's own small peach, pink, and rose-colored abstract canvases hang above the fireplace—their vivid, all-over compositions pulling out the pops of color in the room's cool, clean design. "I just like to build an atmosphere for myself; I don't care what anyone else thinks," she says, explaining that she's drawn to more eclectic and beautiful objects in general. "I am not interested in the history of the piece at all. I'm not an academic; I'm interested in the form." Ms. Marden has also been visiting India for decades, and she has prime examples of Indian sculpture, including a large seventh-century stone figure

Helen and Brice Marden in the dining room of their home in Tivoli, New York.

that "comes to life" in the evening light, and a medieval sculpture of a woman playing with a ball made to hang in a dining room.

Mr. Marden's comprehensive collection of scholars' rocks also appears throughout the nineteenth-century manor. Considered one of the foremost abstract painters of his generation, Mr. Marden first emerged in the 1960s with his matte, monochromatic panels. A master with color, he imbued his paintings with emotional and sensual resonance through nuanced hues and textured surfaces that included wax. In the mid-1980s his work underwent a dramatic shift as, inspired by Chinese calligraphy, he began to draw gestural, looping bands of color, often using long-handled brushes, on single-colored backgrounds.

It was around this time that he began collecting scholars' rocks. Prized in China for their aesthetic and meditative qualities, the naturally eroded stones articulate nature's dynamic impact over time, and for centuries Chinese scholars have kept them in their libraries or gardens. "There's the whole Taoist thought around [these stones], and I had been reading a lot of Chinese poetry, which was a big influence on my work," Mr. Marden explains as he runs his hands over one of the rugged objects. He's placed some of his favorite rocks upstairs in his office, a serene room located just beyond the dramatic two-story library.

More scholars' rocks are installed in the restored basement, which was transformed into a series of charismatic rooms distinguished by stone and brick walls and then filled with art and objects. "It's my museum of things that are mine that no one else could want but me," jokes Mr. Marden as he enters an orderly room where one of his drawings seems to reflect the lines of the scholar's rock below.

The walls of these rooms feature works by the Mardens and other artists, including friends Robert Rauschenberg (Mr. Marden was his studio assistant for four years), Jasper Johns, and Richard Diebenkorn. Additional works by friends are upstairs, including a work on paper by Francesco Clemente, a drawing collaged with glitter by Kiki Smith, and a small abstract painting by Cecily Brown.

The Mardens are born collectors, and in addition to an inn they own on the island of Nevis in the West Indies, they have recently purchased and renovated a small boutique hotel located near their house in Tivoli. Designed with Ms. Marden's impeccable eye, its aesthetic is a pared-down version of their home and provides another destination for their large art and furniture collection that is displayed throughout the rooms and hallways. They also own property in Pennsylvania, a townhouse in Manhattan, and a vacation home in the Greek islands.

Rose Hill offers a window on two contemporary artists whose use of color and line is very different but equally important: Mr. Marden's careful meditations and Ms. Marden's daring splashes complement one another in this lovingly crafted home. As Ms. Marden puts it, "The only unifying theme is us."

Helen Marden / Brice Marden

In the living room, Helen Marden's *Eagles Mere* (2011) hovers above the English fireplace, accentuating color from nearby textiles. In the corner is a medieval Indian sculpture of a woman playing ball from a Durbar Hall, and on the right, tribal African sculptures fill a side table next to Bambara fertility sculptures.

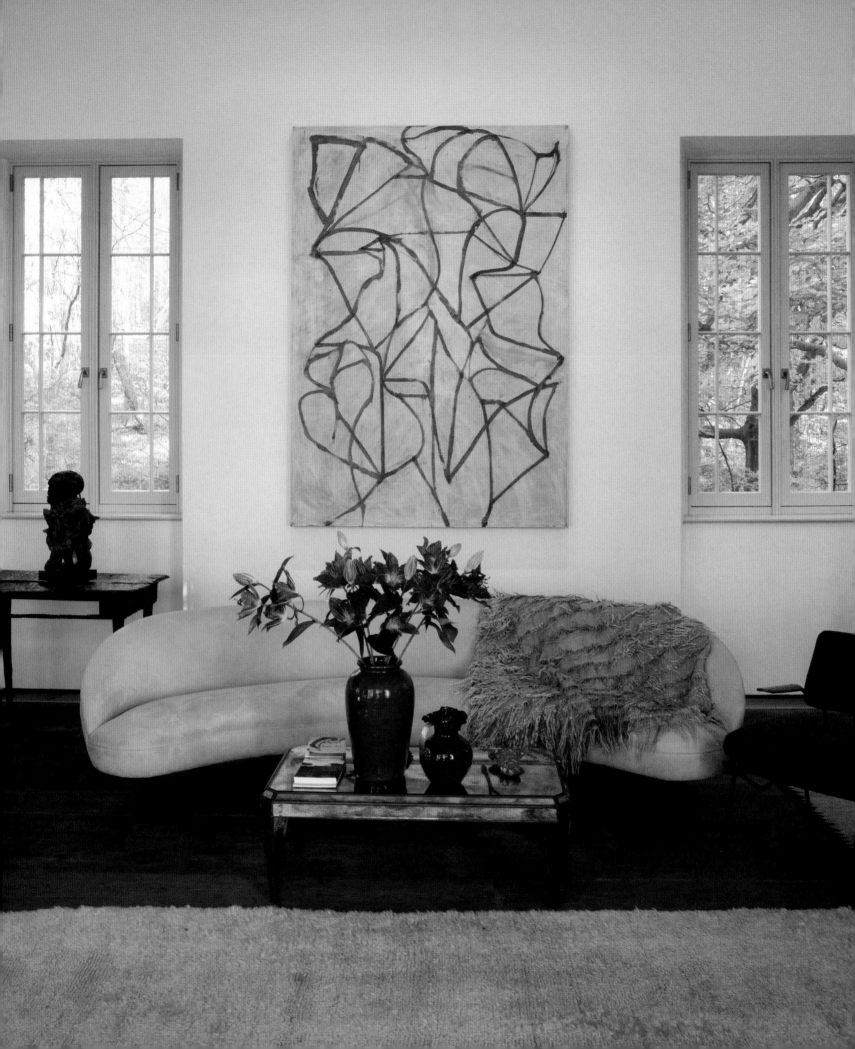

Opposite: In the living room, Brice Marden's *4 (Bone)* (1987–88) hangs above an elegant, curved cream sofa strewn with colorful Turkish textiles. To the left is a Fon Power Figure from the Republic of Benin. Helen Marden selected the textiles, while her husband chose the sofa. "You can tell the difference, who bought what," she says of these choices.

Right: A corner vignette includes a 1973 work by Robert Rauschenberg leaning against a wall in the dining room next to a fourteenth-century relic from Palawa, India. On the table is a large terra-cotta Hopi storage bowl from the mid-nineteenth century.

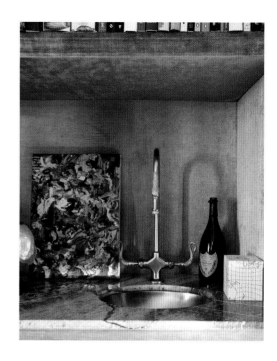

Above left: A 1997 work
by Francesco Clemente
leans against a wall in the
sitting room.

Above: Cecily Brown gave
the Mardens this small
2014 painting—now nestled
in the dining room wet
bar—as a house present.

Opposite: Brice Marden's
Nevis Letter 1 (2007–8)
appears on the first-floor
landing along with a
seventh-century lingam
stone from Cambodia,
one of more than thirty
that Helen Marden owns.

Helen Marden / Brice Marden

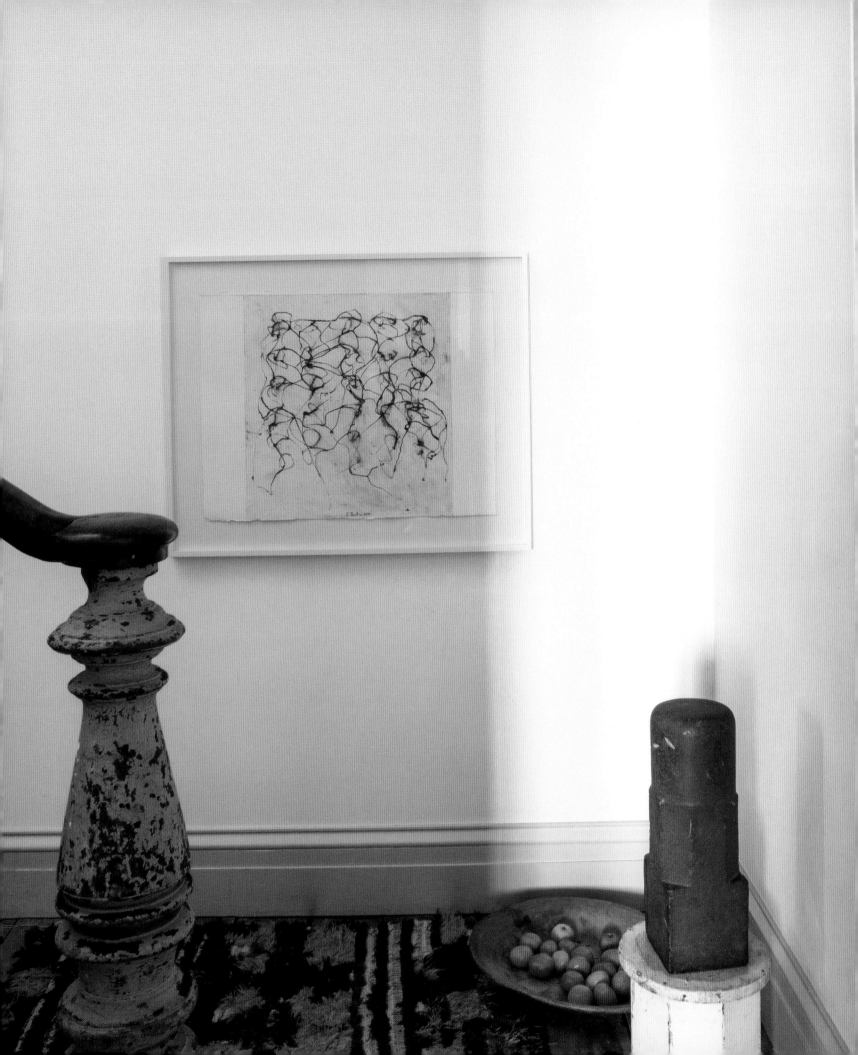

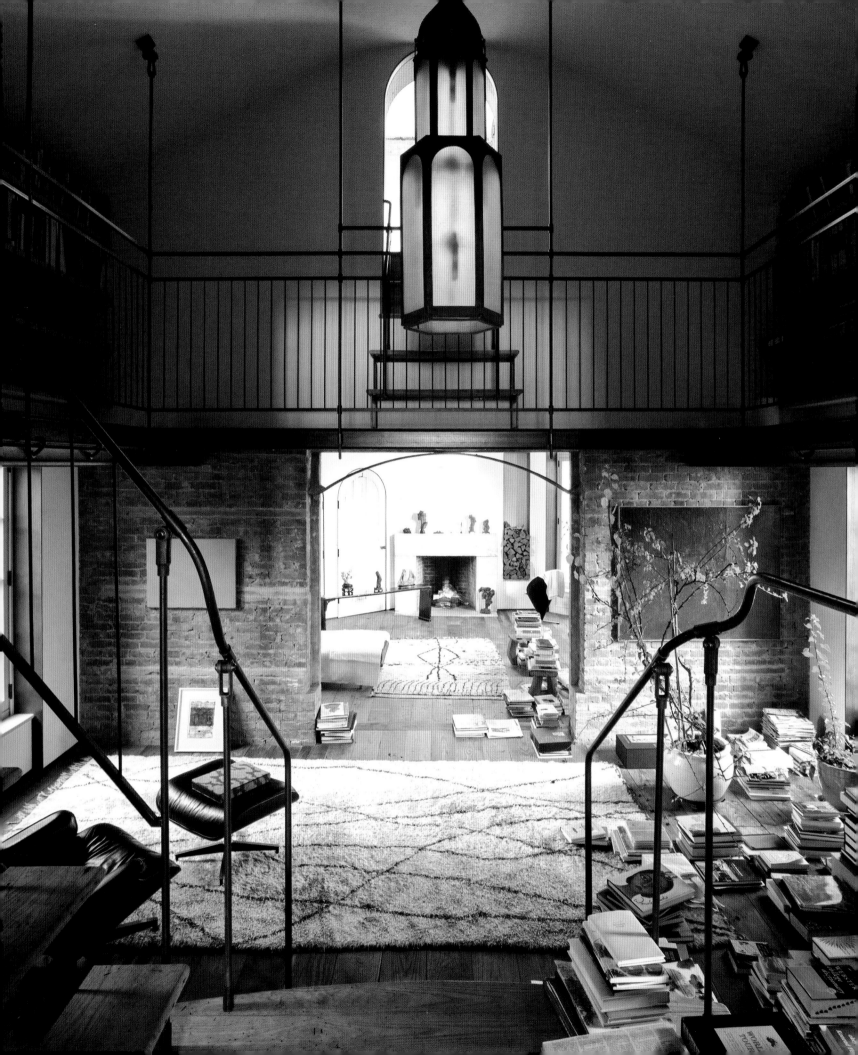

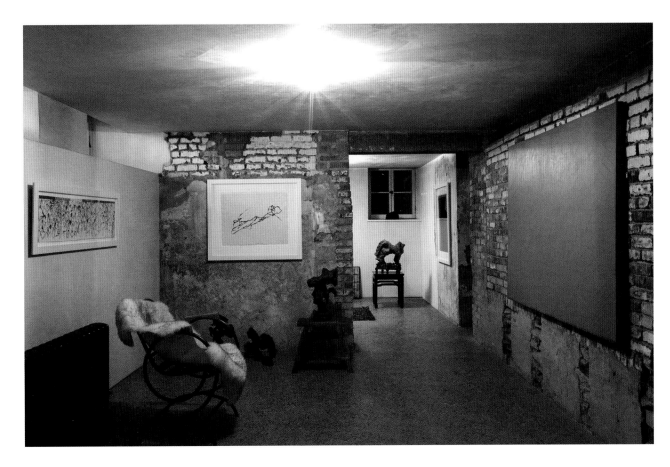

Opposite: A look through the Mardens' double-height library into the serene chamber where Brice Marden keeps many of his best scholars' rocks. Helen Marden travels to Morocco several times a year, often bringing back Berber carpets like the ones in these rooms. Two of Brice Marden's early works hang in the library: *Untitled* (1966) on the left, and *Arizona* (1963) on the right.

Right: In the brick-walled basement, Brice Marden's ink drawing *Japanese Rock* (2002–8) seems to reflect the lines of the scholars' rocks below. On the left wall is Brice Marden's multicolored drawing *Helen's Reminder* (2002–6), and on the right is his painting *Return II* (1964–65).

MARILYN
—
MINTER

Under the stairs in the front hall, one of Mary Heilmann's first club chairs, from 2004, welcomes guests to Marilyn Minter's home; visiting children have been known to hide under the seat. A 2005 pink screen print with graphic black lines by Sue Williams—a wedding gift to Minter and her husband—is installed on Bing Wright's 2012 wallpaper *Silver on Mirror (For Ron)*.

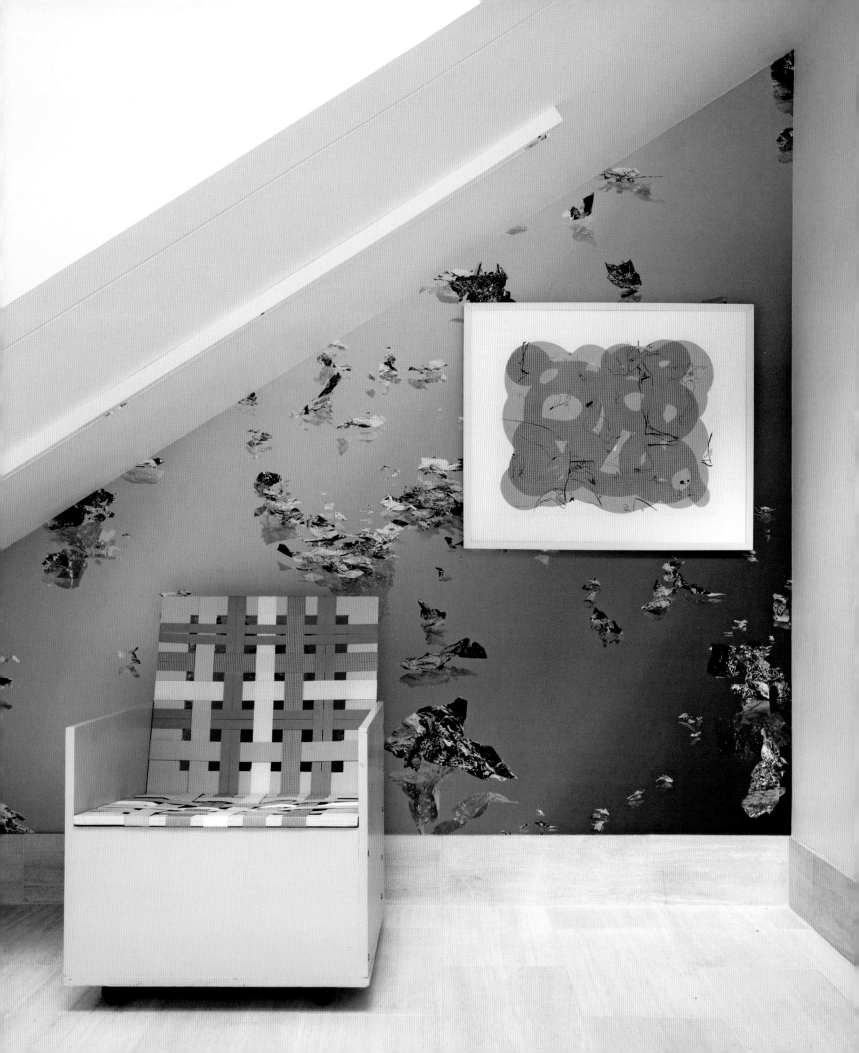

Marilyn Minter stands against wallpaper of her own design in a corner of the new "link" that connects her studio to her existing home. Installed on the wall is Sarah Sze's 2008 paper construction *Notepad*.

"The whole house is a trapezoid; there are no squares in it!" Marilyn Minter exclaims as she describes her recently renovated, contemporary home in Putnam County, New York. Collaborating with Stan Allen, the former dean of Princeton University's School of Architecture, Minter and her husband, Bill Miller, connected their existing house to what had been her freestanding studio. The new construction, which they refer to as the "link," creates a loft-like space ideal for showcasing their carefully chosen art and furniture collection.

Internationally renowned for her paintings and photography, Minter is a master in the photorealist tradition. She stages photographs—often close-up, fragmented views of women dripping with glittery makeup, fake jewels, and stilettos viewed through a pane of wet glass—manipulates the images in Photoshop, and then faithfully paints the resulting composition. The cropped images depict glimpses of debauched glamour, suggesting the seedy side of sexualized female fashion. Her practice is laborious, often taking six months to a year to create a single large-scale oil painting.

"I'm not interested in collecting realist paintings," she notes. "I like things that I can't do. Sculpture, ceramics, things that are gestural, because I don't have that mark." Minter is a natural collector, and she began buying art as soon as she started selling pieces in the 1970s. Nicholas Krushenick, now widely considered an important forerunner of the pop art movement, was her neighbor at the time and bought her a drink to celebrate her first gallery show. She later purchased a work by Krushenick that now hangs on a double-height wall beside a Gerhard Richter print of Mao Tse-tung and works by two of her former students, the in-demand painters Jeff Elrod and Austin Lee.

"Whenever I sold something, I bought something," she says with her trademark enthusiasm, mischievous grin, and ready laugh. "Even when I had no money, I bought art." Her trained eye and instinct have served her well; many of her pieces were purchased before the artists realized commercial success. On one wall alone, Cady Noland's sculpture of a grenade encased in plexiglass (bought for $600) resides next to Cindy Sherman's self-portrait (purchased for $125). Both are now worth far more.

Like many practiced collectors, Minter finds her favorite work is usually the most recently acquired, but with a little prodding she admits that a 2009 Kara Walker is currently

Marilyn Minter

her most prized possession. The image is challenging—a cut-out silhouette of a floating, axe-wielding woman ready to strike between the scissored legs of a naked, inverted, hooded figure. "It's a difficult work, but I find I like art that other artists would find hard to sell to collectors; there's a little shock value to it," she says. Minter had originally taken the star Yankees third baseman Alex Rodriguez to see Walker's show while they were visiting Chelsea galleries. "I thought A-Rod might buy it," she explains, "because I didn't think I could afford to. But I could; I paid it off over two years."

Minter likes to curate small vignettes, which she calls "corners," throughout her home upstate, as well as in her SoHo loft. The Walker hangs on a light pink wall beside David Baker's checkered black-and-white oil painting. The small Baker canvas is inset in a space almost exactly the size of Mary Heilmann's glossy black ceramic piece beneath it.

Occasionally when Minter acquires a piece, she already has a location for it in mind, but if not, she weighs different display options, moving work around until she finds the perfect placement. Here, it's not so much about the specific piece, but about the artist and whether the work fits in the house. She explains, "What's important is how it looks in reference to how the room looks, how the house looks. It's much more important than saying, 'I love this piece; let's find a home for it.' We create moments here."

In one bookshelf nook, she's paired a painted foam rabbit head by her good friend Mike Ballou with Joyce Pensato's cartoon-like rabbit charcoal drawing and small sculpture. Insisting that she put them together simply because she likes the way they look, she also mentions that Ballou and Pensato are close. Like all of her arrangements, the installation is visually appealing but also reflects her web of relationships.

Heilmann, who introduced Minter to her husband, is well represented in the home. In the front entry hall Minter has placed one of Heilmann's first chairs, which she purchased soon after it was built. The boxy, pastel-colored piece is perfectly situated in front of a large wall covered with Bing Wright's silver leaf on glass wallpaper. To complete this "corner," Minter has hung a pink print given to her by Sue Williams as a wedding gift. Minter's relationships with all the artists give her collection a very personal dimension. "It makes my day, every day, living with the works of my friends," she says.

Recently, she organized an editioned portfolio of photographs for the Lily Sarah Grace Fund, a nonprofit that promotes and funds art in public elementary schools. Minter asked five of her artist friends to participate with her. The set of six photographs also includes work by Heilmann, Anne Collier, Jack Pierson, Sherman, and Laurie Simmons. An edition now hangs proudly in her living room.

When Minter decided to purchase a country home, she and Miller drew a circle around Manhattan. The circumference included locations within a ninety-minute drive from the city, where she has lived for thirty years. They eventually settled on Cold Spring. "When we moved up here, we just said to ourselves, 'We don't want to put anything in this house, not a pot, nothing, unless it's really beautiful.'" Minter recalls. "We didn't even buy a spoon unless it was beautiful; we just didn't get anything that didn't hold up."

Following spread: An architectural bookcase holds two ceramic works by Takuro Kuwata on bottom shelves, a Murano glass vase, and Cady Noland's *Grenade Embedment* from 1986. Above the purple sofa on the left is Laurie Simmons's 2010 photograph *Love Doll Day 1/Day 27 (New in Box)*, and on the right, above two Kueng Caputo stools from 2012, is a 2010 painting by Kenny Scharf. Another small work by Kuwata rests on one of the stools.

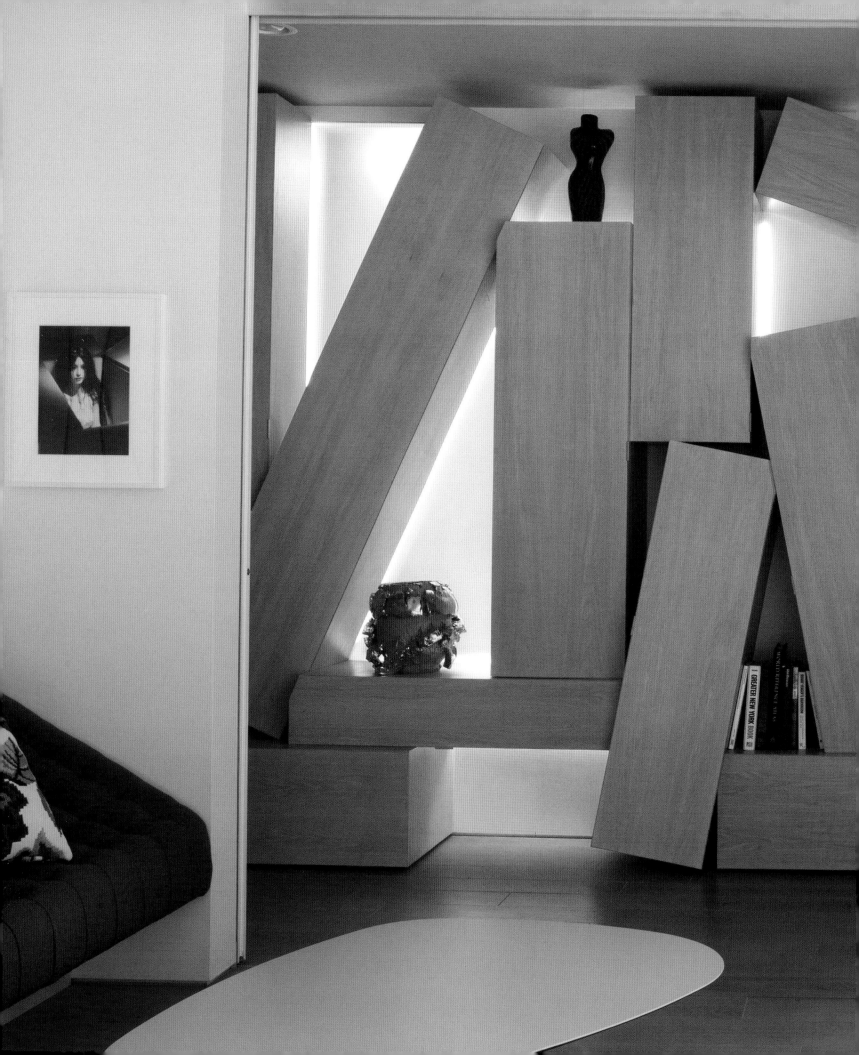

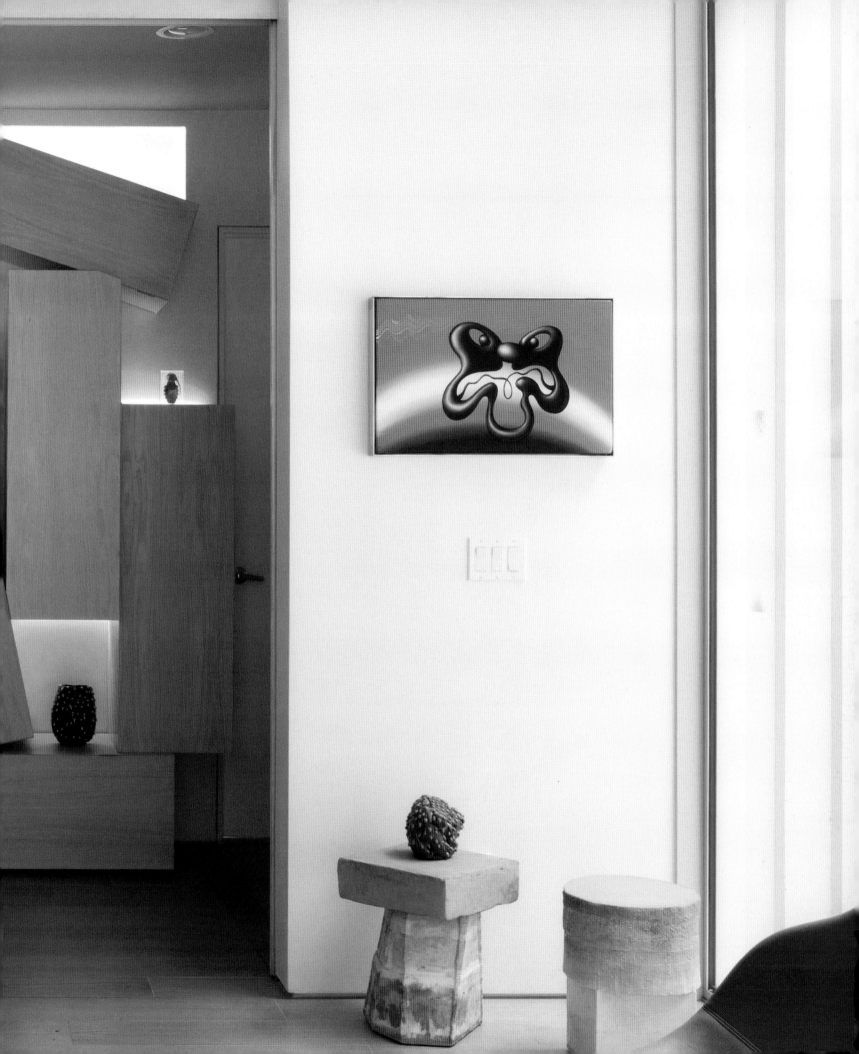

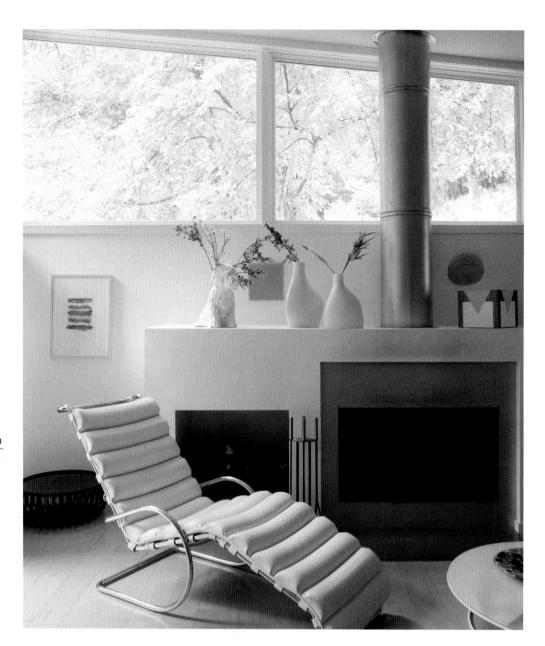

Left: A striped blue Mary Heilmann print from 1998 hangs in the living area, near two of her ceramic tiles—one square and one oval—over the fireplace. On the mantle are Jeff Koons's 1998 ceramic *Puppy Vase* and Richard Artschwager's *Table (wannabe)* sculpture from 2009.

Opposite: Minter recently installed this 2009 Kara Walker collage of cut paper to the left of a small black-and-white oil by David Baker, Mary Heilmann's black square ceramic, and a Murano vase.

Marilyn Minter

Marilyn Minter

Mary Heilmann's 1990 painting *Seam* accompanies a photography portfolio organized by Minter to benefit the Lily Sarah Grace Fund that includes works by (clockwise from top left) Jack Pierson, Cindy Sherman, Heilmann, Anne Collier, Minter, and Laurie Simmons.

Left: In a bookshelf cubby,
Joyce Pensato's drawing
(Mouse) from 1993 sits
between Mike Ballou's 2013
Bunny sculpture and
Pensato's small sculpture
(Ball) from 2013.

Opposite: In Minter's
entrance hall, the 2012 can-
vas *Nobody Sees Like Us*
by her former student
Jeff Elrod hangs above
Mao, Gerhard Richter's
1968 print. Another former
student, Austin Lee, is
represented by *Mr. Worry*,
a neon-hued portrait from
2013 installed below a 1970
collage by abstract pop
artist Nicholas Krushenick.

Marilyn Minter

MICHELE
—
OKA
—
DONER

A large drawing in Michele
Oka Doner's loft is a study
for a scrim commissioned
by Doha sheikhs who made
their fortune in pearls.
The artist was inspired by
a book on the history of
pearls.

Presiding over Michele Oka Doner's expansive, light-filled SoHo loft is a prized seventh-century Khmer Buddha. He looks over carefully curated objects as varied as a preserved cicada discovered in Japan and a witch doctor's amulet from Mozambique. Gazing over the tabletop arrangement, Oka Doner carefully adjusts several artifacts, moving one or the other slightly left or right until her eye is satisfied.

Oka Doner's vast collection of objects, both organic and manmade, has heavily informed her prolific body of work, which ranges from large-scale public installations, drawings, paintings, and sculpture to books, jewelry, and furniture. "I'm a hunter-gatherer," she says with a laugh, reminiscing about her childhood spent combing beaches and streets for shells and other natural treasures in Miami Beach. Indeed one of her most celebrated installations, *A Walk on the Beach* (1995–1999), inlays more than eight thousand cast bronze and mother-of-pearl celestial constellations and sea forms in a terrazzo floor covering more than a mile of walkways in Miami International Airport, welcoming visitors to her hometown in the most personal of ways.

The story of the Khmer Buddha is similarly intertwined with Oka Doner's personal artistic development. She had her first exhibition in 1971 at Detroit's Gertrude Kasle Gallery, which was exhibiting the foremost contemporary artists of the time, primarily New York–based men, in a stark "white-box" type space. In lieu of payment for the sold-out show, she accepted art, including a drawing—"just a scribble" she says—by Cy Twombly, who also showed with the gallery.

Down the hall from Kasle was Gallery 7, a black-artist collective run by Charles McGee. "It was the most interesting space in Detroit," she explains. "He showed African trade beads, masks, Yoruba twins. There was so much texture, physically. All these things, they seemed like magic, and I used to gravitate there."

By 1975, she chose to show with McGee instead of with Kasle, a move that freed her in many ways; for the first time she exhibited her burial pieces directly on the floor instead of displaying them on pedestals. "I never could have done that with Gertrude Kasle," says Oka Doner. She continued to work with more organic themes, such as germination, sculpting thousands of clay seeds and pods for later museum exhibitions in Detroit and New York.

"What I loved about Charles McGee is that we worshipped at the same altar. I didn't worship at the altar of making art. I worshipped at

Michele Oka Doner in front of a door she made from casting carved wax in bronze.

Michele Oka Doner

the altar of passion, instinct, of things born, not made, things that came out of you," she says.

McGee also owned the beloved Buddha, and when he admired her Twombly drawing, she happily traded for it. "I can still feel it, that moment when I saw the Buddha," says the artist. It is a choice that may have surprised peers who might have kept the Twombly, but it's one she still feels passionately about today.

The Buddha is at home among dozens of pre-Columbian artifacts, Mesopotamian seals, Egyptian amulets, Roman buttons, fossils found on digs, and other collected treasures from her travels. The number of objects displayed on nearly every surface might feel overwhelming if not for the fact that each piece feels specifically chosen. Even the larger items, such as her six Bugatti chairs—four of which used to be in Andy Warhol's studio—and the bronze dining tables that she cast herself, all work elegantly together.

Ancient fertility goddesses, arrowheads, and fossils collected with her sons adorn many of the bookshelves in her overflowing library, which is raised several steps off the living room, as if to suggest its importance. "The library is truly the heart of the loft," she says. "I have always had a library, even when I was a child. Here I wanted to re-create the tension of the graduate stacks in college; that moment when you feel all the knowledge of the world," she says.

The library includes rows of *National Geographic* magazines dating from the late 1800s, five generations of family books, and her own personal collection. The artist works fluidly with her volumes and often peruses the stacks, pulling out a book to illustrate a point. Oka Doner is currently designing several "poetry carts," which resemble library restocking gurneys, out of scraps from her foundry. "This is a working loft," she explains, "and it's a reference library." Fittingly for an artist who draws so deeply from organic forms, many of the books reflect her interest in nature, but there are also philosophy, poetry, and history publications that all intersect with her practice.

In fact, the large, lacy, sea fan–like drawing covering the loft's back wall, a study for a scrim commissioned by Doha sheiks, was inspired by a book on the history of pearls. "There was an early microscopic photograph of what nacre looks like as it's put down in layers by the mollusk," Oka Doner says. "It shows how mother-of-pearl becomes opalescent, and why it has the luster it does, by catching the light in a very particular way.

"My art is the extension of ideas," she continues, explaining how the library is important to her practice. "The common denominator is the ideas. I'm synthesizing what I'm thinking about, trying to crunch it down. A metaphor would be if we call the library a garden that is consistently weeded, fertilized, and new sections planted. It feeds me in some way."

Her home is a reflection of that metaphoric library "garden," rife with intelligence, ideas, and inquiry. It is the knowledge and texture of the objects in her home that resonate. "We could call the opus a meadow with lots of wildflowers—writing, making public art, making small objects that are ceremonial for the home. When you mix a perfume, you distill the many ingredients into drops, and that's what poetry is—what art is."

168
169

Following spread: A cast-bronze table of her own design is filled with prototypes from the Reef Collection, her 2005 collaboration with Steuben. A cast-glass radiant disk holding tropical seeds sits in the center. Fossils, petrified insects, Mesopotamian seals, Egyptian amulets, Roman buttons, and other natural-history treasures are carefully arranged on other tabletops throughout the loft.

Opposite: Oka Doner describes her working library as "truly the heart of the loft." Designed by Erich Theophile in 1990, it holds five generations of books from both sides of her family. Yellow spines of *National Geographic* magazines dating back to the 1890s are visible on multiple shelves.

Right: On the top shelf of a library cabinet are three pre-Columbian bowls from Ecuador with delicate paintings of birds and fish on the interiors. On the middle shelf, an ancient white Greek figure is surrounded by Egyptian alabaster cups on the left and an assortment of ancient beads and amulets on the right. Animal skulls that Oka Doner gathered with her family in Michigan are on the bottom shelf. The large example from a tortoise in the back left, found in the Yucatán in 1973, began her collection of skulls.

Oka Doner's Khmer Buddha resides at the center of an arrangement including, on the left, a goddess from the Caspian region of Iran flanked by two silver Japanese parrot cups. In front of the goddess are torso-like coral and stone forms that she found on the beach. Several objects discovered at a witch doctor's market in Mozambique are on the right, along with a chunk of amber—evoking the shape of a hand—that is an ancient tribal piece from the Baltic region.

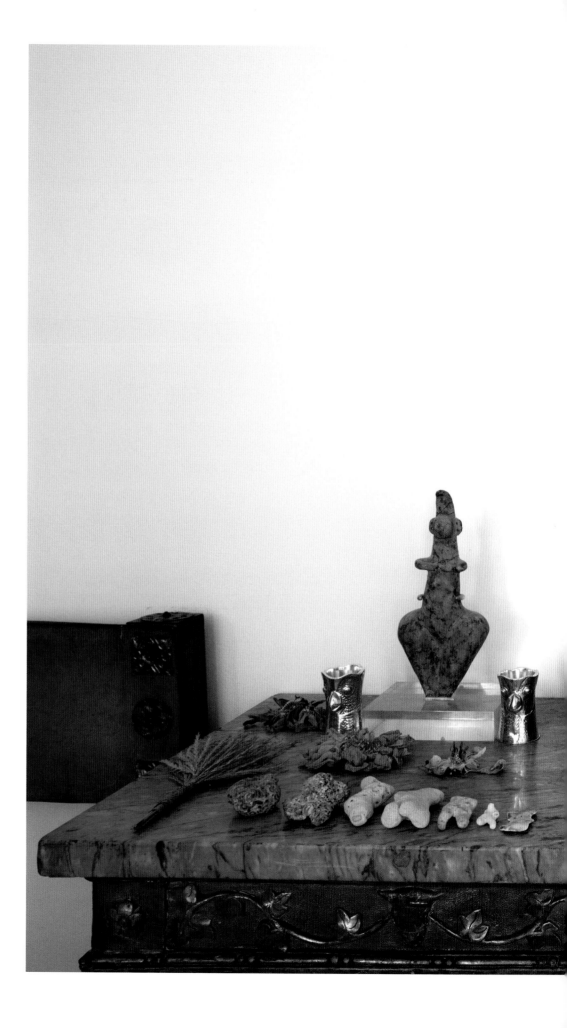

Michele Oka Doner

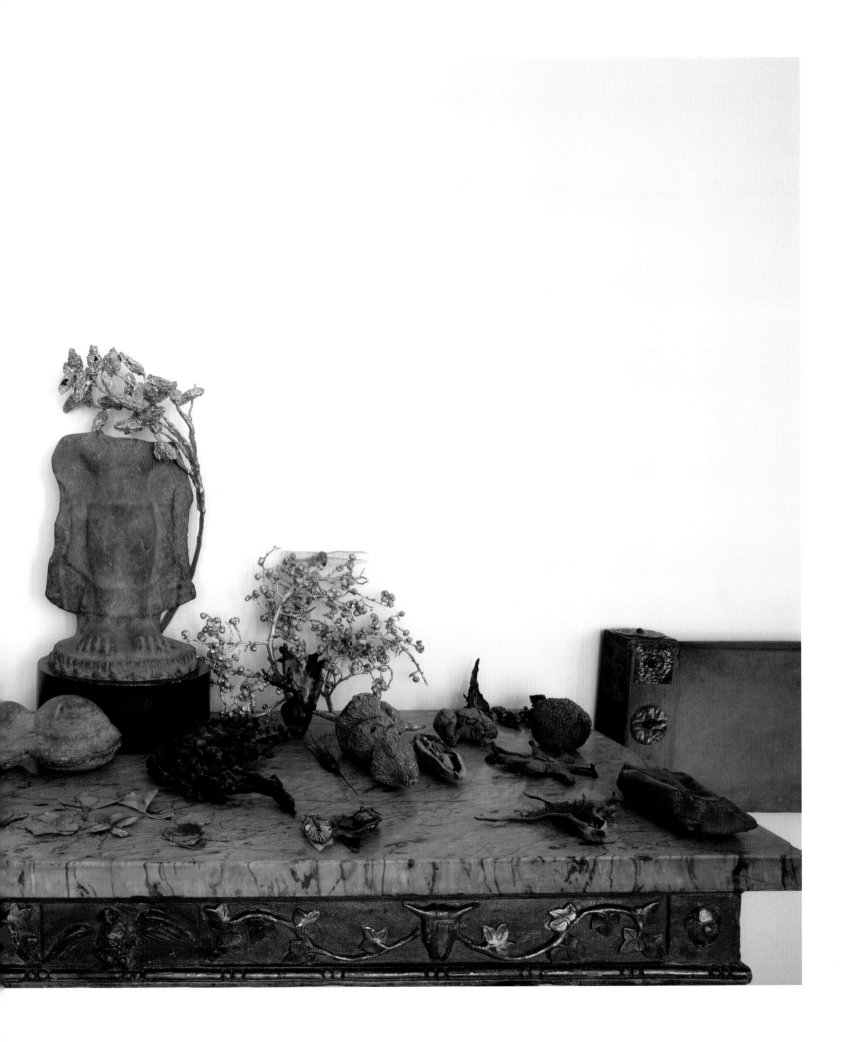

ROXY
—
PAINE

A print in Roxy Paine's
living area illustrates
various species of coral.
The artist is interested in
its dendritic nature.

Roxy Paine has lived in the Williamsburg neighborhood of Brooklyn for twenty-five years, but he feels much more at home in the rugged outdoors of the American West. "My natural habitat would be in the desert," he says, looking toward an open-shelved cabinet in the living room of his garden-level duplex, which holds his collection of minerals, rocks, and dendritic material. Although his grandfather was a trained geologist, Paine was first drawn to these organic materials at the age of sixteen when he left home and traveled west. "First it was the landscape, and then that drew me to trying to understand the formation of these rocks," he says, explaining his interest in the dynamics of earth's history.

Resonating throughout his innovative and expansive practice is the interplay between human activity and natural elements. Focusing on systems of transformation, collision, and control, Paine has built machines that create unique drawings and, most recently, sculpted a meticulous life-size diorama of an airport security checkpoint from maple wood. He is widely known for his tree-like sculptures created from stainless steel rods, pipes, and plates that have been welded and fashioned into branches. *Maelstrom*, his 2009 installation on the roof of the Metropolitan Museum of Art, included 10,000 conjoined elements and stretched 130 feet long by 50 feet wide. In this series, titled Dendroids, the works do resemble trees, but the title also refers to a myriad of natural branch-like or dendritic forms, including respiratory systems, neural networks, and even river formations.

Among the materials collected on his cabinet shelves is a group of coral pieces that he discovered in Cook Island, New Zealand. "I haven't used coral at all in my work, but my interest in dendritic structures follows through to coral," he confirms, pointing to a print on a nearby wall that illustrates several different coral branching structures. In fact, Paine's Dendroid sculptures sometimes resemble these marine invertebrates—slightly awkward tubular forms with jaunty outgrowths—as much as natural trees.

Also on these shelves is one of Paine's favorite objects, a large chunk of sulfur that he found for sale tucked away in the corner of an outdoor rock garden in Utah. "I'm drawn to it partly because of its elemental quality and partly because I'm thinking about history; the potential of this element and how it's been used through history. The alchemists are an important component of that for me. Sulfur is a contained element, but it has this potential."

Alchemy's power of transformation interests Paine: the way elements are distilled and isolated and then recombined to create a new material, such as sulfur's essential role in the production of gunpowder and gasoline.

While in the Dendroid series Paine alters industrial material into what appears to be a natural form, he has also used natural materials and altered them with machines. These inventions allow him to control the operating system while leaving the apparatus to make the physical, unique objects. For *Erosion Machine* (2005), he programmed the instrument to etch sandstone, resulting in marks that vary based on the innate characteristics of the sample's density, permeability, and age. With this clear reference to human impact on the environment, Paine is also questioning the relationship between artist, machine, and natural elements—a theme that underlies much of his work.

A large piece of sandstone that Paine used in early tests of the *Erosion Machine* sits next to a weathered piece of petrified wood on the living room shelves. He came upon the sandstone in the Escalante Desert in southwestern Utah while developing the instrument and later used it for tests; the experimental furrows are clearly inscribed on its surface. In the back garden, he's kept another stone also used to test the machine, and here on the denser surface, the etchings are subtler. "I wanted to test the different hardnesses of rocks to see what kind of erosionary forms would develop in them and how quickly," he explains.

Paine's shelves also hold examples of meteorite, conglomerate, and volcanic rocks. "I like that each of them comes from a particular place, and I can remember finding and getting it from that place," he says. "They're each a geologic expression of the earth and come from different ways of formation." Paine goes on to explain various geological phenomena in detail; sulfur's genesis in volcanically active areas, sandstone's compression through heat and time, and a conglomerate rock's formation from different stones pressurized with various mineral deposits. "The petrified wood is the completely other way of being created," he explains with the perspective of someone fascinated by how things are made, "through an organic material that is slowly replaced molecule by molecule by minerals, so it's a kind of creation by replacement."

Paine is also interested in the multidimensionality of mushrooms, whose underground mycelium networks decompose organic material, allowing it to regenerate. "Early on it was the hallucinogenic, psychoactive, and

mind-altering aspects of mushrooms that interested me," says Paine. "But it's also the regenerative aspects; the transformative, transforming aspects. It's about transforming dead matter into something that is part of life again." Since the late 1990s, Paine has cast lifelike toxic or hallucinogenic fungi and plants in various materials and installed them in fields on the floor or vitrines, work known as his Replicant series.

In a narrow hallway on the garden level, Paine, who is also an avid cook, has several examples from his large collection of mushroom-themed artwork. "I always found the Czech educational prints and posters the most graphically beautiful and just stunning in their composition and detail," he says, explaining the origin of two large prints hanging across from each other. In this room there

is also a smaller, delicate drawing of two mushrooms, and Paine explains that he and his wife, Sofia, have a larger collection of mushroom-themed material at their Upstate New York residence.

Whether mushrooms or rocks, the transformational elements of what Paine collects seem to directly translate to his own practice. "Thinking about the diversity of ways that these things are formed relates to my work," he says, standing next to the shelves that showcase so many various organic creations. "I bring a lot of different kinds of strategies of formation to bear in different materials. It's completely different having a computer-generated machine build something, and then to also build something where everything is about the fingertip and how it meets a malleable material in a really meticulous way."

Roxy Paine stands beside his portrait by friend Bruce Pearson in the entry hall of his Williamsburg townhouse.

Left: One of Paine's many examples of mushroom-themed drawings and prints in a downstairs hallway. "I'm interested in the idea of something that has all these potentials for physical, but also mental, reconstruction or regeneration," he says of the transformational aspects of mushrooms.

Opposite: Shelves in Paine's living room hold sulfur, sandstone, meteorite, conglomerate, and volcanic rock from his collection. The artist is interested in geologic formation and the role of different organic materials in natural processes.

Roxy Paine

Roxy Paine

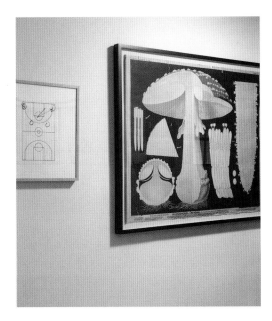

Opposite: Paine has placed a vertebra removed from a twenty-five-foot whale that washed up on a Rhode Island beach on top of a rock composition in his back garden. Surprised by how strongly it was attached to the backbone, he had to use a hacksaw and machete to extract it.

Above: An example of a mushroom print from a Czech educational guide hangs next to a quick sketch by former Knicks coach Jeff Van Gundy illustrating game plays to his team. Paine, a long-time Knicks fan, grabbed the frenetically drawn pages while sitting in the front row at Madison Square Garden.

Right: A grouping of works by Paine's friends, including a large gouache using psychedelic text by Bruce Pearson, a watercolor and gouache by David Brody, and a text piece by Joe Amrhein, the cofounder of Williamsburg's Pierogi Gallery. Paine and Amrhein are among four Brooklyn-based artists recently invited to create labels for a special-edition beer celebrating Brooklyn Lager's twenty-fifth anniversary.

ELLEN PHELAN
—
JOEL SHAPIRO

Bras de Spectre (1925)—a favorite collage by Jean Arp—and a canvas by Stephen Mueller join an early-tenth-century gray sandstone Khmer torso next to the fireplace in the living room of Ellen Phelan and Joel Shapiro's Manhattan duplex.

"I think artists tend to be less interested in subject matter per se and more interested in structure and content," says Joel Shapiro. His case in point: the gory and flaccid still life of a rabbit carcass by French expressionist Chaim Soutine that is centered over the fireplace in the bedroom he shares with his wife, painter Ellen Phelan. Like many of the works that blanket the grand, double-height duplex apartment (including a Lucian Freud drawing of a horse's head that hangs over the couple's bed), the painting is defined by an intense and dynamic line.

"When I saw *Le Lapin* at the show [at New York's Gallery Bellman in the late 1970s], I thought it was the most interesting picture. I would say that in most work, I care more about the content: the fervor and the attitude of the artist and how that manifests itself in the material. Then you have a real sense of the artist," he says, citing the thick, restless brushstrokes in Soutine's painting.

Shapiro is one of today's leading sculptors. His postminimalist works range from early cast-iron miniature houses and chairs, solid and dense with emotional impact, to abstracted anthropomorphic forms to his more recent monumental hanging assemblages comprised of simple, colorful rectangular shapes exploding through space. His admired public commissions include more than thirty sculptures worldwide, including *Loss and Regeneration* (1993) at the United States Holocaust Memorial Museum in Washington, DC.

Over the course of her extensive career, Ellen Phelan has produced paintings of plein-air landscapes, still lifes, portraits, photographic-based work, and doll studies, all distinguished visually by their misty focus and technical fluidity. The portraits of dolls are among her more recognized work and are laden with a dramatic psychological quality. Her own antique dolls, some used as models for the works, now reside in a separate room of the apartment, with her Staffordshire figures, dried sea fans, and other ephemeral collectibles.

In spite of their acclaim, the couple has chosen not to live with their own work. "It's nice to live with stuff that takes you outside of yourself or informs your own work in a more interesting way. The nice thing about living with art is that it's slow and it reveals itself over time," says Shapiro thoughtfully.

Though Shapiro tends to gravitate more toward three-dimensional work, the couple agrees that they largely have the same taste, especially when it comes to drawings. "I'm a big [Arshile] Gorky fan, so most of the Gorkys were my instigations," says Phelan of the many Gorky pieces displayed throughout the apartment. When asked about their appeal, Phelan, the former director of visual arts at Harvard University, quickly recalls de Kooning's famous quote about his historic meeting with the painter who would greatly influence his work: "I met a lot of artists, and then I met Gorky."

But still, it comes back to the line. Shapiro finds a verso drawing, the profile of a woman's head that Gorky drew on the front and back sides of a piece of paper, more interesting than the marks in *Khorkom*, a better-known Gorky drawing that the couple also owns. Shapiro explains that the two iterations in the profile are an example of Gorky truly questioning his use of line or, as he puts it, "a real manifestation of the search." *Khorkom* and another Gorky drawing of Leonora Portnoff are interspersed among works by Henri Matisse and Axel Salto in the red-toned library, a gallery of masterful works that would be at home in any museum.

One of the first pieces Shapiro owned is a small Ashanti sculpture that now sits in the front hall, a gift from his father when Shapiro was a child. Shapiro would later develop an interest in Southeast Asian art during two years spent in India with the Peace Corps in the mid-1960s, a time when he decided to become an artist rather than pursue medicine. His interest persists today, and there are several fine examples of Southeast Asian sculptures throughout the apartment, such as an eleventh-century statue from Uttar Pradesh of a Buddhist deva intertwined with a Hindu deity, as well as a prized tenth-century North Indian sandstone sculpture of a male figure that sits in the dining room. Shapiro says that it was the emotive powers of these types of sculptures that he then tried to channel into his own sculpture "to convey the intensity of the psychological states."

Shapiro has recently been spending time studying a Joan Miró etching from his 1938 Black and Red series that hangs over his desk next to an equally compelling Robert Rauschenberg collage and a Lucian Freud etching of a man's head. Made in reference to the Spanish Civil War, the Miró is an energetic display of red and black biomorphic figures accented by crescents and calligraphic swirls. Shapiro, who is also an accomplished printmaker, marvels at the work, describing in technical detail how Miró superimposed two plates—one red, one black—to create a final piece that is greater than its parts, adding that

it has "an intense, brilliant vitality that is radical and yet so simple, and also profoundly human and engaging."

Many of the couple's friends are represented in their vast collection, an assembly of some of the most important artists of the late twentieth century. A Jasper Johns grisaille crosshatched silkscreen from 1977 greets visitors in the entryway, and several Elizabeth Murray watercolors line the study. Two major works by Richard Artschwager—a large oil painting and a wooden-cross sculpture that Phelan appreciates for the artist's use of "illusionary space"—hang in the second-floor hallway. And in the dining room, a sizable Julian Schnabel collage is juxtaposed with two other Gorkys, including a brush, pen, and ink drawing from 1932 to 1934 titled *Column with Objects*.

An oversize portrait of their friend, silkscreen printer Hiroshi Kawanishi, painted by another friend, Alex Katz, commands over the dining table. In the image, Kawanishi is foregrounded, almost expressionless in a suit and tie, against a nightscape of illuminated city buildings. As in much of Katz's work, the painting's simple lines and composition seem to capture the subject's essence with ease. Phelan admires the painting's flatness and organization and the way Katz can visually describe a person and place with a sparse, minimalist style. Shapiro agrees: "It has a simplicity and at the same time complexity; it's not elaborately fussed with. He's just so modern."

This is a home for artists who are interested in what other artists have to say and think and who don't take the subject lightly. In fact, Shapiro could be talking about the Soutine or the "profound" Jean Arp collage in the living room when he says, "Artists tend to collect work that is essential regarding the understanding of the entire process. That it be a masterpiece or not, beautiful or not, does not seem like relevant criteria as long as the work is about discovery. It's a privilege to live with art."

Ellen Phelan and Joel Shapiro in their dining room, in front of a 1981 collage by Julian Schnabel.

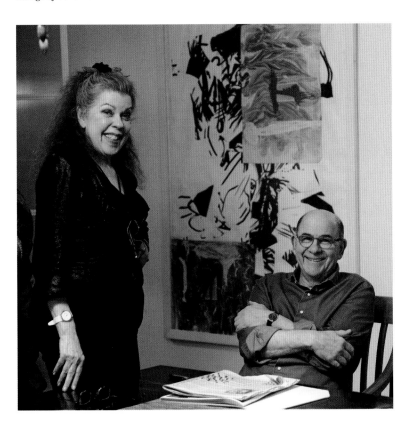

The duplex's red-toned library. *Khorkom* (1933–36) by Arshile Gorky holds a place of honor over the fireplace, flanked by Henri Matisse's drawing *Portrait de Femme* (1921–27) to the right and Gorky's *Portrait of Leonora Portnoff* (1938–40) on an adjoining wall. A 1979 charcoal drawing by Elizabeth Murray is on the wall to the left of the fireplace. Ceramic works by Axel Salto appear on either side of the fireplace.

Ellen Phelan / Joel Shapiro

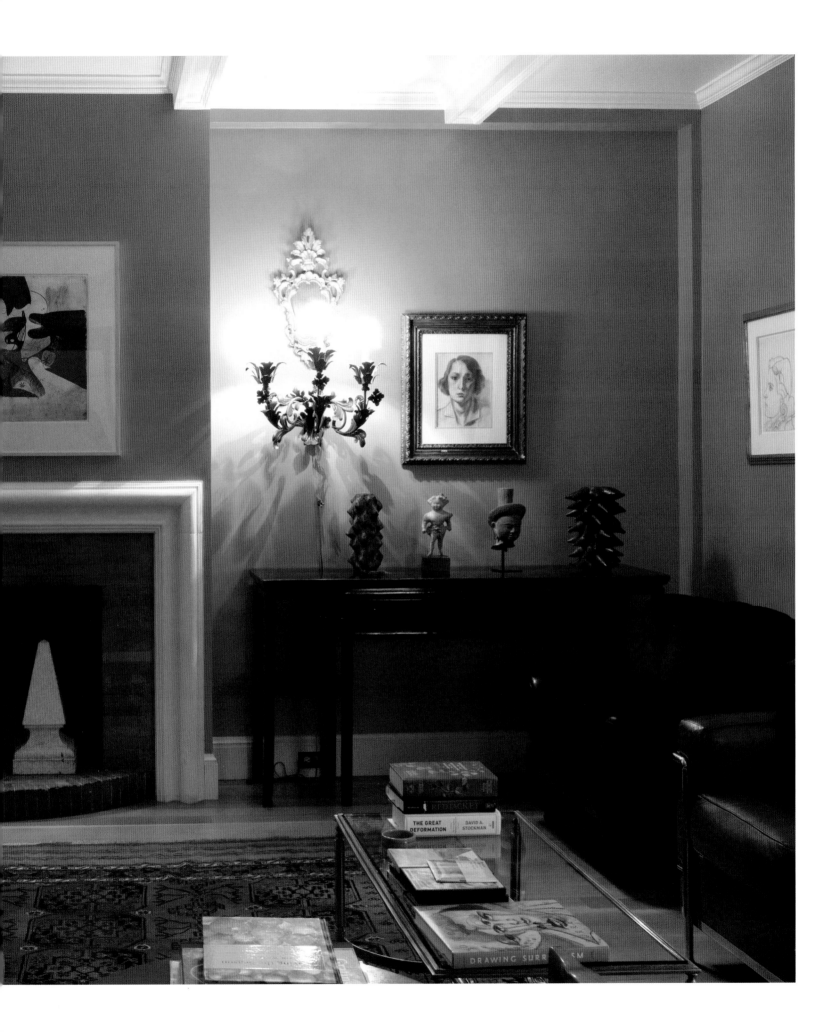

Left: *Dutch Wives I*, a 1977 Jasper Johns silkscreen, stands in the entryway.

Right: Edgar Degas's *Study of Dancers*, circa 1896, lies propped on a bedroom sofa. Above is a 1943 untitled oil painting by Arshile Gorky centered among works by Martha Diamond on the top left, John Torreano on the bottom left, and a Walter Gay watercolor.

Ellen Phelan / Joel Shapiro

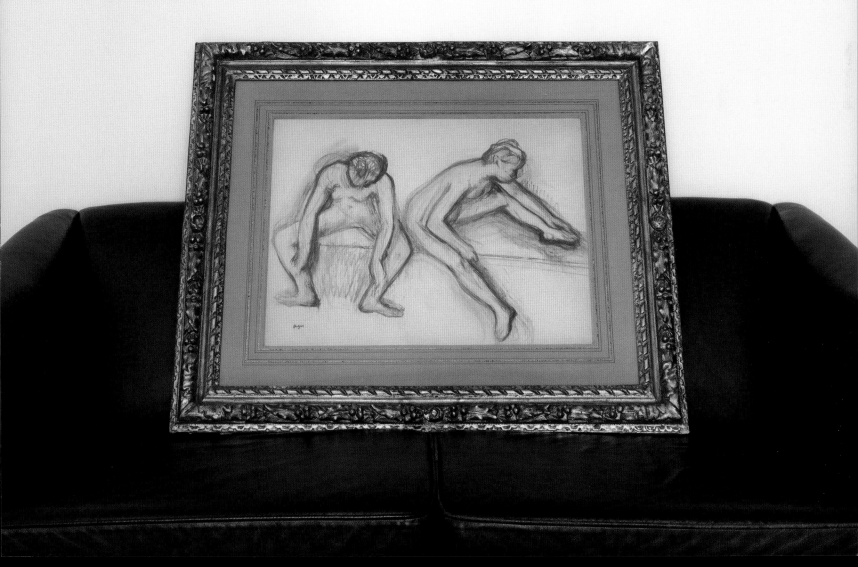

Alex Katz's 1981 portrait of silkscreen printer and publisher Hiroshi Kawanishi dominates the dining room. To the left is a 1936 untitled Gorky ink drawing, and to the right is a tenth-century North Indian sandstone male figure.

Ellen Phelan / Joel Shapiro

Above: Near the fireplace, a 1998 gouache by Sol LeWitt plays off the shapes of a sculpture from New Guinea. Several hand axes from Shapiro's collection are visible on the mantelpiece.

Opposite: Chaim Soutine's *Le Lapin* (1926), mounted above the fireplace in the couple's bedroom.

Ellen Phelan / Joel Shapiro

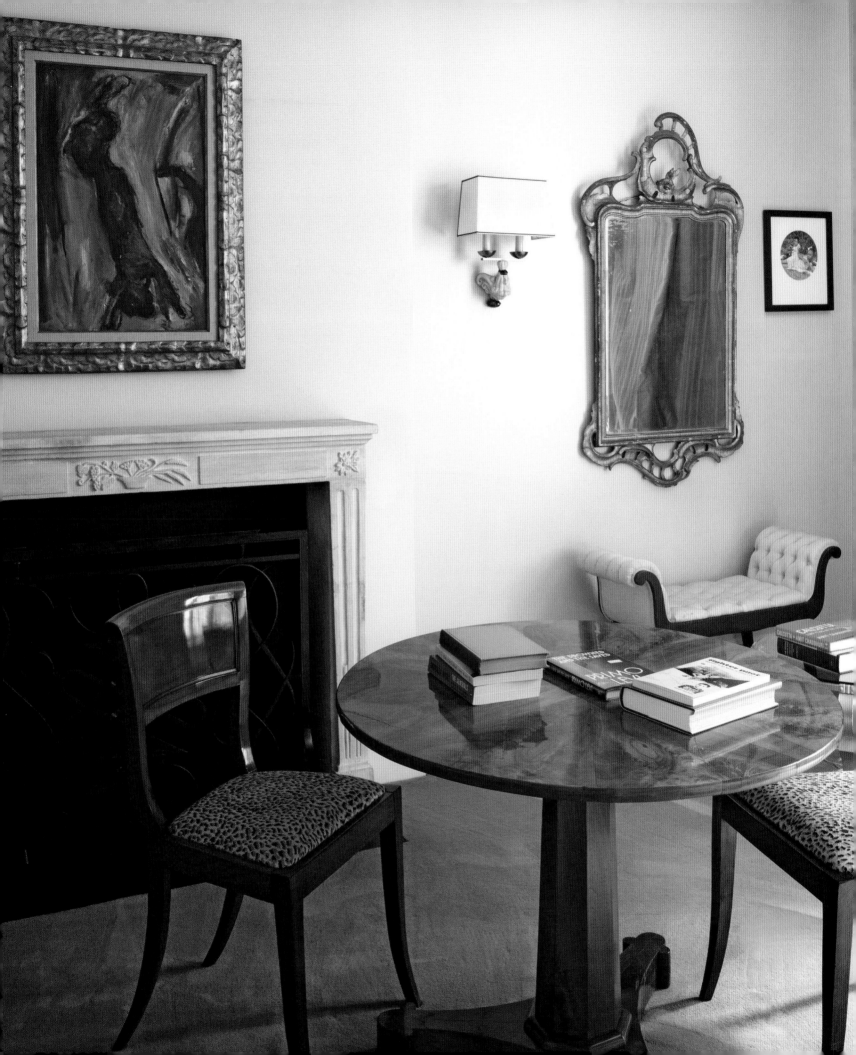

UGO
—
RONDINONE

A stained-glass window, designed by Urs Fischer in 2001, faces the living room on one side and the bathroom on the other in Ugo Rondinone's Harlem apartment. To the left is *Coronation*, Verne Dawson's 2004 small landscape painting. The chair is also by Fischer.

Ugo Rondinone lives on the second floor of a former Baptist church in Harlem, an apartment resplendent with stained-glass windows, fleur-de-lis ornamentation, and ornate, filigreed chandeliers dangling from forty-foot ceilings.

The 15,500-square-foot church, which Rondinone bought and restored in 2011, is an appropriately imaginative milieu for an artist as renowned for his fantastical artworks as he is for his productivity. And the church is more than a home: Rondinone has dedicated the double-height, former congregational space to his private studio, while the basement houses smaller studios for a rotating cast of visiting artists.

Rondinone works in nearly every form of media imaginable, producing subjects ranging in size, shape, and subject matter from oversize neon rainbow signs (with tongue-in-cheek, bubble-lettered mottos such as *Hell, Yes* (2007) on the roof of New York's New Museum of Contemporary Art) to small, delicate bronze birds; life-size painted-aluminum olive trees; round paintings of multicolored target circles; mystical face masks; and even a set of 30,000-pound primitive stone figures that once presided over Rockefeller Center. Though the aesthetics of his work vary greatly, there is an underlying sense of fantasy that is also felt the moment one enters the monumental limestone church.

"It's important for me to have art around me. I consider artists a magical tool, so they empower me," says Rondinone, who began collecting Swiss artists in the early 1990s before broadening his focus.

Among an edition of Paul Thek etchings framed in individual yellow plexiglass boxes, Cady Noland aluminum silkscreens, and an early black fiberglass wall relief by Peter Halley are some of his own works with particular personal significance. Rondinone has kept the first works from several of his series; his first olive tree, this one in polyester, stands in the living room, while his first mask and first bird sculpture appear in his bedroom.

Brightly painted rocks, models for future larger sculptures, dot the dining table that he himself crafted. "I use all the romantic symbols of nature. Nature is a big part of my work," says Rondinone, whose first works were landscape drawings. "I like the force of nature." To that point, he has lined an entire bookshelf in the kitchen with his collection of scholars' rocks that have also inspired some of his own sculpture. And though they are not currently hanging (Rondinone loves to adjust his art),

Ugo Rondinone in his studio.

Ugo Rondinone

he also owns approximately twenty paintings by the landscape artist Louis Eilshemius, a nineteenth- to twentieth-century painter. "He's really the only American romantic—that is a sweet spot for me," Rondinone says.

Rondinone is friends with many of the artists he collects and trades with and has a curator's eye for display. In fact, he has organized several internationally acclaimed exhibitions and also curates an ongoing window gallery near his former downtown studio where he highlights artists in his collection. One artist he's included is Latifa Echakhch, a Moroccan artist whose rug with its center disemboweled so that only the outline remains hangs near the fireplace and "creates an emptiness around" that resonates with Rondinone. And while he acknowledges that he finds a connection with Swiss artists, there are other elements Rondinone seeks when trading or buying art.

"Most of these artists create their own little world; they create their own iconography," he explains. "And most of these artists are not studio artists; they do not have a big operation. That's what I like."

Upon closer inspection, a green and white stained-glass pane—echoing not only the room's stained-glass windows but also the stained-glass clocks that Rondinone has installed next to the door of his bedroom—reveals a toilet and sink in the foreground. Designed by fellow Swiss artist and friend Urs Fischer, the image is an exact replica of Rondinone's bathroom in his former apartment and Rondinone thought it only appropriate to move it uptown. Rondinone also owns a Fischer sculpture of two rabbits being pulled out of matching top hats by a pair of suspended hands, as well as several Parkett book editions Fischer designed that sit on the coffee table.

Rondinone has explored the masculine/feminine divide in his work, a dichotomy that has also informed the art he has collected. When asked to explain how, he says with a smile, "Just in the Freudian stuff," indicating Cady Noland's rubber tire penetrated by a steel pole sitting beside Sarah Lucas's provocative pink rubber phallus, *Obodaddy II*. There's also a little landscape by Verne Dawson that Rondinone admires for its fairy-tale aspects, pointing out the crux of the story: A prince is depicted copulating with his horse so that he can be coronated.

Rondinone is deeply indebted to the teaching of the Austrian sculptor Bruno Gironcoli, explaining that Gironcoli "was interested in similar questions about the human condition. He always made a juxtaposition between hard-edged forms and very soft forms to represent masculinity and femininity." Two early abstract metallic sculptures by Gironcoli are prominently displayed and also directly reflect this point—a silvered, concave ovoid hangs near the dining table, while a golden pipe-shaped form protrudes over the fireplace, the works deliberately placed to relate to each other. In his bedroom, Rondinone continues this gender exploration with rows of nude drawings by such stellar twentieth-century draftsmen as John Currin, Karen Kilimnik, John Copeland, Joe Brainard, and Andy Warhol. There is no pattern to this arrangement, he admits, apart from how the simple aesthetics of the various figures play off one another.

Rondinone maintains that every piece he owns is of equal importance, emphasizing that he has no intention of selling any of his artwork. "It is always uplifting to live with these works—they radiate this magical divide between the here and the other side," he says, standing in the middle of his own magical space. It is almost as if Rondinone sees the potential in every form, perhaps because he is so comfortable working in so many media; he is presently toying with the idea of incorporating a preexisting archway in his home into a sculpture of a sunrise. In a way, the church itself has provided Rondinone with enough space for his ever-expanding artistic pursuits.

Above: *Sigh, Sigh, Sherlock!*, a 2004 piece by Urs Fischer, sits on a table directly inside the apartment's front door.

Opposite: Latifa Echakhch's cutout rug *Frame* (2012) is in full view above Rondinone's desk. Painted rocks—models for larger sculptures—dot the dining table, while the first olive tree Rondinone ever cast, in 1997, is in the foreground. A sculpture by Bruno Gironcoli protrudes from the fireplace.

Following spread: Paul Thek's series of etchings that Rondinone framed in yellow plexiglass is lined up under the oversize stained-glass windows of the living room. The chairs are by Franz West, while Rondinone himself made the dining table.

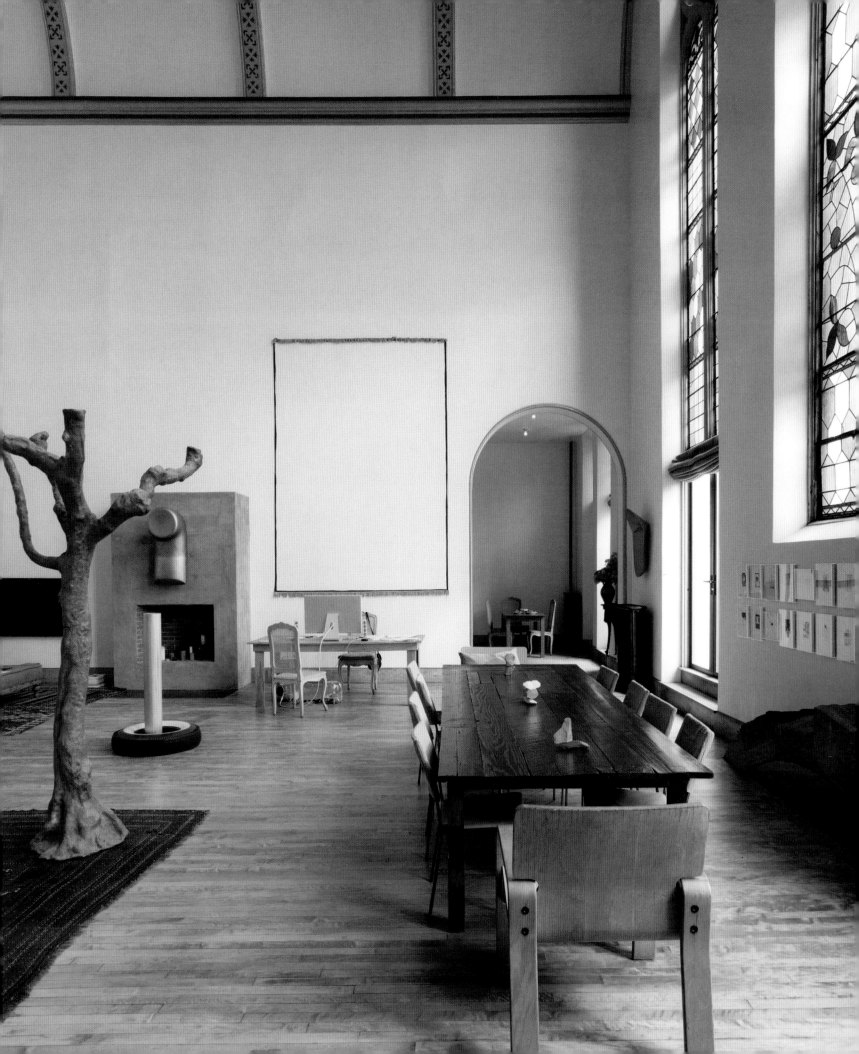

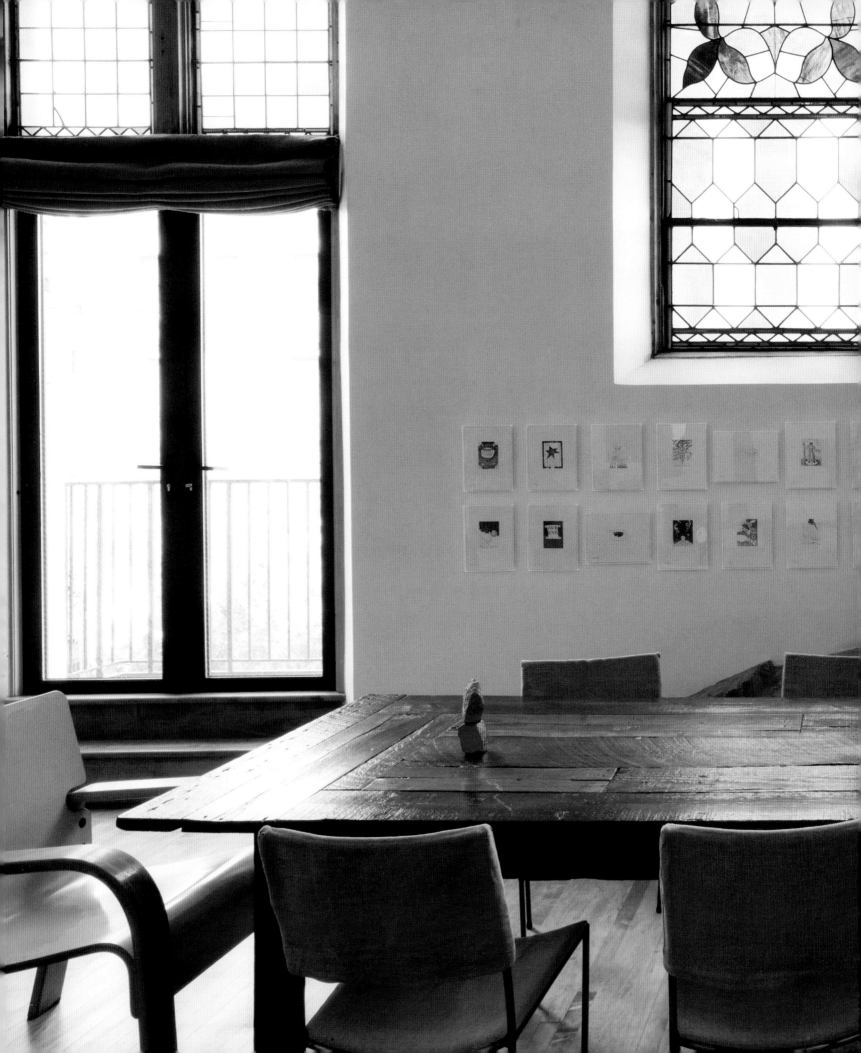

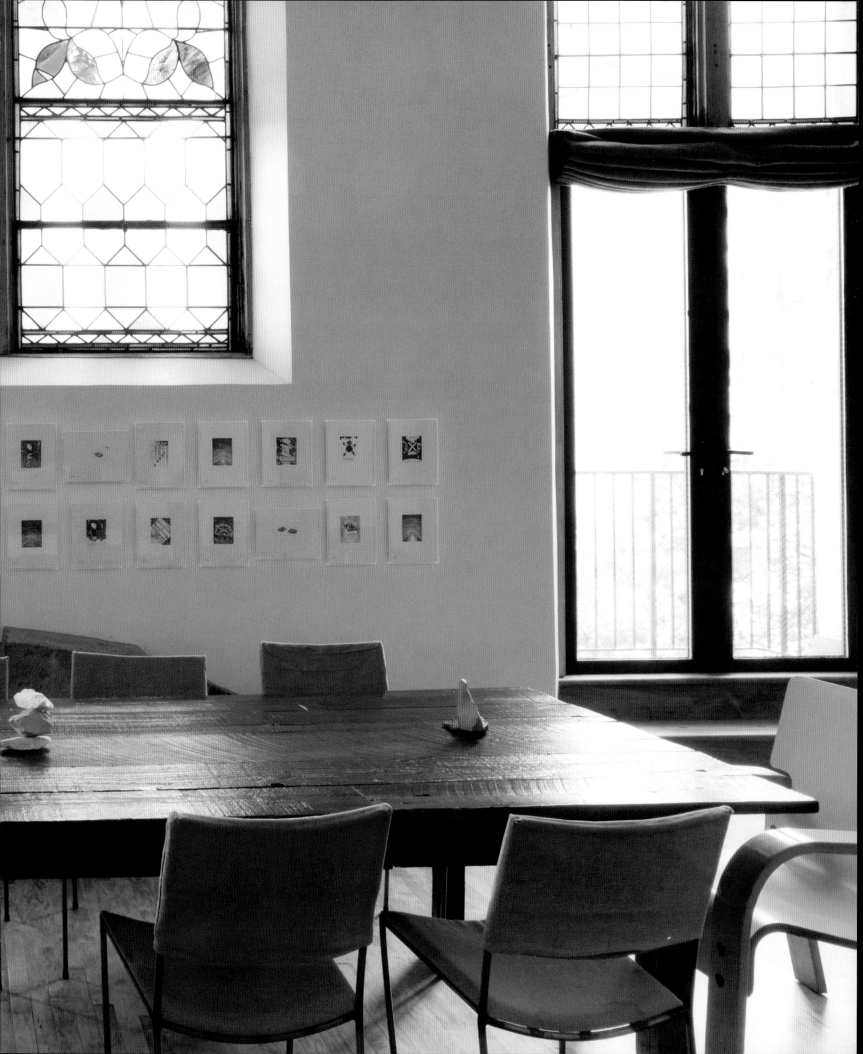

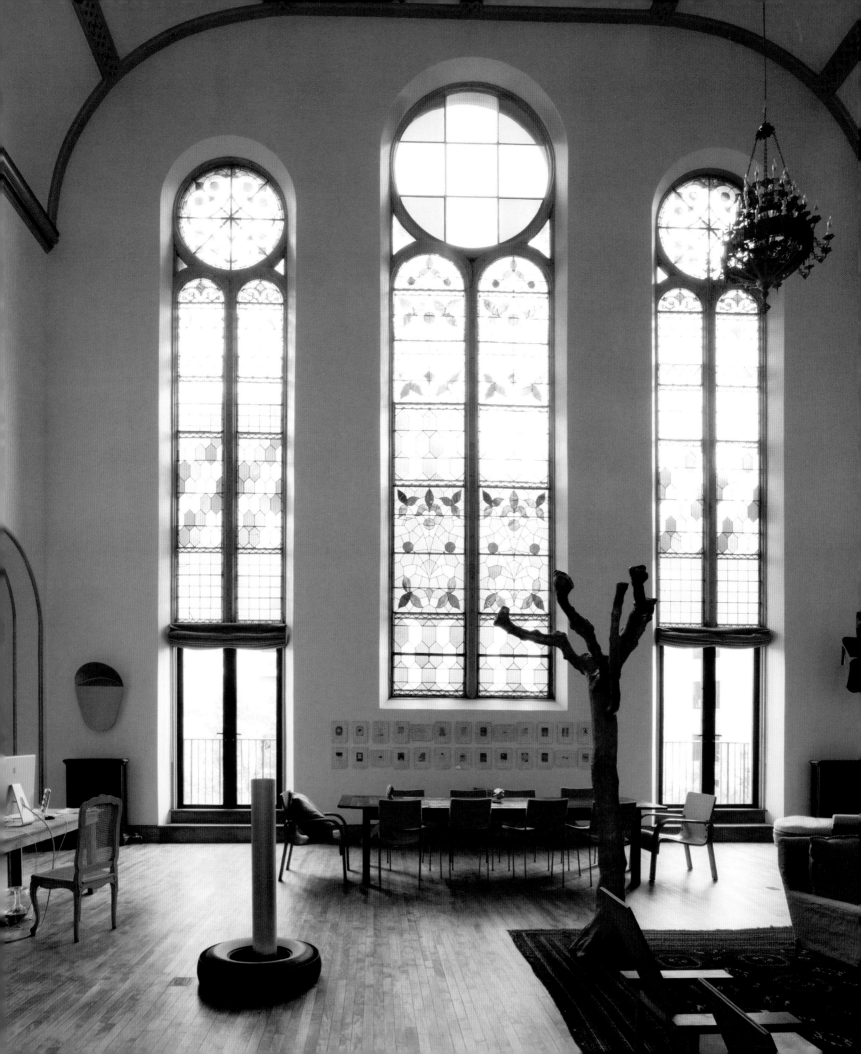

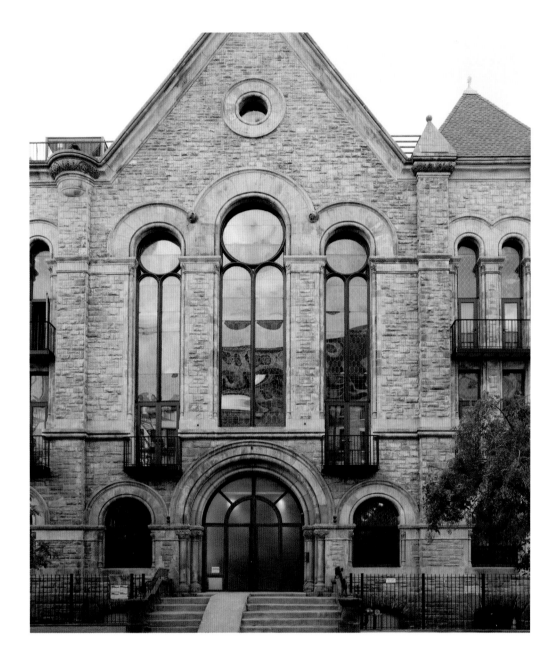

Opposite: A different view
of the living room. The
chairs are by Gerrit Rietveld.
"The space turned out better
than I envisioned it," says
Rondinone. "It is almost
a square space; it is very easy
to install in a square space."

Right: The exterior of the
15,500-square-foot church
in Harlem.

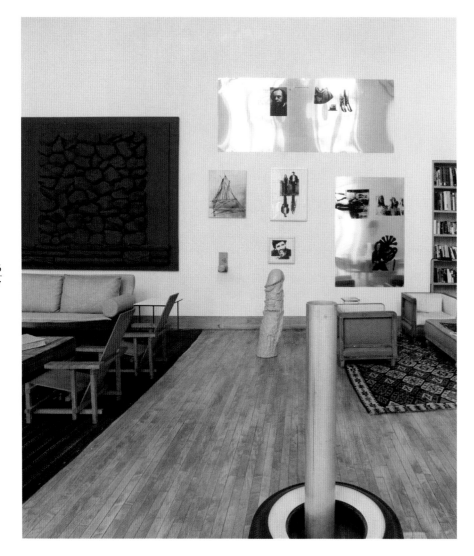

Above left: Cady Noland's
tire sculpture (1997-98) is
coupled with Sarah Lucas's
pink phallus, *Obodaddy II*
(2010). On the left is Peter
Halley's 1990 wall relief
Stacked Rocks, alongside
two aluminum newsprints
by Noland from 1989 and
1990. Sarah Lucas's sculp-
ture *Michael* (1999) is the
arm that appears to spring
out of the wall.

Above: A kitchen book-
shelf houses a selection
of Rondinone's scholars'
rocks. "They inspire me,"
says Rondinone, who
enlarged seventeen into
sculptures, five of which
were shown outside the
Art Institute of Chicago in
2013-14.

Opposite: A 2006 Valentin
Carron cross, which
Rondinone calls "a bit of a
mock," hangs above his bed,
while a montage of nudes,
including work by John
Currin, Karen Kilimnik,
and Andy Warhol, fills the
adjacent wall. "You see the
masculine and the feminine
here," explains Rondinone
about his considered
arrangement.

Ugo Rondinone

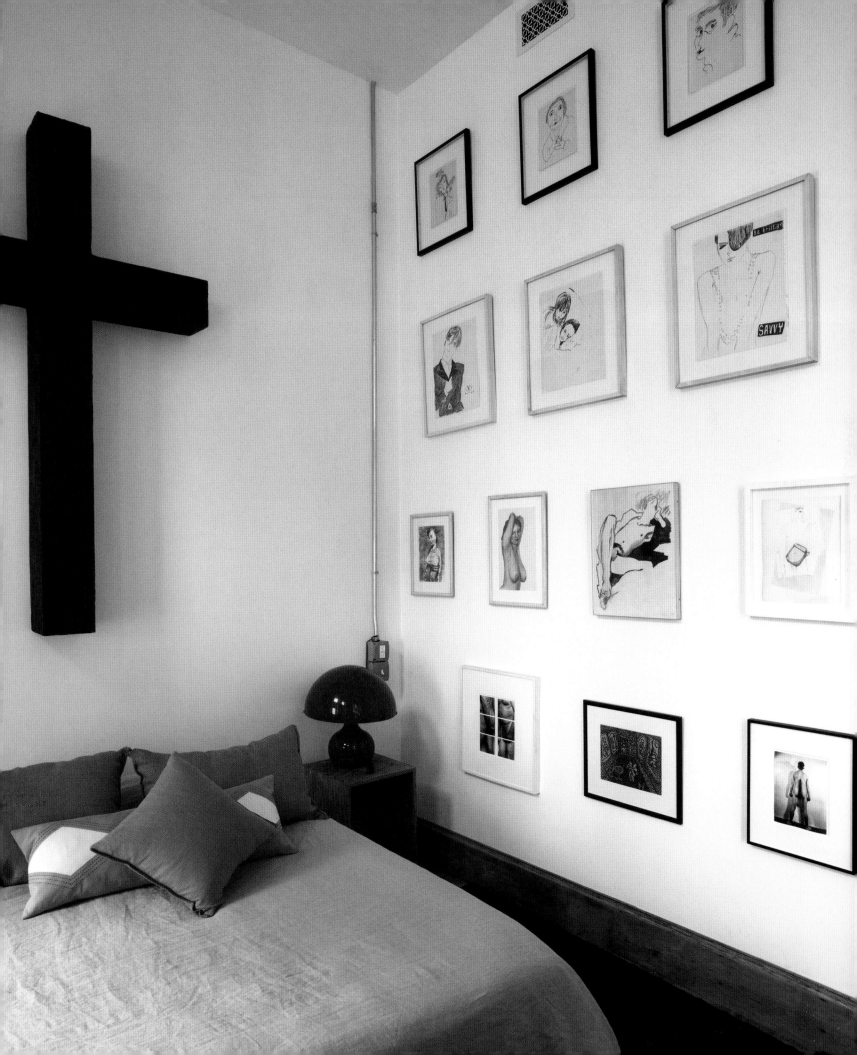

ANDRES
—
SERRANO

A seventeenth-century Spanish sculpture of the head of St. John the Baptist lies on a fifteenth-century Alpine cabinet in the entryway of Andres Serrano's Greenwich Village apartment.

Andres Serrano at home.

A standard-issue, plain gray metal door greets visitors at the entrance to photographer Andres Serrano's Greenwich Village home. But the other side of the door has a decidedly different look: Serrano has meticulously veneered a seventeenth-century carved oak door onto the inside door facing his living room—a fitting introduction to a home that showcases his extensive collection of sixteenth- and seventeenth-century European religious art, furniture, and icons.

"I felt like I had a collection that had a certain amount of age, and I wanted to renovate in order to bring in that age," he says of the broader aesthetic of the home. So Serrano lined the interior walls with pearly Jerusalem limestone, installed heavy oak paneling and floors, and covered arched doorways with Spanish and Portuguese tiles so that the apartment perfectly reflects a very distinct, Old World aesthetic. The result is a peaceful, serene space, not unlike the churches he likes to visit on his frequent trips to Europe.

Serrano's palpable love of and interest in religious objects may come as a surprise to those who remember the controversy and protests surrounding his 1987 photograph *Piss Christ*, a color-infused display of a plastic crucifix submerged in urine. The work became a rallying point for conservatives opposing what they saw as the desecration of religious iconography in contemporary art.

The juxtaposition of beautiful imagery with controversial subjects is central to Serrano's work, and his graceful, even exquisite, rendering of troubling motifs, such as the anonymous dead bodies in his 1992 Morgue series, can be disquieting. Yet Serrano explains and defends his long-held Christian beliefs. "The religious in my work is an homage to the church, and it's using the aesthetics and language of the church. Because I am an artist who is not that simple, the work has to be layered, it has to have the edge and uncertainty of great art. You don't know what it really means. I've always said that my work is a mirror and you see what you want to see in it." In fact, his 1990 series of the Ku Klux Klan stems from an interest in the transformative ritual of wearing a robe, whether on a Klansman, nun, or priest.

A self-described obsessive collector, Serrano travels constantly, visiting local auction houses and antiques stores and will even scour basements and track down elusive owners of seldom-opened shops in search of new treasures. Though he started collecting art deco pieces twenty-five years ago, he

Andres Serrano

eventually turned his focus to the medieval and Renaissance periods—nothing later than the seventeenth century, because, as he explains, this era pleases him aesthetically. "The Renaissance is the period of highest achievement and civilization in terms of art and culture, so I feel like you can't go wrong. It feels right to me."

A large, wooden crucified Christ, which, according to Serrano, is sixteenth-century French—"I have to trust the auction house research," he laughs—dominates one living room wall. The figure is hung high, as if over an altar, opposite a seventeenth-century Gothic-style bishop's chair. The tall chair back is indicative of the bishop's importance, says Serrano, and he has installed a neo-Gothic carved canopy on top, simply because he thinks that the two pieces complement each other. Next to the canopied chair, a seventeenth-century Spanish provincial giltwood Madonna and Child sculpture is mounted, also above eye level—one of many Madonna and Child icons Serrano has displayed in the apartment.

Serrano doesn't limit himself solely to religious objects, however. Secular furniture, which he admires for its masculine look and well-patinaed wood, has also caught his eye over the years and integrates easily with the religious pieces. Curated groupings of objects appear on the surfaces of this furniture throughout the apartment. One oak cabinet features seventeenth-century French real estate ledgers, their ruffled pages full of handwritten notations, set among antique skulls, while a French iron box and giant heavy brass candlesticks top another oak cabinet.

Toward the back window of the living room, four antique 4x5 and 8x10 large-format cameras sit atop the photographer's seventeenth-century Italian cassone (or trunk) intricately carved with flowers. "I've actually been thinking about trying to use them," he notes of the cameras. Serrano can discuss with authority how, over time, the cassone evolved into the cassapanca, a bench-like form, which then developed into the modern-day sofa—a perfect example of which stands under the sixteenth-century Christ figure. Both furniture forms traditionally hide storage space underneath, which Serrano utilizes, so the apartment remains clean and nearly empty, allowing the grandeur of his pieces to fill the room.

"The collection is meant to be used, and I use everything, even sculptures. If you buy it, you can touch it. Dealers explained to me that these sculptures were touched, and sometimes you see where people have touched them the most, like Christ's feet," says Serrano.

Serrano spotted the seventeenth-century walnut cassapanca partly hidden under a rug at the home of neighborhood dealer Maurice Margolis; legend has it that Mikhail Baryshnikov had originally been interested but they couldn't agree on the price. Stories are behind many of Serrano's pieces, such as the throne-like chair that he bought in southern England when on assignment photographing Alexander McQueen, or the full-length gilt mirror in the upstairs bathroom, unearthed the last time Serrano was in Belgium for a gallery show. "I never know what I am going to find. Sometimes I think, 'Oh, I know why I came to this place—it wasn't for this show, it was to find this so I feel like I have a piece of that place.'"

Serrano sleeps in an enormous Charles I four-poster canopy bed that he bought, sight unseen, through Christie's auction house in London three years ago, after a heated and competitive auction. Despite a figure of a Spanish monk that peers out from the wall next to the bed, the basement bedroom is, like the rest of the home, still and tranquil. In fact, Serrano describes sleeping in the seventeenth-century bed like "being in your own private box."

As a friend once commented to Serrano after visiting the apartment, "Your aesthetic is complete," referring to the quiet dignity of his home as well as to how he treats the subject matter in his photographs. "I try to make work that feels like you are there with the person [in the photograph], the way you can almost hear a pin drop, like in a church. Work that I feel has longevity and a classical element—that is why I feel at home with these objects, because they give me that very traditional feeling."

Following spread:
The main living area of Serrano's apartment, which he repaneled with salvaged wood from a nineteenth-century church in New Jersey. Among the objects are a fifteenth-century English throne chair (against the left wall), an early-seventeenth-century English oak draw leaf table, and an early-sixteenth-century Franco-Flemish marriage chest (against the back wall). "Anything that I put here usually does not look out of place, because it belongs to around the same period," says Serrano.

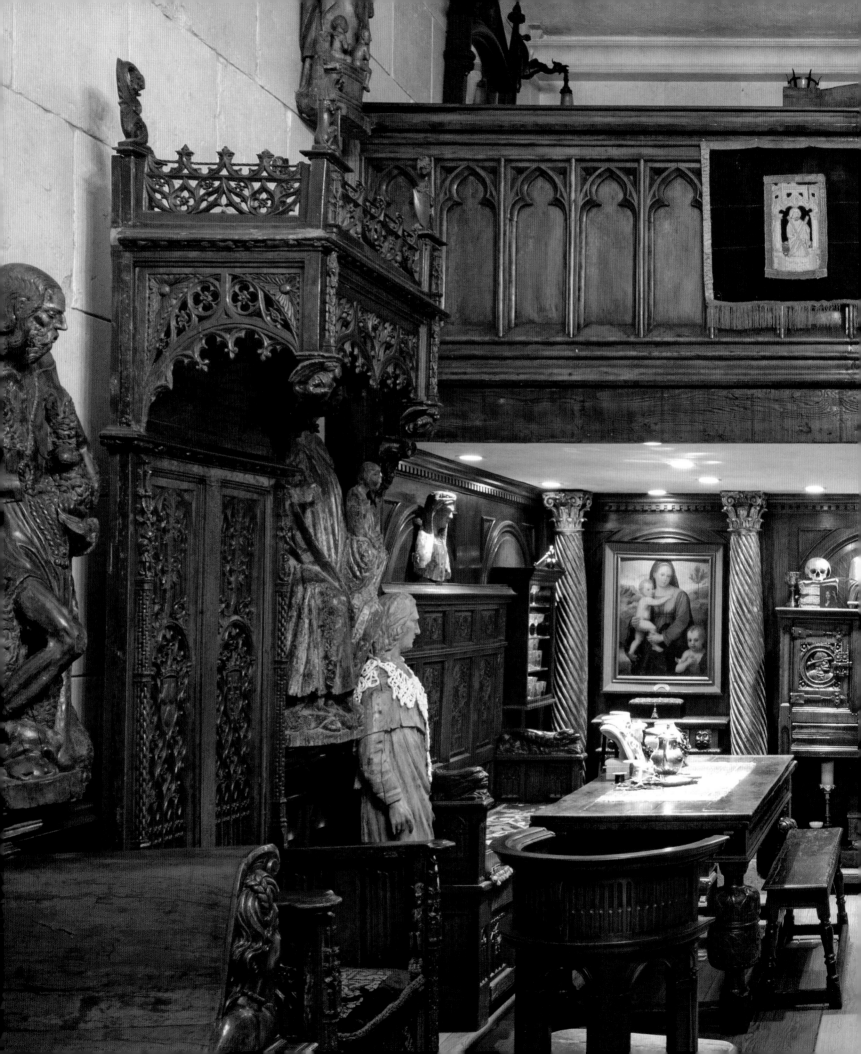

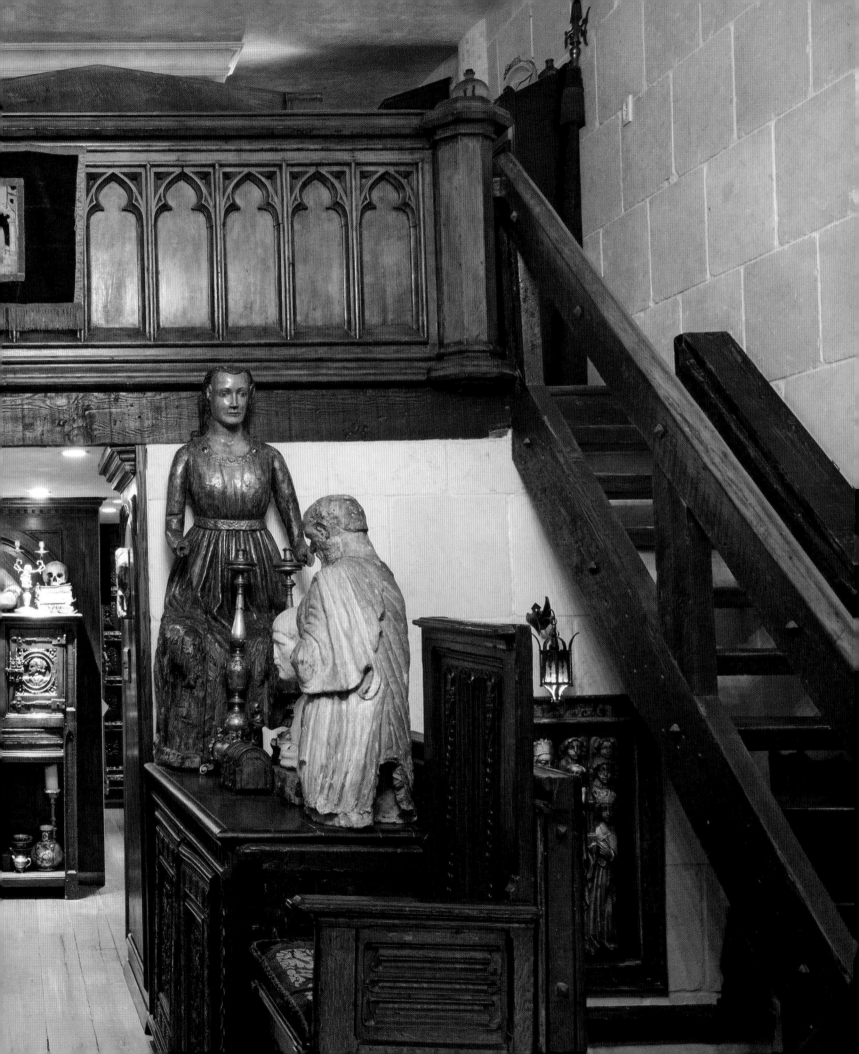

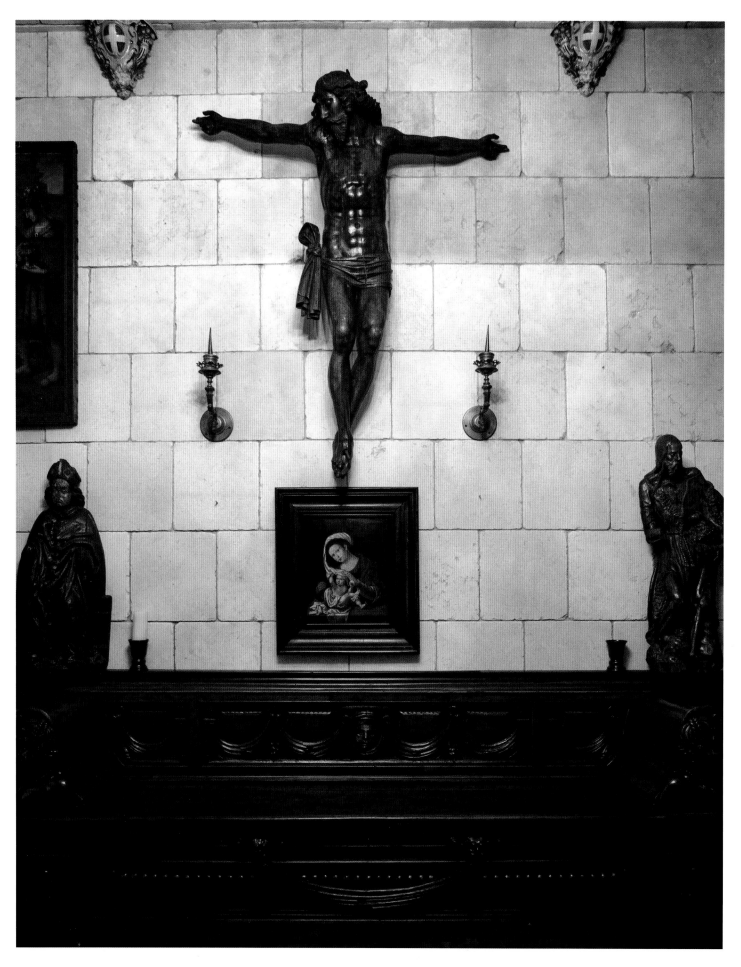

Andres Serrano

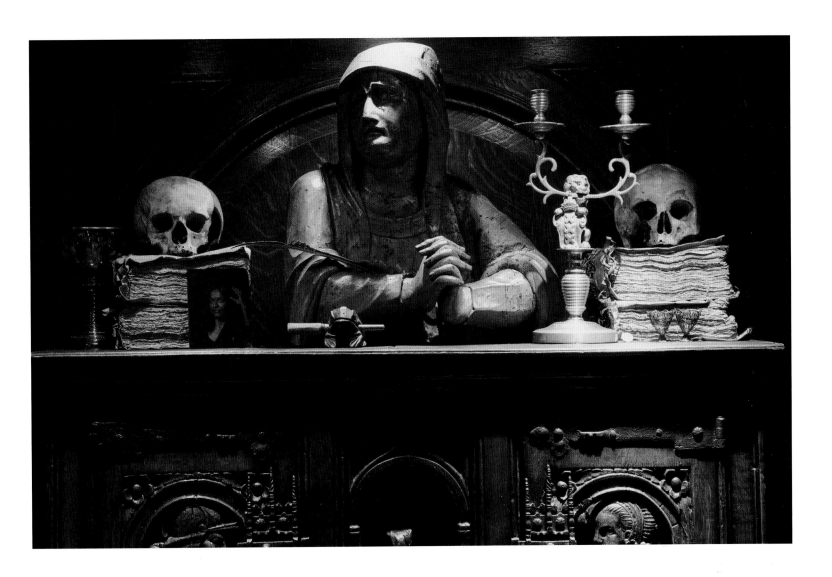

Opposite: A seventeenth-century Italian bench, known as a cassapanca, serves as extra seating for large gatherings. The suspended Christ figure is sixteenth-century French and looks over a fifteenth-century Spanish sculpture of St. John the Baptist holding a lamb (on the right) and a fifteenth-century religious painting.

Above: A seventeenth-century bust of a female saint sits on the marriage chest, among four seventeenth-century French real estate ledgers, accompanied by eighteenth-century skulls whose origins are unknown to Serrano.

Left: A Charles I oak
tester bed from the early
seventeenth-century that
Serrano bought at a com-
petitive auction. He says
sleeping in it is like "being
in your own private box."

Opposite: The reverse view
of Serrano's living space,
with a row of antique cam-
eras visible on top of
the seventeenth-century
Italian trunk, or cassone,
in front of the window.

Andres Serrano

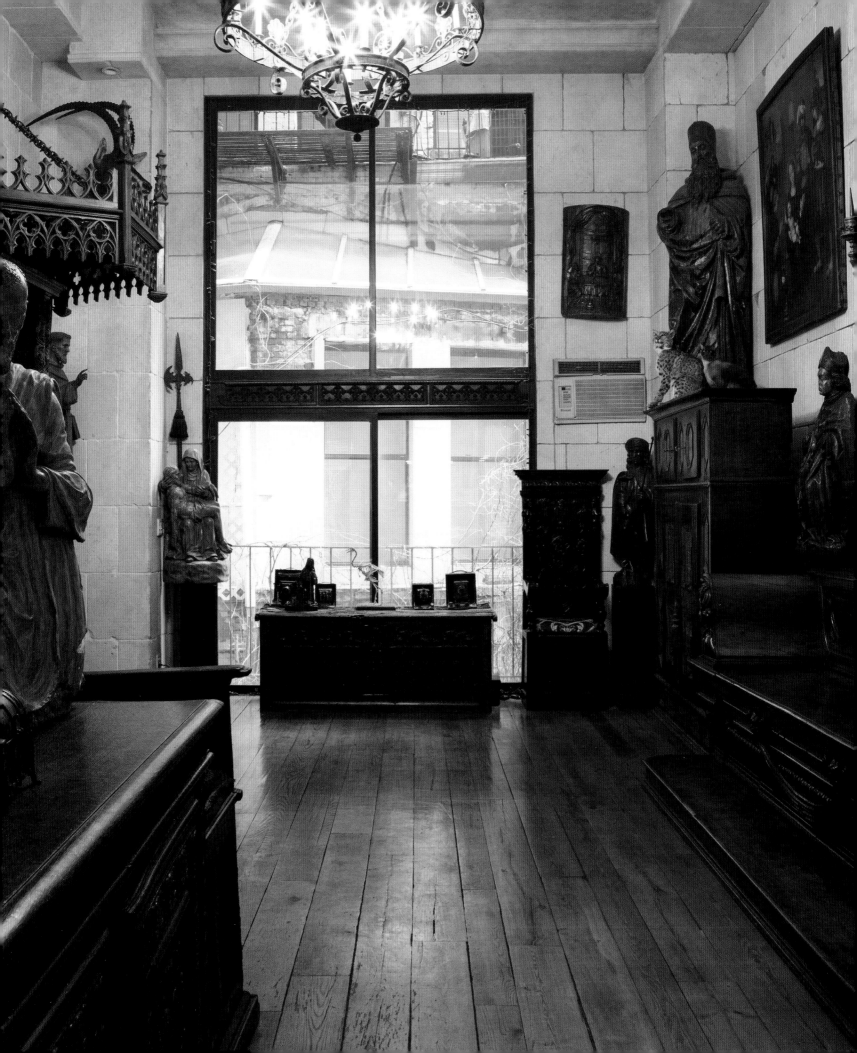

CINDY
—
SHERMAN

An arrangement of works by Ukrainian artist Sergey Zarva, originally discovered at a Moscow gallery, is installed in Cindy Sherman's dining area. To the left is a ceramic by Matthew Solomon.

Entering Cindy Sherman's duplex penthouse through her studio, where she tidily stores decades' worth of the clothing, wigs, and masks she's used to transform herself in photographs, you immediately notice that she enjoys living with the work of other artists. While her props fill the studio, it's the work of friends—Sarah Charlesworth, Robert Longo, Lisa Yuskavage—as well as outsider artists, ceramicists, and younger artists she admires, that fill her walls.

"I try to support smaller galleries and young, lesser-known artists. It's about how I relate to myself as a young artist," she explains, "feeling so excited when Chuck Close came to see an early show, or when someone bought something at a really early time. It just meant so much to me." In fact, a characteristic gridded self-portrait by Close, now a friend, hangs above a worktable in the studio.

Connected to the studio, a hall holds rows of shelves stacked with drawings and photographs. Describing the commonality of the works, Sherman notes: "There's texture, a mix of media. For a while I collected a lot of photography, which I tend to do more than painting. I relate to photographic images and recognizable things like that." Here, the work is primarily figurative but almost always distorted. A small de Kooning figure is arranged beside a prized nineteenth-century photograph of Comtesse de Castiglione, an aristocrat who commissioned more than four hundred portraits by Pierre-Louis Pierson of herself posing in elaborate costumes, reenacting roles taken from theater, literature, or her own imagination. Below, a 1976 black-and-white photograph by Laurie Simmons depicts the blurred face of a doll. Again, the figure is present but transformed.

This could be expected from an artist who has helped define the medium of photography and postmodernism by taking on various disguised and altered roles in her own images. Photography's exploration of the line between reality and fiction, and its ability to blur this separation, is central to Sherman's work, in which she plays the roles of set designer, costume director, makeup artist, model, and director. Beginning in 1977 with the immeasurably influential *Untitled Film Stills*, her appropriated personas probe questions of collective identity and culture. Diverse depictions of an array of 1940 to 1950s female film archetypes—a hitchhiker, femme fatale, and career woman—seem almost recognizable from their specific narratives but are not derived from existing motion pictures.

A newly purchased ceramic head by the Stockholm-based artist Klara Kristalova sits on a table in the hall under three mummified Barbies by E.V. Day. It's a delicately glazed, expertly rendered piece of a disturbingly oversize and misshapen form. Sherman began collecting ceramics about five years ago, initially with the work of Chicago-based Chris Garofalo, whom she discovered through a blurb in the *New York Times*. Garofalo's porcelain pieces resemble colorful sea anemones but are, in fact, creations of her own imagination. Their slightly surreal quality is enhanced by a visual fragility that contrasts with their sharp, spiky outgrowths. Once Sherman discovered them, she explains, "I ended up buying about twenty of them and putting them all over the house. I always feel as if I want to touch them and move them around. They are just so beautiful." Like sea creatures themselves, the works are installed on walls and surfaces, spilling out into the space around them.

Sherman has gone on to buy the work of other ceramicists, including both abstract and figurative works from the influential teacher Ken Tisa. One characteristic example depicts the head and upstretched arms of a white figure with a frightened expression, seemingly trapped in a delicate pot. She's also commissioned Matthew Solomon, whose botanical-inspired ceramics she owns, to make a new work for the fireplace in her bedroom.

In Sherman's bedroom, in front of a floor-to-ceiling window, a sculpture by Olaf Breuning takes center stage. Depending on the reading, it's either an angry-faced man walking a submissive, frightened dog, or two figures engaged in a sexual act. Constructed entirely of musical instruments purchased from the discount Chinatown store Pearl River, it employs bells, harmonicas, and guitar picks to depict the facial expressions of each character. Breuning's subtle manipulations clearly relay each character's divergent emotions, an effect that is both humorous and disturbing.

In certain cases, Sherman follows an artist for years before she purchases a work. By the time she visited a Nicole Eisenman exhibition, she wasn't able to buy one of the large canvases. "I have a bad habit of seeing things the day they are closing, or going the last week of the show," she comments ruefully. The portrait she eventually purchased depicts a man who has been blinded by pieces of what Sherman describes as "flowery things coming out of his eyeballs." The grassy pieces neutralize the portrait's frightening statement. Sherman continues: "It's kind of funny. It's like my sense of humor, a mash-up of things that are gross and

disgusting but humorous too. Like a horror movie that you just want to laugh at, but it's also disgusting."

Ukrainian artist Sergey Zarva is one of Sherman's favorite finds, and she has a wall of his paintings installed in the dining area. She was introduced to his work while visiting a Moscow gallery and later bought additional pieces at a New York art fair. When she purchased the work, she knew nothing about the artist, and she emphasizes that she knows little more now. Zarva paints over photographic images, distorting facial features with garish colors and expressions. Sherman's arrangement includes one from his series of magazine covers from *Ogoniok*, the long-running Russian publication.

Sherman's collection also extends into less conventional work, including shelves of children's toys, an installation of voodoo art, and many pieces by outsider artists. The materiality and humor in the work and a focus on altered bodies, no matter the medium, unite the wide-ranging collection. "Weird body parts, weird faces, weird hair portraits, weird characters, weird mixing up and mash-ups of the body" are what interest Sherman in art, a fitting draw for an artist who transforms herself so completely and convincingly in her own work.

Cindy Sherman in her studio among props and costumes from her work.

Following spread: An installation in Sherman's living room consists of, from top left, a work by John Hiltunen next to a small painting by Esther Pearl Watson, with James Welling's 2010 photograph below. To the right, a large black-and-white drawing of a buried man by Dana Schutz, *(Untitled) Dead Guy*, from 2003; Michele Abeles's print of an outstretched hand; and an exploding thread piece by Megan Whitmarsh. Another small Watson lives beside Martin Kippenberger's 1994 *O'Preis* painting. On the far right, the 1990 fabric piece *Double Flaccid Cat* by Mike Kelley sits above a second Welling photograph. On the top shelf are Chris Garofalo's ceramics, and on the left a piece by Ken Tisa.

Left: A misshapen ceramic head by Klara Kristalova, *Nosey* (2011), and the legs of three barely visible mummified Barbies by E.V. Day. To the left is Morton Bartlett's doll photograph, and to the right, an Urs Fischer table holding a Brie Ruais ceramic.

Opposite: Betsy Berne's 1996 painting *Dong Song* next to Otto Piene's 2011 glazed clay piece *The Golden Idaho*. Berne, a longtime friend of Sherman's, is now primarily a writer. Sherman bought the Piene at a benefit auction.

Cindy Sherman

Opposite: Leaning on shelves among dozens of works in Sherman's hall is a small sketch by Willem de Kooning next to a Pierre-Louis Pierson photograph of Virginia Oldoini, Comtesse de Castiglione. An aristocrat who commissioned more than four hundred portraits by Pierson, Oldoini would pose for photographs in elaborate costumes, assuming roles taken from theater, literature, and her own imagination. Below at left is Laurie Simmons's *Untitled (Woman's Head)* from 1976.

Right: Olaf Breuning's *We Only Play Around* (2005) is constructed from musical instruments purchased at the Chinatown store Pearl River.

Sherman has arranged an assemblage in her bedroom including, from left, a drawing of houses by her studio manager, Margaret Lee, and works by Alexander Ross, Paulina Olowska, Charles Long, and Wayne White. On the bottom row, from left, she's included artists Bruce Lieberman, Martha Rich, M. Henry Jones, and John Lurie. The sculpture of the vase with flowers is by Matthew Solomon.

Cindy Sherman

PAT
—
STEIR

Hanging prominently above the fireplace in Pat Steir's living area is John Cage's *Fire* (1985). Steir's studio assistant, Alexis Myre, is represented on the mantle with *Fall* (2011) and, above, *Chorus* (2009), the sculpture of upstretched legs. There are also examples of cubic pyrite from Spain that were once rearranged by sculptor Joel Shapiro during a dinner party.

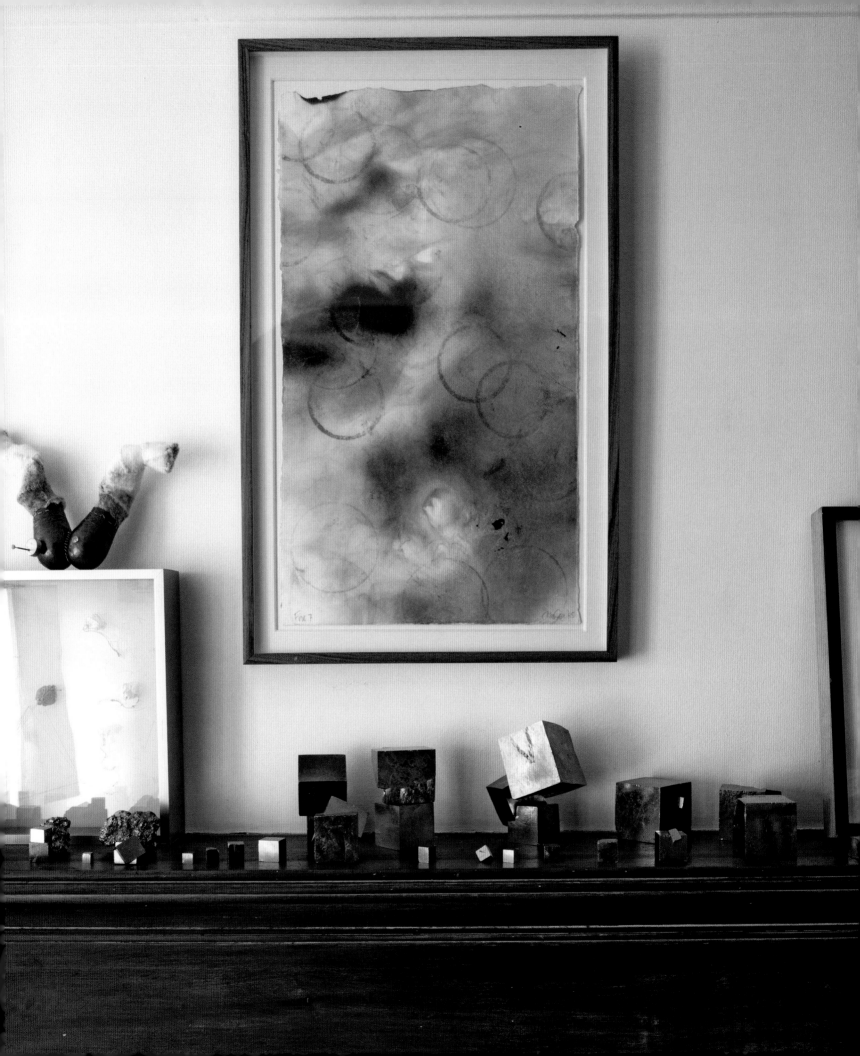

Pat Steir in her second-floor parlor in front of Sol LeWitt's wall drawing from August 1994.

Pat Steir, the revered painter of large, luminous, abstract canvases, lives in a handsome townhouse overlooking a communal garden with her husband, the publisher Joost Elffers. "I don't really collect," she says modestly. "I don't like to have too many things." Yet her Greenwich Village home is full of beautiful objects and artwork, a testament to both her visual acuity and her five-decade-long career as a painter very much at the forefront of her profession.

Best known for her waterfall paintings, a series of works begun in the late 1980s where she pours and drips paint onto a canvas from a stepladder above, Steir combines a conceptual approach with painterly gesture. "I picture it in my mind. I figure out my colors, the size of my pouring, my layers, and then I do it. I visualize and control it." The paint moves down the canvas, interacting with existing layers of paint and creating intentional and unintentional results.

The role of chance has played an important part in Steir's life, just as it has in her work. In 1968 an unexpected meeting led to a spontaneous but monumental change of course. "I was at a party with Bruce Nauman," she recounts. "Bruce said, 'I'm having a retrospective in Pasadena; do you want to come?' The next day I packed up the car and left."

What was intended to be a short visit was extended when John Baldessari invited her to speak at CalArts. "John had signs all over the building that said 'somewhat famous artist' giving a lecture," says Steir. The lecture was a success, and the school hired her to teach painting. She then agreed to housesit for the Naumans, where, she was told, another artist was also staying: Sol LeWitt, the influential conceptual artist, with whom she would have a lifelong friendship.

As a result, dozens of LeWitt's works from various points in his career appear throughout Steir's townhouse, including a very early piece from the late 1960s in her entryway: a triangle-shaped drawing with sinuous graphite lines framed by the artist himself. When Steir moved to the townhouse in 1993, LeWitt conceived one of his signature wall-size works as a gift—a large circle of tightly drawn white crayon scribbles on a bright yellow base—that now dominates her second-floor parlor, diffusing a warm light throughout the room.

Hanging on a nearby wall is another large-scale work by LeWitt that Steir admits is one of her favorites, a work on paper depicting dense white undulating lines on a dark blue

ground. "Sometimes I lie on the couch, and I try to figure out where he started," she says of the work. "I just like the way it looks."

Richard Tuttle also has a site-specific work in this room, a delicate tin piece resembling a leaf installed on a light-gray painted wall. It's an intimate gesture of thanks from Tuttle, who stayed with his wife at the townhouse when they moved to New York. In the same room, a glossy red contoured ceramic by Lynda Benglis sits among natural artifacts and a Kiki Smith twig sculpture on a table positioned below a painting by Steir's former student Ross Bleckner.

Steir refers to the special works of art that have been given to her as "love gifts"—such as Smith's etching of birds flying around a rising figure, which she discovered one day rolled up in her mailbox—and typically these offerings have stories, sometimes simple, sometimes dramatic. In her kitchen, several early Bernd and Hilla Becher photographs of industrial landscapes recall a 1978 trip to visit the couple in Düsseldorf. Steir was driving late at night, and, as she remembers: "I drove up on the wrong side of the autobahn, and Sol was screaming so loud, it was like white noise. A truck stopped this far away [she gestures about a foot] from us, facing us, and the police came, and they let us back onto the other side, and they didn't arrest me or even give me a ticket; they gave me a lecture." They continued on to their destination, and when Steir arrived, the couple gave her the photographs in an attempt to calm her down.

Steir notes that the groundbreaking composer, writer, and artist John Cage has had an immense impact on her work and became a close friend over time. Two of the only works she has purchased include his Fire prints, prime examples of Cage's method of indeterminacy. To create these pieces, the artist set fire to papers on a printing press in a method dictated by the *I Ching*, an ancient Chinese method of divination, which Steir describes as similar to dice throwing. This theory of randomness also greatly influenced Steir when she began her method of pouring paint.

"I was always interested in Chinese landscape and brushstroke painting, where the calligrapher would meditate on his poem and his brushstroke, and he would just sit until he was ready," Steir says. "He would eat and drink and sit and look at the paper, and suddenly he would get up and do his work. I emulate that process." She also credits Cage with her interest in Buddhism and meditation, both still important aspects in her practice.

One of Cage's prints hangs above a fireplace ledge that is lined with objects, including pyrite cubes that Joel Shapiro once rearranged while at a dinner party, a large meteorite, and works by her studio assistant Alexis Myre and John Newman.

Across the room, a Frank Gehry cardboard table holds sculptures from Japan and China, and ceramics by friends Mary Heilmann and Betty Woodman sit on other tabletops. Above the well-used sculptural sideboard hangs a tableau of works on paper, including an etching by Anish Kapoor, an early Josef Albers woodcut, a Robert Mangold collage, and a Stephen Mueller painting. There is also an etching by her friend of fifty-four years, fellow abstract painter Brice Marden. "I was like the girl who had a smart older brother with her," she says with a mischievous smile, recalling when she first socialized with Marden in college. "Now I think that my painting hanging with Brice's in the MoMA is like a feminist statement. But just as important, it's also an art statement; art is art."

Above: A 1988 print by
Anish Kapoor overlooks a
pot made by Hojin, a Zen
monastic, a George Ohr
ceramic, stones (including
gifts from Joan Jonas), two
Indian lingams, a piece of

meteorite, and mud balls
made by James Lee Byars,
Tom McEvilley, and Eric
Orr in Egypt. On the far
right is a 2003 sculpture by
Kiki Smith.

Opposite: Sol LeWitt's
*White Crayon Scribble Lines
on a Yellow Wall* installed
August 1994, was created
as a gift when Steir moved
to her townhouse. In front
is an array of fossil stones,
and on the left wall is a
wooden Dogon elephant
mask.

Pat Steir

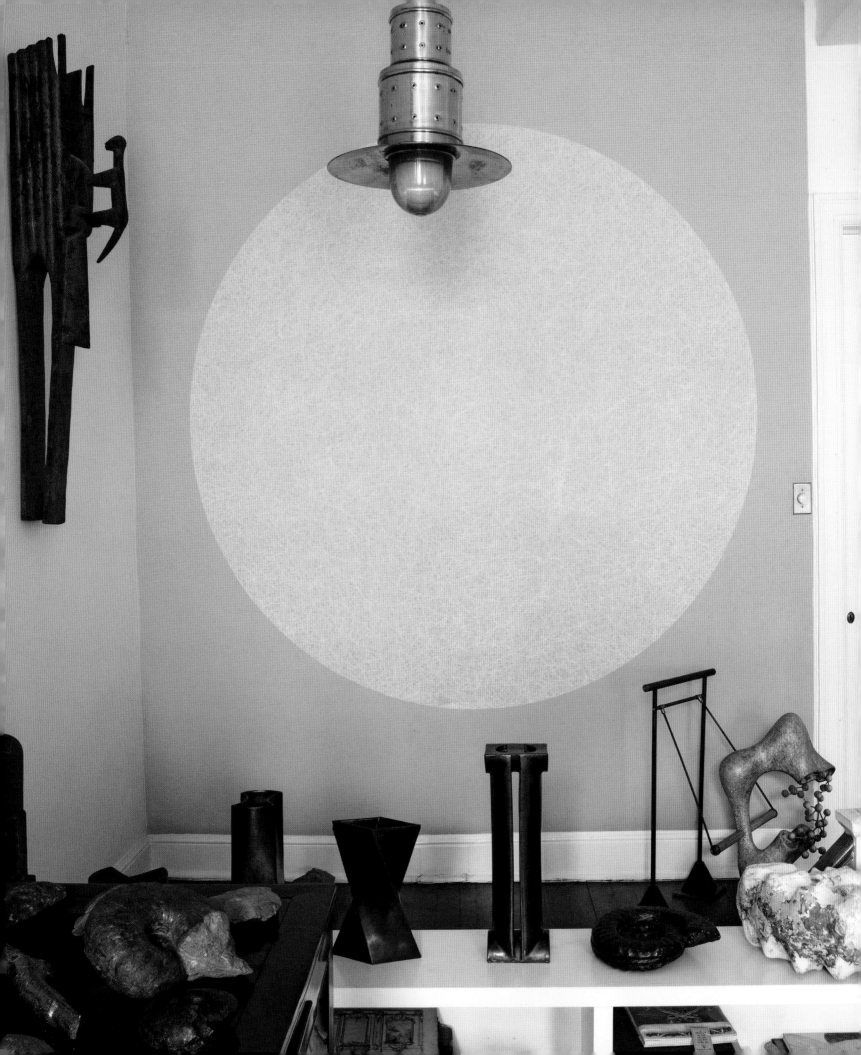

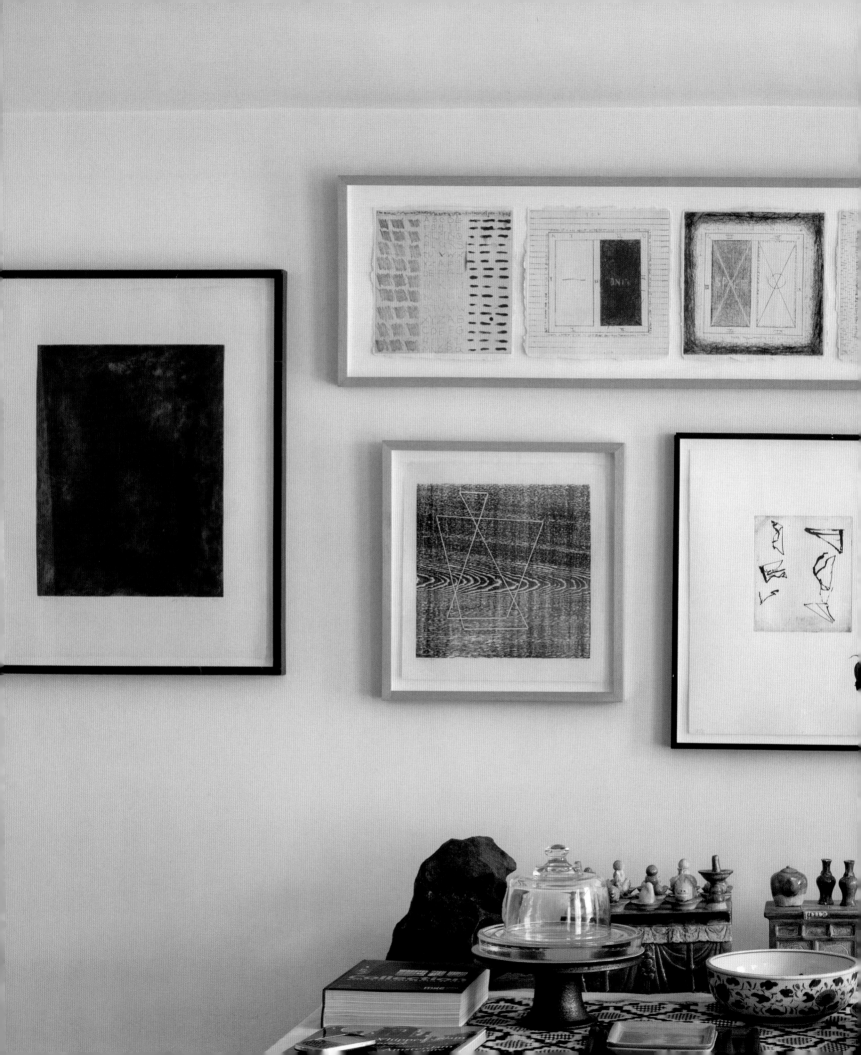

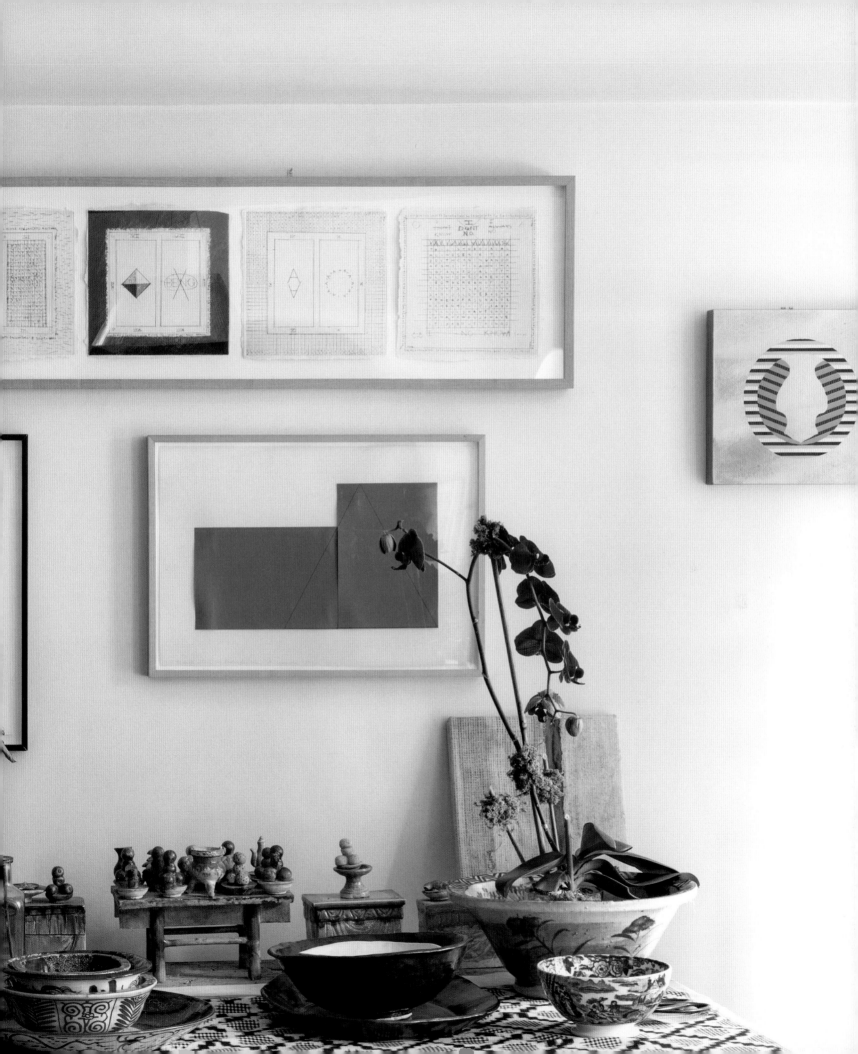

Left: A close-up of Richard Tuttle's *Peace and Time #3* (1993), composed of a delicate tin sculpture installed on a gray wall.

Opposite: A view of the second-floor parlor shows Richard Tuttle's installation and Betty Woodman's large ceramic *Winged Vase* (1989–90) on the window-sill. A small, ceramic Mary Heilmann tile is to the left of the mirror. Navajo rugs are thrown over the sofa, next to wooden furniture pieces from India, China, and Guatemala.

Previous spread: Above a Frank Gehry–designed cardboard table filled with Japanese and Chinese pottery, Steir has arranged a grouping that includes her 1974 print *The Burial Mound*, and below from left, an Anish Kapoor etching, a Josef Albers wood-cut, a 1986 Brice Marden etching, a 1977 Robert Mangold collage, and a Stephen Mueller painting.

Pat Steir

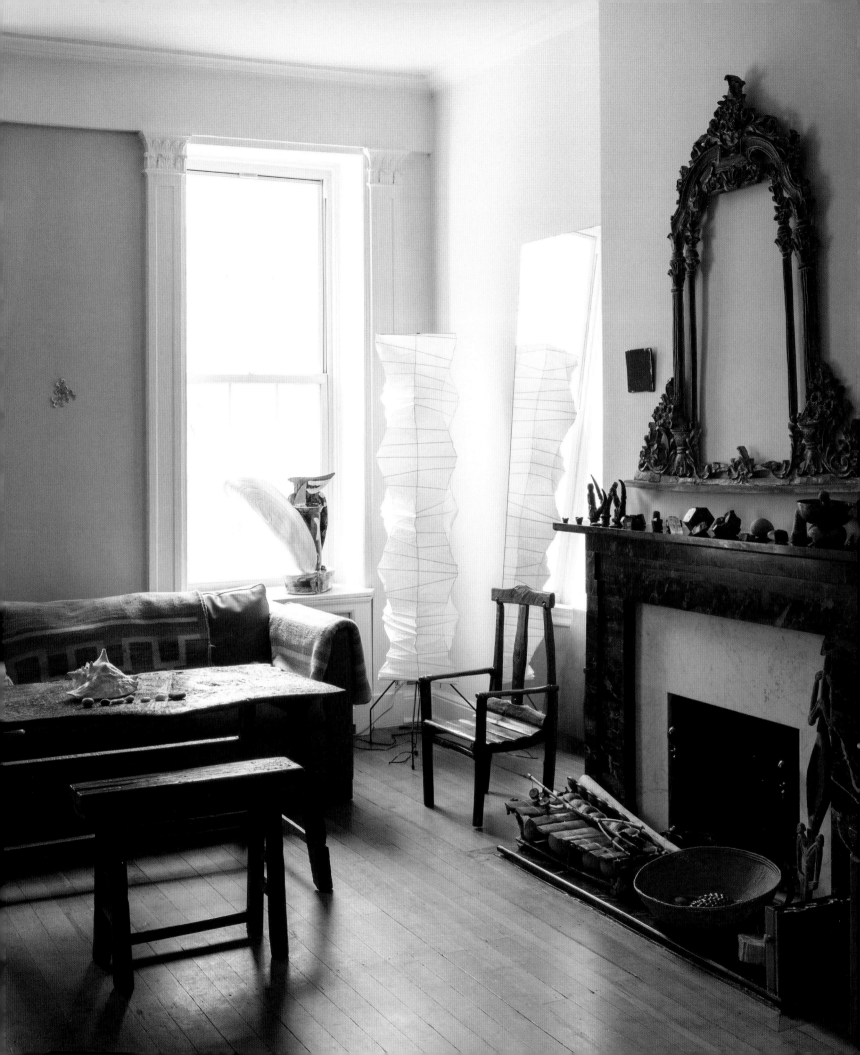

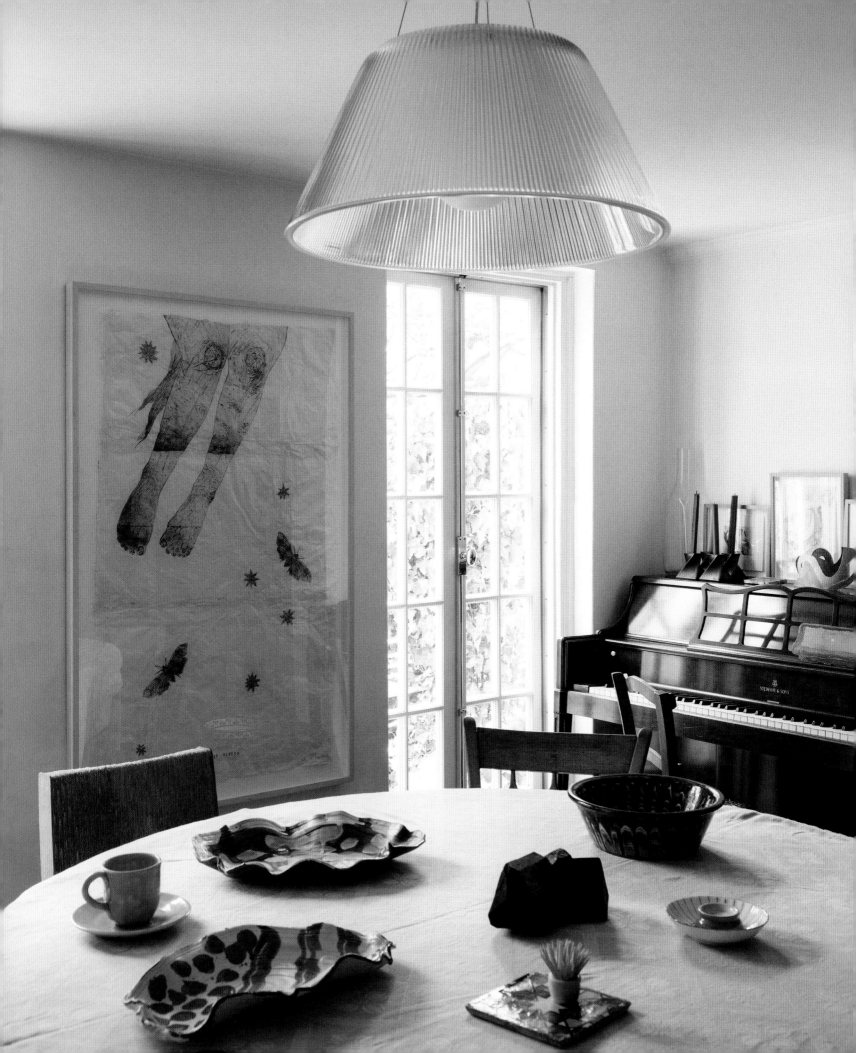

Opposite: A view of the living area includes Kiki Smith's large etching *Mid Heaven* (2007). Mary Heilmann's teacup and saucer share the table with Betty Woodman's ceramic plates. The piano holds another work by Woodman and a framed drawing by Elizabeth Murray.

Above: In the second-floor parlor, a 1993 painting by Steir's former student Ross Bleckner hangs over a table holding Lynda Benglis's 2013 ceramic *WONG-GE*. Also on the table are snail fossils, ancient arrow-heads, a tree fossil, and a tree twig sculpture made by Kiki Smith.

MICKALENE
—
THOMAS

An untitled 2010 collage by
Dani Leventhal hangs over
a pair of desks in Mickalene
Thomas's living room.
"What I appreciate about
Dani's work is the sense
of the freedom and intu-
itiveness she has with the
element of chance," says
Thomas. "Her work comes
out of the formal aspects
of collage making—very
organic but direct."

"I am always looking at people who work out of collage, at how they pull these forms together and how they exist in the world. How they bring the forms back to their practice and what they make of them," says Mickalene Thomas during a tour of her colorful, art-filled Brooklyn brownstone. As she discusses the many collaged works she owns, predominantly by her friends and peers, she continues, "It's like we are all different cooks, and we have the same recipe, but it's how we execute it."

Thomas often uses the aesthetic of collage in the large-scale photographs, paintings, prints, and mixed-media pieces she fashions in her nearby studio. Her work often confronts the traditional objectification of women throughout popular culture: female subjects will boast large Afros, gold hoop earrings, and halter tops and are carefully posed in clothes and settings that allude to sources as varied as blaxploitation films and classical art history scenes. Her elaborate backgrounds are often riotously colored and patterned, and then textured with applied enamel and her signature dazzling glitter, crystal, and rhinestones, further pushing the viewer to explore the many layers of beauty depicted.

"I think there are political aspects in my work, especially with the paintings of women with the Afros; it was the black woman's stance and prowess, 'Look at me, take all of me, this is who I am,'" she explains.

Similar themes of identity also appear throughout her collection. A delicate Olaf Breuning drawing of a woman's head with an oversize Afro lives next to her bed, and three card-size portraits by the Malian photographer Seydou Keita, known as the father of African photography, are installed over the water cooler in her kitchen. The photographs, Thomas explains, date from the 1950s and represent one of the first times that an African photographer—as opposed to a colonial photographer—documented his own community. The photographs were then used for passports, as well as for family records.

Thomas began collecting early in her career, mostly buying works on paper. And while it is meaningful to her to collect African American artists, she says it is the work itself that is of paramount importance. She now regularly visits other artists' studios and exhibits and looks for art that draws her into conversation and dialogue. "I collect artists I respond to and think, 'I wish I made that,'" adding that "I look for things that I haven't necessarily seen out there, and it tells me a bit of who they

are—it's a personal relationship with who they are when you bring art into your home."

In a corner of her dining room hangs a small Huma Bhabha work on paper, a photograph of a sphinx collaged over a washed-pen-and-ink drawing. Thomas discovered Bhabha early in the Pakistani artist's career and purchased this drawing at a gallery show. "She just has a great sense of her materials and how to use them. They are just smart and viscerally phenomenal. I could look at them forever," she says, revealing that she would someday like to own one of Bhabha's much-sought-after sculptures.

On a nearby wall is a small Leslie Hewitt photograph, from her Riffs on Real Time series. A photo of a blurred landscape sits atop a red book cover that is then placed on top of a grainy wood surface, creating a collage with an illusion of three-dimensionality that Thomas admires. "I love the presentation of her photographs. She's a fantastic conceptual artist. Her work is beyond photography—it's sculptural, it's painting, it's poetic and complex. It's literature, it's site specific," says Thomas.

On the other side of the dining room fireplace is a portrait of a standing female figure in profile, one stilettoed leg bent and propped on a ball, her hair in a tight knot. It's a collage by Wangechi Mutu, a Kenyan artist who is also one of Thomas's closest friends. Thomas has positioned the work so that sunlight streaming in from the window illuminates the globular spheres of white light that float within the lines of the subject's body. In Thomas's opinion, Mutu is "the best artist out there today who works with these elements of collage and form and the figure." Directly underneath Mutu's work, Thomas has arranged a shrine, the center of which is the urn for her beloved mother, Sandra Bush, who often served as a model in her work, further adorned with a vase for incense and orange prayer beads Thomas bought in Beijing.

A large painting by her friend Henry Taylor hangs in her living room. It reveals a human form, seen from behind, in a somewhat awkward position, and in a room that vaguely resembles a bathroom; Thomas explains that she bought the piece because she liked its very layered and gestural painting technique as well as its humor, reminiscent of Taylor's distinct "powerhouse" personality. Taylor's humor is further evidenced in a white Kleenex box that he designed with an O-shaped hole open to the letters "b-a-m-a" inside—in combination, they spell the name of the president in a clever,

three-dimensional, playful portrait. "He just has a way of bringing political aspects to his work that are powerful with a sense of humor, but really allow the viewer to come into the work without feeling like you are getting hit over the head. But then again, he is hitting you over the head to make you think about the complexity of his work."

A panoply of richly colored artworks rotate on the walls of her daughter Junya's bedroom. Among Kiki Smith's print of a blue bird and collage pieces by Thomas's former assistants are two of Thomas's own early works, small oil paintings of featureless black women. The works play off another, smaller Henry Taylor painting of a featureless woman with an

Afro set against a bright blue background, which sits on the mantelpiece and reinforces the identification Thomas feels with Taylor. "A lot of people don't realize that I started as a prolific *painter* painter like Henry, so when I look at artists, it's a part of who I am as an artist anyway," she says.

While collage specifically allows her to tackle complicated questions and explore the concept of identity, Thomas also feels that the idea of collage is universal. "We're all related to collage; we're sourcing from a world that is very complex and amalgamated, and it doesn't make sense, but we are all different people, and we have to find ways of fitting together. We are collage."

Mickalene Thomas in front of a Huma Bhabha 2010 ink-on-color photograph. "I love that it's a photographic work and the collage painted on. From a distance it looks like a beautifully painted watercolor," she says. "Huma's work inspires me and makes me want to be a better artist. It's everything I love about art."

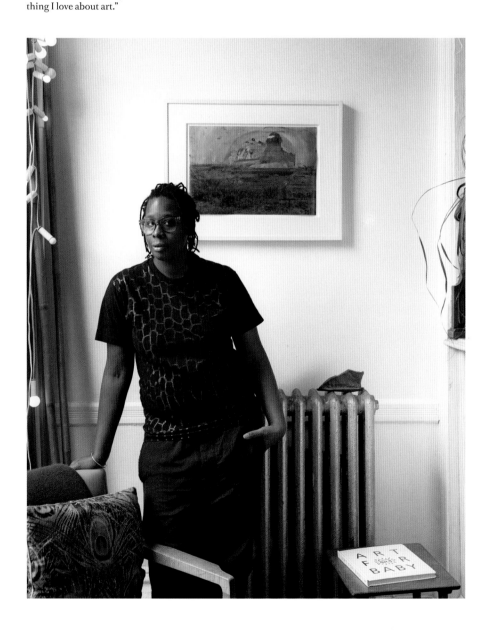

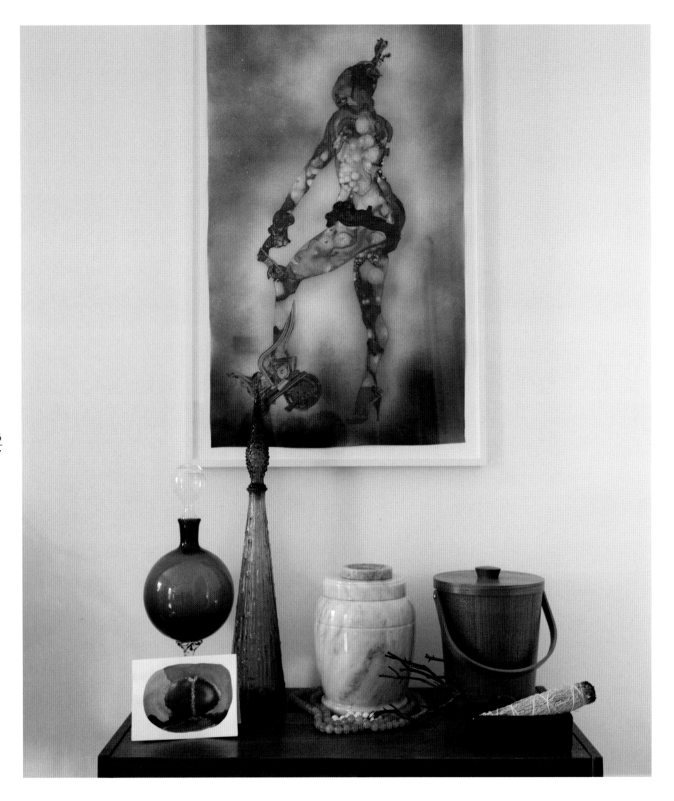

Left: *To the Left*, a
2006 collage on Mylar
by Thomas's friend
Wangechi Mutu, rests
over an arrangement
of objects in honor of
Thomas's late mother
and muse, Sandra Bush.

Opposite: A view of
Thomas's living room.

Mickalene Thomas

Opposite: Another collage by Dani Leventhal, *Squirrel and Oval* (2010), adorns a bedroom wall.

Above: *We Need More Than Luck* (2010) by Thomas's friend Henry Taylor anchors the seating area of the living room. Underneath is his constructed Kleenex box, *Obama*, a playful 3-D representation of the president's name. "He just has a way of bringing political aspects to his work that are powerful with a sense of humor, but really allowing the viewer to come into the work without feeling like you are getting hit over the head—but then again, he is hitting you over the head to make you think about the complexity of his work."

Above: A montage in the
bedroom of Thomas's
daughter includes Kiki
Smith's *Dead Blue Bird* print
with glitter from 2010 and
several works by Benjamin
Lindquist. Two of Thomas's
early paintings from 2000,
women without facial fea-
tures, bookend the middle
row. *Jake*, a painting by Sam
Messer, Thomas's professor
at the Yale School of Art, is
on the bottom right.

Opposite: Olaf Breuning's
2008 drawing resides next
to Thomas's bed.

Mickalene Thomas

LEO
—
VILLAREAL

On a coffee table in Leo Villareal's loft, Rachel Feinstein's wood sculpture of a knight on horseback stands on a base carved in the shape of the number "4"—in honor of Villareal's son. Adam McEwen's glow-in-the-dark painting *Dresden (Phosphorbrandbombe) II* (2006–12), made with phosphorescent paint and chewing gum on aluminum, radiates in the background.

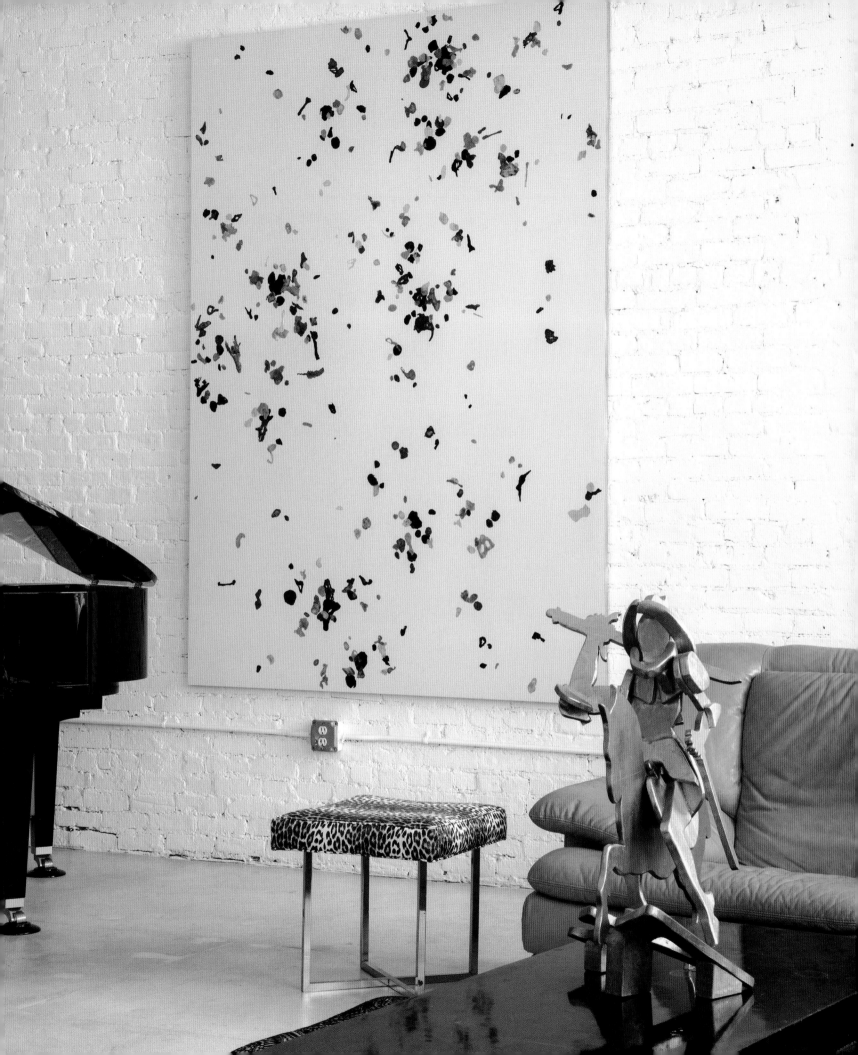

Leo Villareal sitting with
the family dog, Puffbaby, in
front of Rachel Feinstein's
Rhoda mirror painting
from 2008.

Among the most spectacular public art instal-
lations in recent memory is *The Bay Lights*
in San Francisco. The work, which debuted in
2013, features twenty-five thousand sequenced
white LED lights that illuminate the San
Francisco–Oakland Bay Bridge's western
span from dusk to dawn, a dazzling animation
of the Golden Gate's often-overlooked sister
bridge. Designed by Leo Villareal, the creator
of other light-based works, such as *Multiverse*
(2008), an underground concourse at the
National Gallery, and the honeycomb-shaped
Hive (2012) at the Bleecker Street subway
station in New York City, *The Bay Lights* is
the largest light sculpture in the world and
a dynamic offering to the area's residents.

 "It seems like it's a golden age for public art
right now," says Villareal. In order to compose
the San Francisco project's design, the artist
first did a cable walk of the bridge to study the
bay and then set out to invent a piece whose
lights reflect the energy and oscillation of the
water below. "I see technology as an artist's tool
for art making," explains Villareal, comparing
his use of custom-programmed computer
algorithms to control light movement to the
intuitive way one plays a musical instrument.
"You can almost play the software."

 The Villareal household has contrib-
uted to public art in other important ways:
Villareal's wife, Yvonne Force, is the
cofounder of Art Production Fund, which
commissions and produces large-scale public
art projects throughout the country. The
two first met at A/D Gallery, where they dis-
covered they had each bought an oversize
John Chamberlain carved-foam sofa. Force's
was covered in parachute material, Villareal's
in brown suede; Force's still holds a place
of honor in the center of the living room.
"Art has intertwined into our story very
deeply," says Villareal.

 As a result, the couple's artwork, which
they often rotate and loan out to exhibitions,
reflects both their deep art-world friendships
and backgrounds. "It's one big mix," says
Villareal, adding, "I think that's the really excit-
ing part: When you put art together with other
art, it then becomes the ultimate material."

 Noting their friendship with artist Rachel
Feinstein, he points to a wood sculpture of
a knight on horseback resting on a base carved
into the shape of the number four. This sculp-
ture was a gift for their son, Leo IV, known as
"Cuarto" (which means "fourth" in Spanish).
It sits on a coffee table in the living room, near
Feinstein's oval mirror painting of an elderly
woman holding a parasol. "I love the whole

Leo Villareal

fantasy world she creates, merging her history and art history," he says of Feinstein's work.

Large canvases by other important contemporary artists line the walls of their expansive, brick-walled West SoHo loft. Lisa Yuskavage's iconic triptych, *Blonde, Brunette, Redhead* (1995), anchors the dining area where Villareal knowingly deconstructs Yuskavage's use of geometric forms as bases for each model's depiction. A triangle is used for the blonde, a cylinder for the brunette, and a circle for the redhead, he explains, revealing how the artist borrowed the color palette from the classically feminine British designer Laura Ashley. Yuskavage is another close friend of the couple, who also own another yellow-palette work from the same series, as well as smaller drawings and paintings, several, in fact, of Force. Yuskavage even sculpted the figures that adorned the couple's wedding cake.

A bronze floor sculpture of a pair of monkeys by another friend, Sean Landers, is situated under Villareal's own *Big Bang* (2008) spiral light sculpture. "The kids love to climb on it," laughs Villareal, and it's a pairing that, to him, invokes associations with the classic sci-fi movie *2001: A Space Odyssey*. He also appreciates Landers's humor in *The Insomniac*, a 1997 painting of a bird-nosed, feather-necked creature against a background of neatly printed, stream-of-consciousness phrases. "I am interested in humor and some bad-boy artist stuff," he says, which perhaps explains why Landers's painting resides in the foyer with a Dash Snow found photograph of a young girl collaged with a campaign button (it reminds Villareal of the old-fashioned portraits he grew up with in Texas "but with a little edge"), as well as a Dan Colen triptych of bird-shit paintings.

Two works by Alex Katz—one a drawing of the couple on their wedding day, and the other a large oil portrait of the couple against a rose-colored background—further reveal the pair's intimate connection with their art. Katz has called the portrait a "real meatball," according to Villareal, meaning that Katz was pleased with its outcome. Next to the flat rendering is a silkscreen by Nate Lowman and Adam McEwen; a Carol Bove peacock piece; and two paintings by Rudolf Stingel, one a large red textured abstract, the other a small self-portrait. On the opposite wall hangs a large-scale Adam McEwen glow-in-the-dark painting, with affixed pieces of gum. Though Force discovered the piece, it's in tune with Villareal's light-artist sensibility. "I love experiential work and things that deal with illumination and when the invisible becomes visible. It's something I think a lot about with my work," he says.

Villareal's first purchases were an early drawing and photograph by Matthew Barney, who studied art at Yale University at the same time as Villareal. An example of Barney's guillotine series from 1993, a set of seven small color photographs of two wrestling satyrs—one of the artist's first experiments with costumes and mythology—is suspended in a row directly over the couple's bed. "I've had this since before I was married, and it's always been above my bed, because I feel that Matthew works on this dreamy, deeply psychological level, and whenever I see one of his films, it affects my dreams intensely," says Villareal.

Despite the "mix," as Villareal describes their collection, an overall aesthetic cohesiveness emerges in the predominance of boldly painted canvases. As Villareal puts it, "We have a lot of work that is very different from what I would make, but I don't see it as that different. I think my work is very painterly and deals with a lot of classical issues of abstraction so I see all the connections."

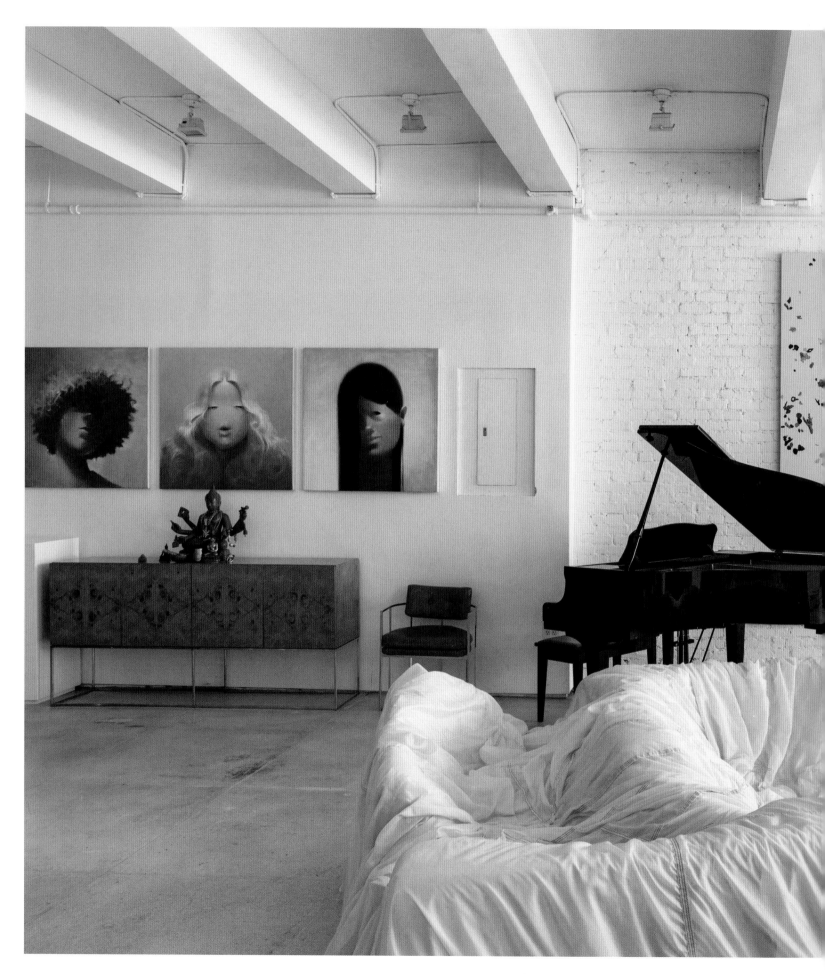

Leo Villareal

Lisa Yuskavage's triptych *Blonde, Brunette, Redhead* (1995) hangs to the left of the piano. John Chamberlain's oversize carved-foam couch from 1969, swathed in parachute material, is positioned in the center of the living area.

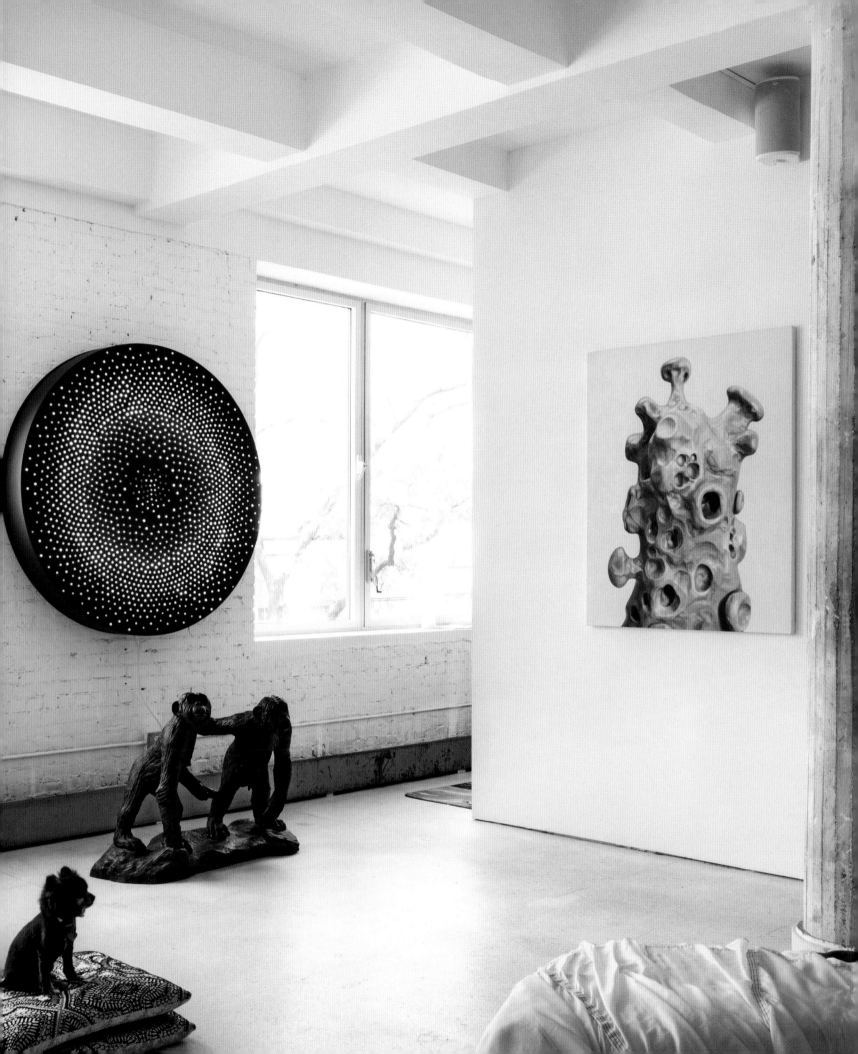

Opposite: Villareal's circular light sculpture *Big Bang* (2008) hangs above a sculpture by Sean Landers, *Singerie: Le Sculpteur* (1995). On the right wall is an untitled 1997 painting by Alexander Ross.

Right: *Altima Bomber Harris* (2006), a gum and silkscreen ink on canvas, a collaboration by Nate Lowman and Adam McEwen, hangs to the left of a portrait by Alex Katz of Villareal and his wife, Yvonne.

Matthew Barney's photographs *Envelopa: Drawing Restraint 7 (Guillotine)* (1993) are suspended above Villareal's bed. "I've had this since before I was married, and it's always been above my bed, because I feel that Matthew works on this dreamy, deeply psychological level," he says.

Leo Villareal

URSULA
VON
RYDINGSVARD

A close-up of African knives and teapots from China and Japan coexist on a bookshelf in Ursula von Rydingsvard's Manhattan apartment.

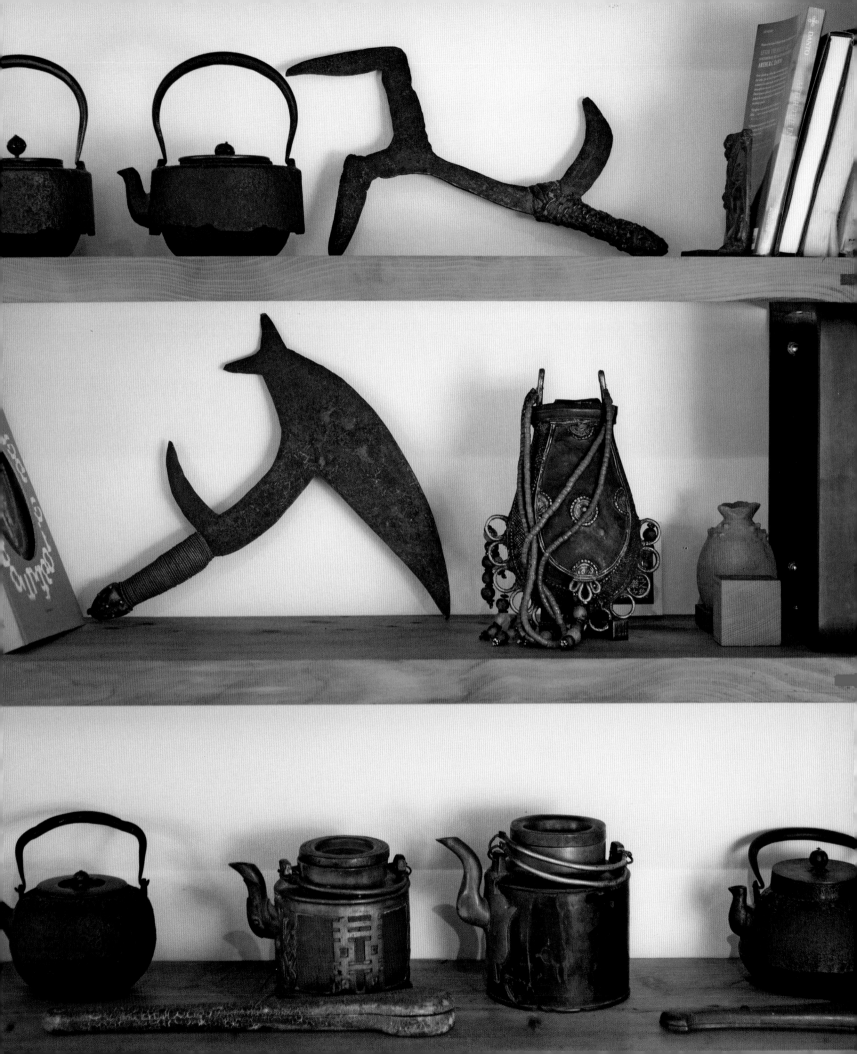

When Ursula von Rydingsvard explains why she loves the distressed look and feel of one her many African masks, cast-iron Chinese teapots, or woven market baskets, she could be describing the very physical appeal of her own world-renowned, large-scale wood or cast sculptures. A small crew of assistants helps her piece together these massive works, while she painstakingly cuts, assembles, and laminates, finally rubbing powdered graphite into the work's textured faceted surfaces. The resulting pieces—often on display in public forums as varied as the Storm King Art Center and Brooklyn's Barclays Center—feature tactile surfaces distinguished by a handmade appearance. In fact, her chiseled cedar sculptures, covered with surface texture and often partially blackened with graphite, naturally age and evolve over time, an effect heightened in the outdoor work.

Similarly, von Rydingsvard is attracted to objects made from organic material with a well-worn patina and a definite sense of gravity and purpose, an appreciation perhaps born out of a childhood spent in post–World War II German refugee camps. She forages flea markets around the world, from Manhattan's famed scrum on West Twenty-Fifth Street to the crowded stalls in Beijing, which she first visited twenty years ago. "That was the best; the flea markets were loaded. I went again maybe ten years later, and they were already depleted, and recently there wasn't anything that you would want to get your hands on," she says with a sigh. Though the pieces she's chosen may seem primitive to the untrained eye, von Rydingsvard quietly asserts that "these craftsmen were as talented as any of us."

Von Rydingsvard is also drawn to textiles, admiring their handmade intricacy. Pulling out a delicate kimono from a stack stored in a high chest in her living room, she points out its worn structure, remarking: "Things like this teach me about my own surfaces, the kind of wear that has credibility and gives the objects this kind of history." In an almost ritualistic routine, von Rydingsvard likes to practice folding and unfolding her textiles, especially the black funeral kimonos adorned with family insignias, in an attempt to re-create how the Japanese have performed this similar ceremony for centuries; only when she has achieved the perfect fold is she satisfied that the fabrics are now at rest in the positions for which they were originally designed.

And yet von Rydingsvard is not particularly interested in the backstories of the objects she collects. Rather, what fascinates her is their

Ursula von Rydingsvard in front of one of her beloved textiles hung over her bedroom door.

Ursula von Rydingsvard

craftsmanship and cultural purpose, and she often labels the insides of her possessions with the country of origin. Rows of hundred-year-old teapots line shelves in a guest bedroom, organized by their size and shape rather than by nationality. The smaller, more delicate models tend to be Japanese, while the squatter ones are Chinese, and the smallest are Japanese sake pots. Though von Rydingsvard has never used any as utilitarian objects, the sculptor in her clearly enjoys examining their construction. Cradling one pot in a loving but almost clinical manner, she reveals an undercarriage designed for a fire so that sake could be reheated when one was traveling; another has "sweet" hinges shaped like hands to grasp its top; and a third features coin decorations used to bring the drinker good luck.

Perched carefully among the teapots are two particularly prized African knives. Again, von Rydingsvard admires what she calls their "beaten-down" appearance and functionality, especially the scythe-shaped cutter, made to spiral through the air as it is thrown at its desired target. And though she demonstrates by fake-tossing the knife, she sees in its design and dilapidated edges an object of beauty rather than menace. "There's something that happens to the surfaces—it had to be pounded in [to] the shape, it's so full of honor and full of want," she comments, caressing the undulating wave of its steely surface.

Back in the dining room, among a Dogon monkey mask peeking out from a wall and a large mother-and-child sculpture from the Makonde tribe in Tanzania, are a dozen square-shaped Tibetan sticks of various lengths, meticulously lined up and hung over the sideboard. Appropriately enough, the sticks were used in temples for stamping symbols on the surfaces of food during certain holy days. Von Rydingsvard bought them all at the same time in Beijing, attracted to the repetition of their inscribed symbols, which reminds her of how she would count Hail Marys on rosary beads during her Catholic upbringing in Poland. As a young girl, von Rydingsvard had wanted to be a nun. Now, though she is no longer a practicing Catholic, she is still attracted to and collects religious icons, displayed both in her bedroom and in a shrine-like arrangement in the front hall.

Von Rydingsvard is particularly intrigued by the design of her deeply grooved, wooden African masks, showing on one how the carver used the same line for the eyebrows to continue down the face for the beard. She savors these little moments, like the faint smell of smoke still emanating from the mask that is so resonant of Africa.

The soft-spoken, elegant sculptor has been known to follow one of her favorite Nigerian dealers from the Twenty-Fifth Street flea market to a rented storage unit just to examine and buy more of his imported gems—a Gabon tribal mask or a set of small figurines from the Nandi tribe—which have found sanctuary among her possessions.

Though the objects and materials in her apartment hail from many corners of the globe, a tangible feeling of age and substance unites them. Von Rydingsvard is always searching for something indescribable yet specific to her sensibilities. And she only knows it when she sees it. "When I bring something home, I can't wait to hang it up or live with it or see how it feels to live with, so I think the joy is not in how it gets here or even the history of that, but it's something else. It makes me feel like I have a greater support in my own home, that it is more welcoming, that it is more interesting."

A row of carved wooden sticks used in Tibetan temples for stamping symbols on food during holy days are neatly lined up over a sideboard in the dining room.

Ursula von Rydingsvard

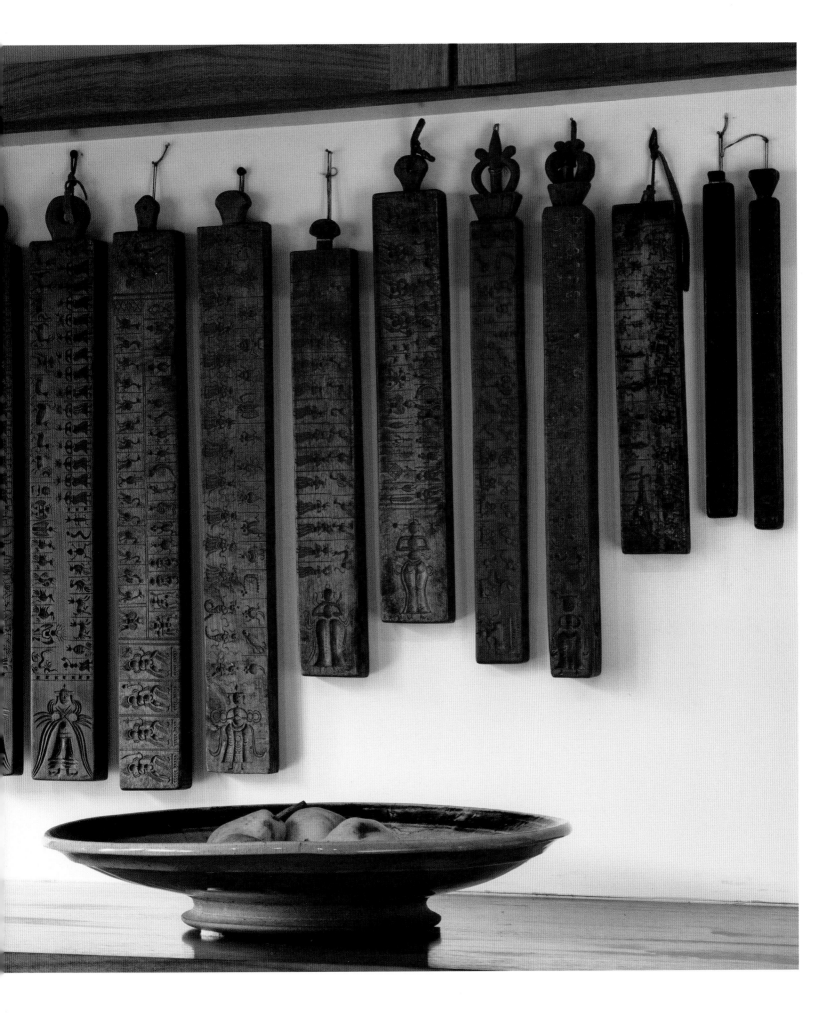

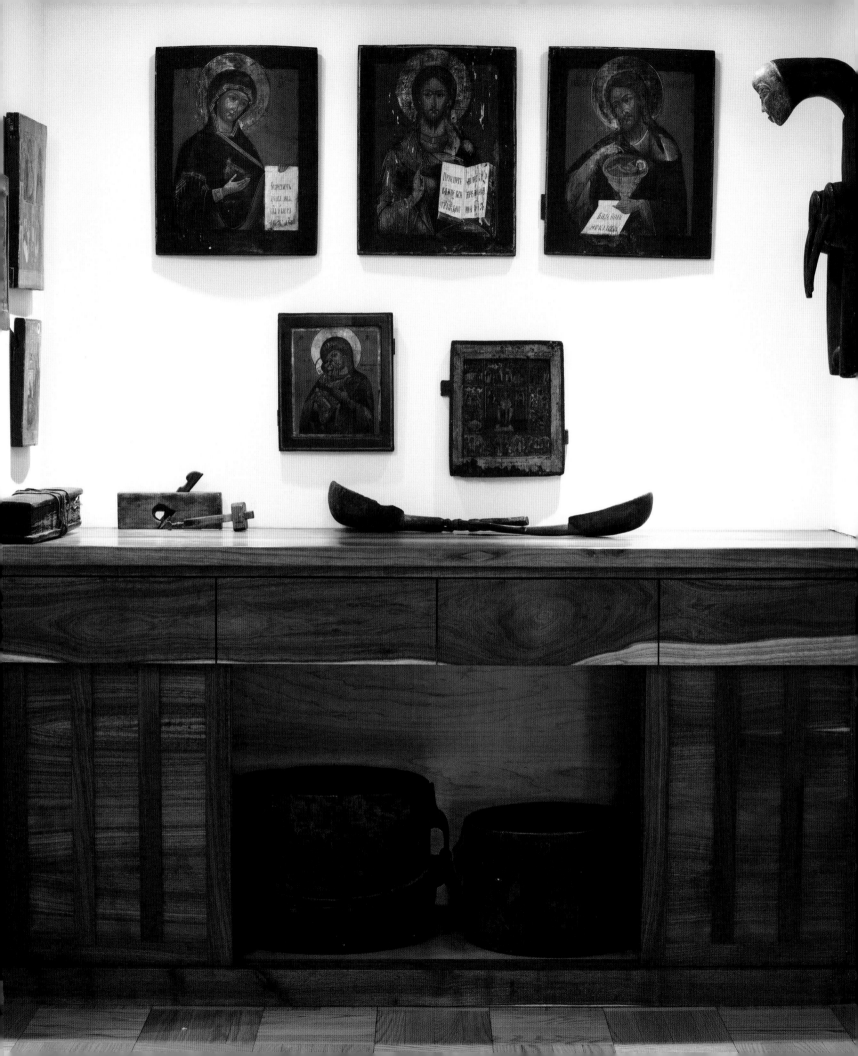

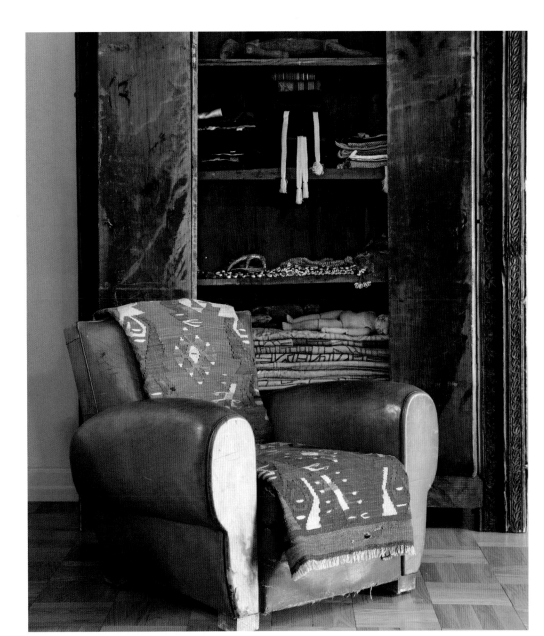

Opposite: Von Rydingsvard
has paired Russian icons
with an African bellow from
Gabon (on the right wall)
and wooden spoons and
bowls from Africa to form
a shrine-like tableau in the
apartment's entryway.

Right: A Turkish rug is
draped over a leather chair,
in front of a cabinet that
houses Von Rydingsvard's
collection of Kuba cloths,
antique Japanese kimonos,
and other neatly folded
textiles from Japan, China,
and India. Dolls from
Tanzania and China also
appear on the shelves.

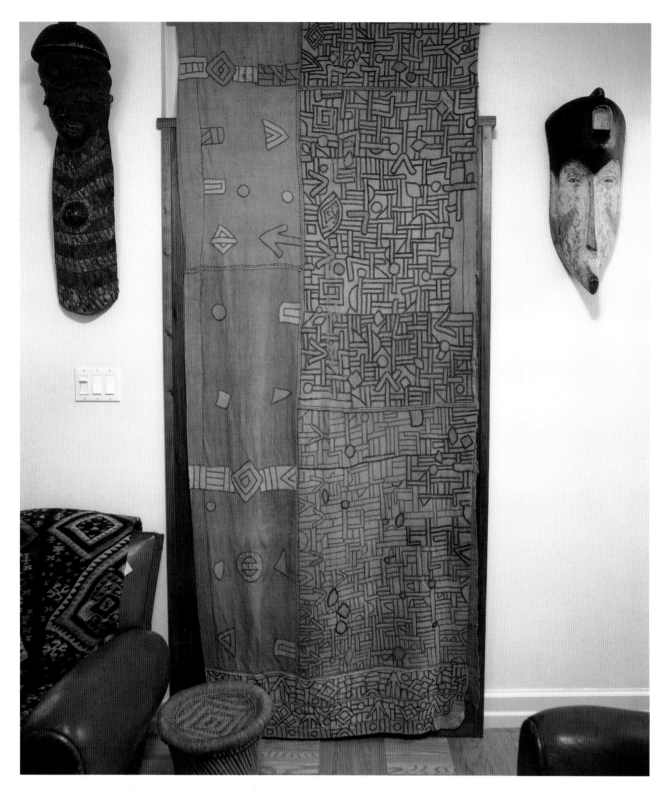

Above: A Kuba cloth hangs
next to a wooden mask
from Gabon on the right.

Opposite: Von Rydingsvard's
friend, Puerto Rican sculptor
Charles Juhasz-Alvarado,
designed the cabinetry
using a variety of rare woods.
Among a white clay box
and the plaster-cast hands
made by her daughter, Von

Rydingsvard has arranged
a colorful beaded African
cap (top shelf, center) with
Japanese cast-iron teapots
below, next to an Ashanti
stool from Ghana on the
far right. On the bottom
row, the folded blankets

on top of the suitcase are
U.S. Army blankets she
used while staying at
German refugee camps
after leaving Poland. The
cardboard suitcase and
books are also remnants
from that time.

Ursula von Rydingsvard

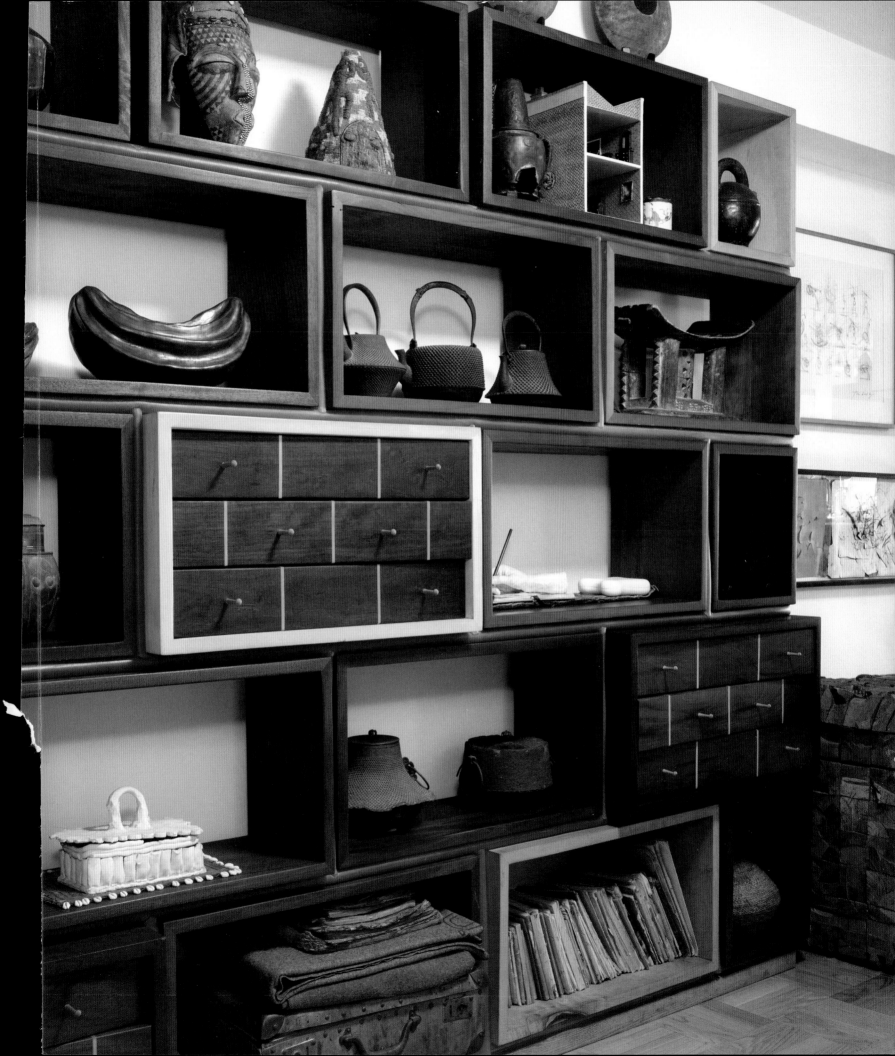

Image Credits

pp. 10-17, Courtesy of Josh Smith and Luhring Augustine, New York; Courtesy of Mary Manning; Courtesy of Andy Coolquitt; Courtesy of Kamau Amu Patton; Collection of Tauba Auerbach, New York; © 2015 Alex Olson; Courtesy of the Estate of Shawn Mortensen; pp. 18-25, © The Estate of Jean-Michel Basquiat/ADAGP, Paris/ARS, New York 2015; © Eric Fischl; Copyright © 2015 Artists Rights Society (ARS), New York/VG Bild-Kunst, Bonn; Art © Jasper Johns and Gemini G.E.L./Licensed by VAGA, New York, Published by Gemini G.E.L.; pp. 26-37, © Kiki Smith, courtesy Pace Gallery; pp. 38-49 © 2015 The Andy Warhol Foundation for the Visual Arts, Inc/ Artists Rights Society (ARS), New York; Art © Japer Johns and Gemini G.E.L./Licensed by VAGA, New York, Published by Gemini G.E.L.; Art © David Salle/Licensed by VAGA, New York; © Ryan McGinness/Artists Rights Society (ARS), New York; pp. 50-59: © 2015 Artists Rights Society (ARS), New York/ADAGP, Paris; Courtesy of Sean Landers; pp. 60-69: Courtesy of Luke Butler and Jessica Silverman Gallery; Courtesy of Vito Acconci; © Matthew Benedict; courtesy Alexander and Bonin, New York; Courtesy of Rob Pruitt and Gavin Brown Enterprise; pp. 70-81: Courtesy Carl D'Alvia; Courtesy of Marilyn Minter and Salon 94; © Mel Bochner; Courtesy John Newman; pp. 82-91: Bill Brandt © Bill Brandt Archive; © 2015 Susan Rothenberg/Artists Rights Society (ARS), New York; Courtesy of Jeannette Montgomery Barron; Courtesy of Laurie Lambrecht; Courtesy Francesco Clemente; pp. 92-101: © The Andy Warhol Foundation for the Visual Arts, Inc/Artists Rights Society (ARS), New York; © The Milton Resnick and Pat Passlof Foundation, Courtesy Cheim and Read, New York; Courtesy of Ross Bleckner; Courtesy of Peter Halley. Courtesy of Sebastian Blanck; Courtesy of Francesco Clemente; Courtesy of Cecily Brown; Courtesy of Isca Greenfield-Sanders; Courtesy of John Sanders; Courtesy Doug Starn and Mike Starn; pp. 102-11: Courtesy of John Waters and Marianne Boesky Gallery; Courtesy of Roy Fowler; Courtesy of Don Christenson; Courtesy of Billy Sullivan; Courtesy of Jack Pierson; Courtesy of Stephen Mueller; Courtesy of Paul Gabrielli; Courtesy of Sarah McDouglas Kohn; Courtesy of Rick Liss; Courtesy of Candace Hill Montgomery; Courtesy of Joanne Greenbaum; Courtesy of Jan Hashey; Courtesy of Elizabeth Cannon; pp. 112-21: Courtesy of Margaret Lee; Courtesy of Sam Gilliam and David Kordansky Gallery, Los Angeles; Courtesy of Glenn Ligon and Regen Projects, California; Courtesy Mai-Thu Perret and David Kordansky Gallery, Los Angeles,; Courtesy Anthony Pearson; pp. 122-31: © Lawrence Weiner; pp. 132-41: © On Kawara NOV. 22, 1978 from Today series, 1966-2013 "Wednesday." Acrylic on canvas, 10 x 13 inches (25.4 x 33 cm), Courtesy David Zwirner, New York/London; Copyright © Gabriel Orozco; Copyright © Lawrence Weiner; Art © Vik Muniz/ Licensed by VAGA, New York, NY; pp. 142-53: Courtesy of Brice Marden; Courtesy of Helen Harrington Marden; Art © Robert Rauchenberg/Licensed by VAGA, New York; Courtesy of Cecily Brown; Courtesy of Francesco Clemente; pp. 154-65: © Joyce Pensato; Courtesy Kenny Scharf; © 2015 Richard Artschwager/Artists Rights Society (ARS) New York; Art © Kara Walker; Courtesy Mary Heilmann; Courtesy of Takuro Kuwata and Salon 94; Courtesy Laurie Simmons and Salon 94; Courtesy Keung Caputo and Salon 94; Courtesy of Jeff Elrod and Luhring Augustine, New York; © Gerhard Richter; Courtesy of Sue Williams and 303 Gallery, New York; Courtesy of Austin Lee; pp. 176-83: Courtesy of Bruce Pearson and Ronald Feldman Gallery; Courtesy of David Brody; Courtesy Joe Amrhein; pp. 184-95: © The Arshile Gorky Foundation/The Artists Rights Society (ARS), New York; © The LeWitt Estate/Artists Rights Society (ARS), New York; © 2015 Artists Rights Society (ARS), New York; Courtesy the Estate of Stephen Mueller; Courtesy Martha Diamond; © 2015 Succession H. Matisse / Artists Rights Society (ARS), New York; Art © Jasper Johns/Licensed by VAGA, New York; Art @ Alex Katz/Licensed by VARGA, New York; pp. 196-207: © Urs Fischer, courtesy of the artist; © The Estate of George Paul Thek; Courtesy Alexander and Bonin, New York; Courtesy of Peter Halley; Courtesy of Verne Dawson; pp. 218-29: Courtesy of Matthew Solomon; Courtesy of Margaret Lee; Courtesy of Klara Kristova and Lehmann Maupin, New York/Hong Kong; Courtesy of E.V. Day; Courtesy of Olaf Breuning and Metro Pictures; pp. 230-41: Courtesy Brice Marden; © 2015 The LeWitt Estate/ Artists Rights Society (ARS), New York; © 2015 The Josef and Annie Albers Foundation/Artists Rights Society (ARS), New York; Art © Lynda Benglis/Licensed by VAGA, New York; © Kiki Smith, Courtesy Pace Gallery; © 2015 Anish Kapoor / ARS, New York / DACS, London; 2015 Robert Mangold/Artists Rights Society (ARS), New York; Courtesy of Alexis Myre; Courtesy the Estate of Stephen Mueller; Courtesy of Richard Tuttle; Courtesy of Betty Woodman and Salon 94; Courtesy of Ross Bleckner; pp. 242-51: Courtesy of Henry Taylor; © Kiki Smith, Courtesy Pace Gallery; Courtesy of Dani Leventhal; Courtesy of Olaf Breuning and Metro Pictures; Courtesy of Huma Bhaba and Salon 94; Courtesy of Wangechi Mutu; Courtesy of Olaf Breuning and Metro Pictures; pp. 252-61: Courtesy of Matthew Barney; Courtesy of Lisa Yuskavage and David Zwirner, New York/London; Courtesy of Adam McEwen; Courtesy of Sean Landers; Courtesy of Nate Lowman and Adam McEwen; Art @ Alex Katz/Licensed by VARGA, New York; Courtesy of Rachel Feinstein and Marianne Boesky Gallery; © Fairweather & Fairweather LTD/Artists Rights Society (ARS), New York.

Acknowledgments

We would like to thank the countless people who helped create *Artists Living with Art*. The project had two "fairy godmothers": our great friend Marianne Boesky, who was a valuable sounding board and introduced us to Abrams, and Ann Gund, whose generous enthusiasm helped the project enormously through her affiliation with Skowhegan School of Painting and Sculpture. We also extend a special and warm thanks to Oberto Gili, and the amazing Joy Sohn. There were many others who helped—putting in a good word on our behalf, weighing in on editorial decisions, and supporting us through this process. The book wouldn't have been the same without Frances Beatty Adler, BJ Topol Blum, Katrina Brooker, David Cashion, Alison Cody, Andrea Danese, Rose Dergan, Chrissie Erpf, Roy Furman, Claire Gilman, Sue Hostetler, Brad Johns, Barbara Landreth, Alexis Lipsitz, Brett Littman, Jennifer McSweeney, Dana Miller, Peter Reuss, Joanne Ramos, Markham Roberts, Jennifer Ash Rudick, Kara Vander Weg, and Shelley Wanger. In addition, we would like to acknowledge and thank the hundreds of artists whose works appear in these homes, providing so much inspiration, as well as the many studio assistants who graciously answered our countless questions and requests. And last but not least, we send love and thanks to our families and especially our husbands, Rob Goergen and Clayton Benchley.

Editors: Andrea Danese and David Cashion
Designer: Jeanette Abbink, Rational Beauty
Production Manager: Denise LaCongo

Library of Congress Control Number: 2015959558

ISBN: 978-1-4197-1782-6

Text copyright © 2015
Stacey Goergen and Amanda Benchley
Photographs copyright © 2015 Oberto Gili

Printed and bound in China
10 9 8 7 6 5 4 3 2 1

Abrams books are available at special discounts when purchased in quantity for premiums and promotions as well as fundraising or educational use. Special editions can also be created to specification. For details, contact special-sales@abramsbooks.com or the address below.

THE ART OF BOOKS SINCE 1949

115 West 18th Street
New York, NY 10011
www.abramsbooks.com

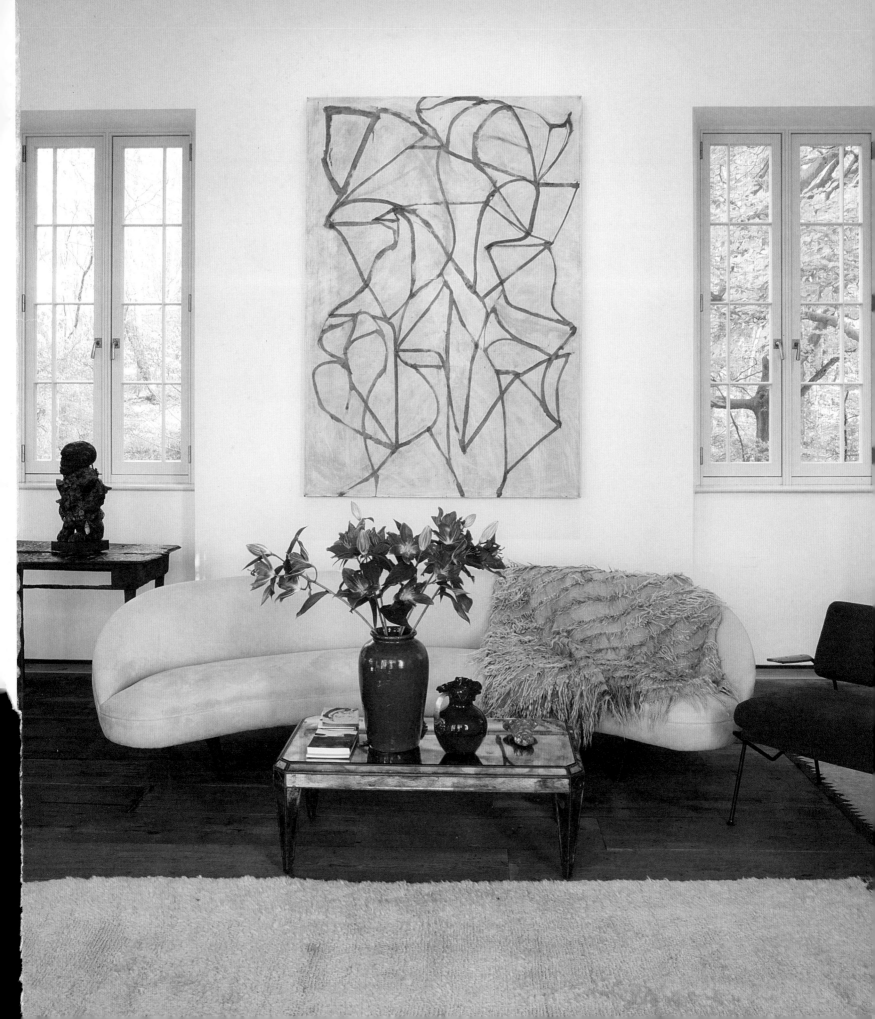

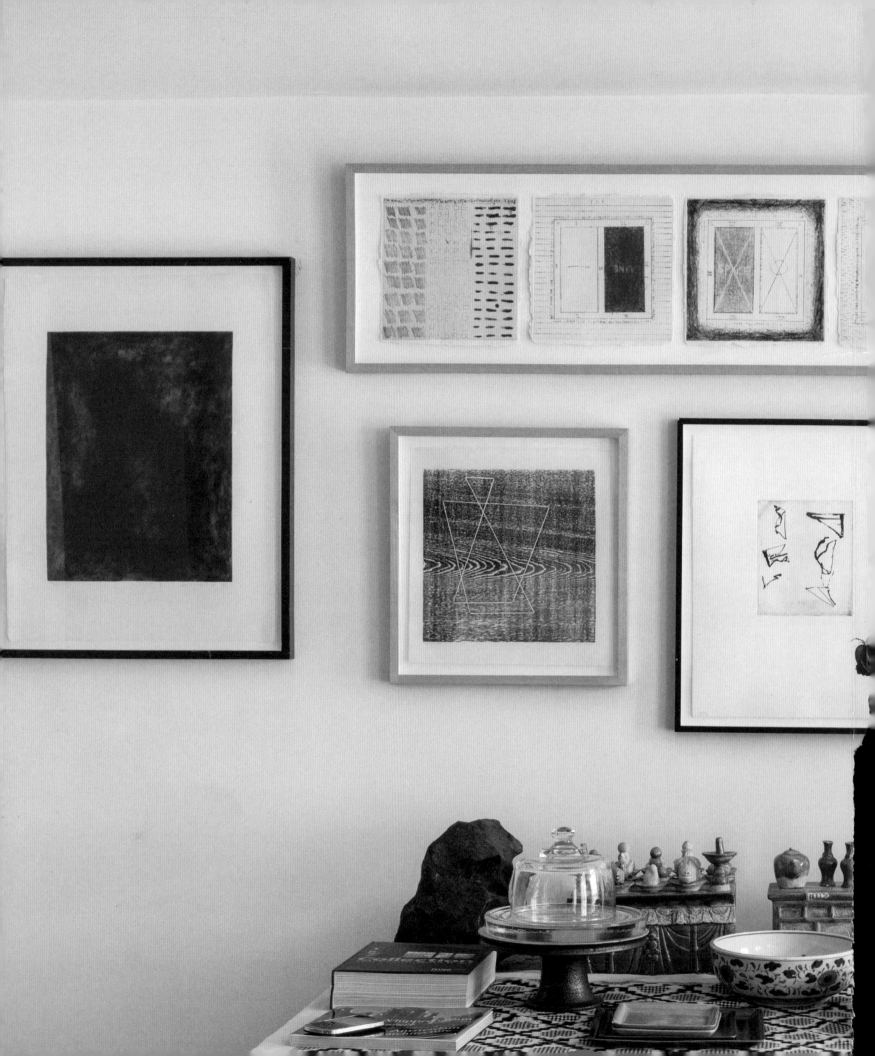